JOHN HEDGECOE'S
PRACTICAL
PORTRAIT
PHOTOGRAPHY

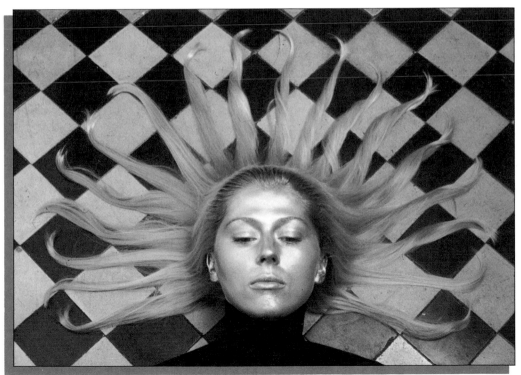

A Fireside Book
Published by Simon & Schuster, Inc.
New York · London · Toronto · Sydney · Tokyo

John Hedgecoe's
Practical Portrait Photography

A MOBIUS INTERNATIONAL BOOK

Edited and designed by
Mobius International Limited
197 Queen's Gate
London SW7 5EU

Simon and Schuster/Fireside Books
Published by Simon & Schuster, Inc.
Simon & Schuster Building
Rockefeller Center
1230 Avenue of the Americas
New York, New York 10020

SIMON AND SCHUSTER, FIRESIDE and
colophons are registered trademarks of
Simon & Schuster, Inc.

First published in Great Britain in 1987
by Ebury Press,
Division of The National Magazine
Company Limited
Colquhoun House
27-37 Broadwick Street
London W1V 1FR

Printed and bound in West Germany
by Mohndruck

10 9 8 7 6 5 4 3 2 1
10 9 8 7 6 5 4 3 2 1 Pbk.

Library of Congress
Cataloging-in-Publication Data

Hedgecoe, John.
 John Hedgecoe's practical portrait
 photography

 "A Fireside book."
 1. Photography — Portraits. I. Title.
TR575.H35 1987 778.9'2 87-14665
ISBN 0-671-64714-8
ISBN 0-671-64713-X (pbk.)

CONTENTS

INTRODUCTION

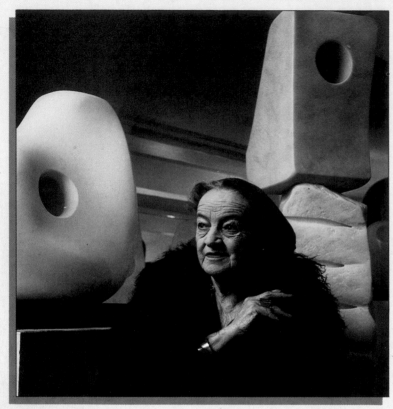

◄ **Lighting and framing**
Much in portrait photography depends on a careful lighting scheme and framing that adds to our understanding of the subject. Here I posed the sculptress Barbara Hepworth between two of her works and lit her with daylight-balanced flash, recording surrounding tungsten light as bright orange.
□ *Hasselblad, 80 mm, Extachrome 64, 1/60 sec, f 16*

► **Backgrounds**
For this study of the painter Francis Bacon, the most appropriate and easiest background in this case was his canvases, propped against a studio wall using the studio daylight.
□ *Pentax, 28 mm, Ektachrome 64, 1/125 sec, f 8*

Most of us consider taking pictures of people, which is all that portraiture is, to be one of the main reasons for owning a camera. This book aims to show you how even simple studies of family or friends can have wider appeal and to encourage you to broaden your approach to this fascinating subject.

As with all aspects of photography, obtaining a technically correct picture is vital, and so the first chapter presents a brief survey of the latest cameras and lenses and their applications. Next, with the help of explanatory text and full technical data, we start to see how technique can begin to be applied in a more creative way.

Other chapters deal with aspects of photography in a wide range of situations, both in the home or studio and on location. And because lighting, either artificial or natural, is central to successful portraiture, you will find diagrams explaining how I took particular photographs.

As your confidence grows, you may want to try a thematic approach. This requires a greater commitment since subjects such as people involved in specific types of occupation or sharing common interests, can be difficult to gain access to. However, the results are very immediate and, as a record of events or activities, can give you and your subjects long-term pleasure.

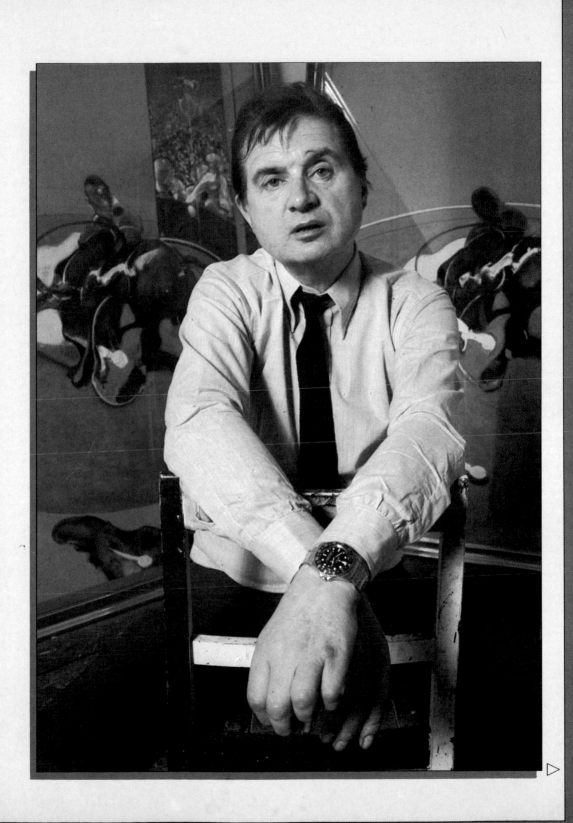

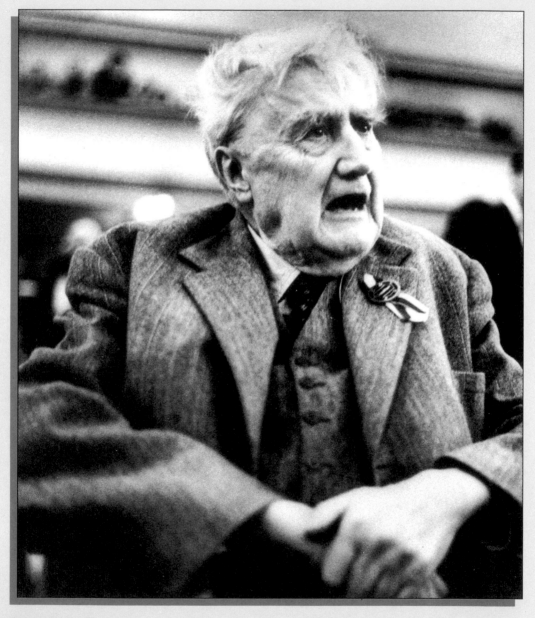

▲ Low-key approach
For a varied portfolio of portrait photographs, you must learn to adapt your style and approach to your subjects. This shot of the composer Vaughan Williams shows that his attention, and obvious concern, was concentrated on the performance of the orchestra. Even at rehearsals you will probably not be allowed to use flash because it is distracting, and even the camera shutter noise can disturb the music.
□ *Rolleiflex, Ilford HP5, 1/60 sec, f5.6*

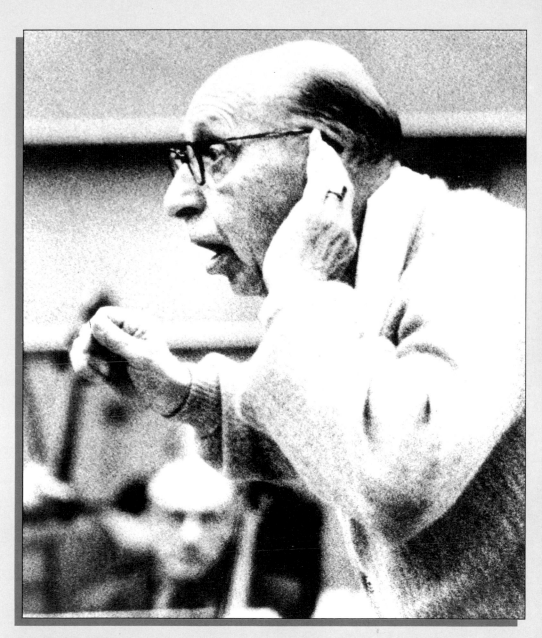

▲ Artist at work
Different temperaments pro-
duce different atmospheres,
and it is this unpredictability
that makes portrait photo-
graphy such an engrossing
subject. Here we see the Rus-
sian-born composer Igor
Stravinsky conducting his
orchestra during a rehearsal.
This is an image of a more
controlled personality than
Vaughan Williams, opposite,
and someone totally immersed
in his music.
□ *Leica, 50 mm, Kodak Tri-X,
1/30 sec, f 8*

▷

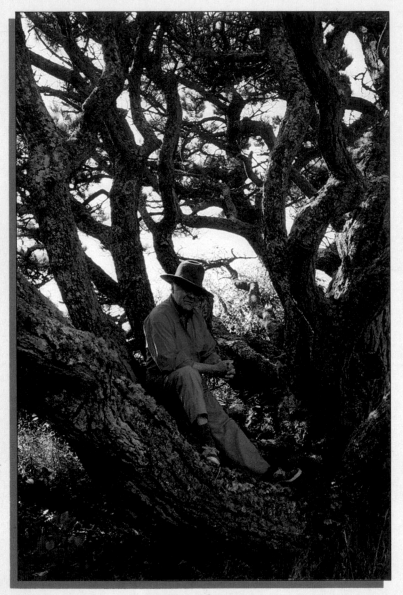

Each photograph is unique and can be thought of as a time capsule, summing up all that is particular about a certain person, style, or age at any precise moment. This picture of fashion designer Mary Quant posing with her then new-born baby is semi-formal in approach and I used daylight-balanced flash bounced off the ceiling to produce an even, diffused light and also to avoid overly bright reflections from the surface of the leather sofa. Obviously a person concerned with her appearance, here she looks every inch a high priestess of style.
□ *Hasselblad, 60 mm, Ektachrome 200, 1/60 sec, f 11*

▲ **Natural light and shadow**
This picture of artist Patrick Heron suggests a flamboyant personality, dressed as he is in contrasting blues, red, purple and green. My intention was to create a balanced composition by posing him surrounded by the highly textured surfaces but subdued color of an imposing, ancient tree, thus giving emphasis to his brightly colored clothes.
□ *Pentax, 85 mm, Ektachrome 64, 1/125 sec, f 11*

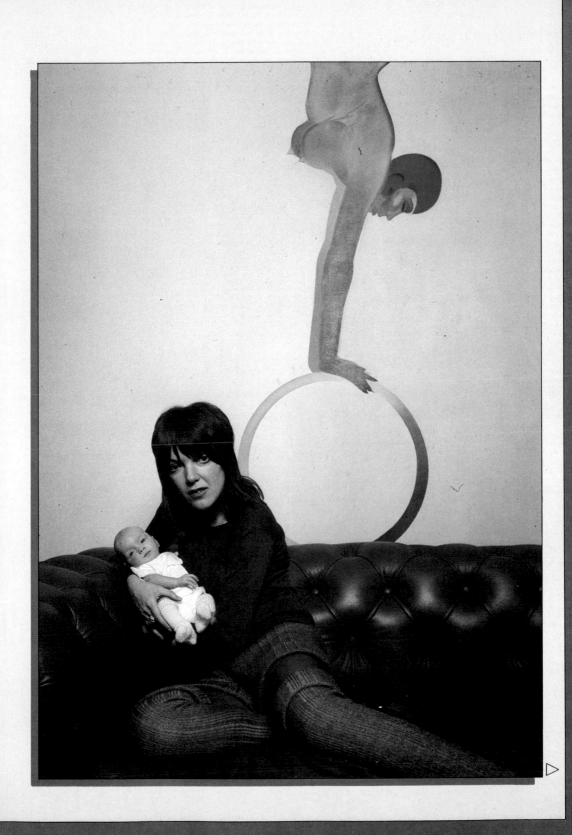

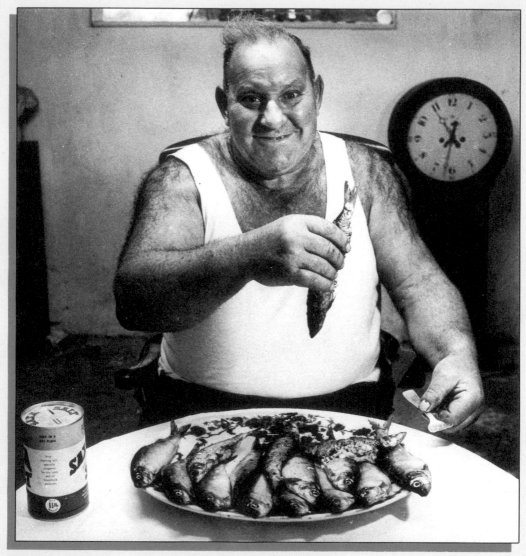

▲ Hearty appetite
One of the abilities of successful portrait photography is a desire to get on with many different types of people and to find common points of interest as part of the rapport you need to build with your subjects. It is an easy mistake to think that all your portraits need to be 'natural' and appear unaffected by the presence of the camera. The strength of this picture lies in the fact that the gourmand was playing to the camera and to me as photographer. The unconcealed glee with which he is about to tackle a plate of freshly grilled fish, makes him, despite his massively overweight frame, a very appealing character.
□ *Hasselblad, 80 mm, Kodak Tri-X, 1/60 sec, f 8*

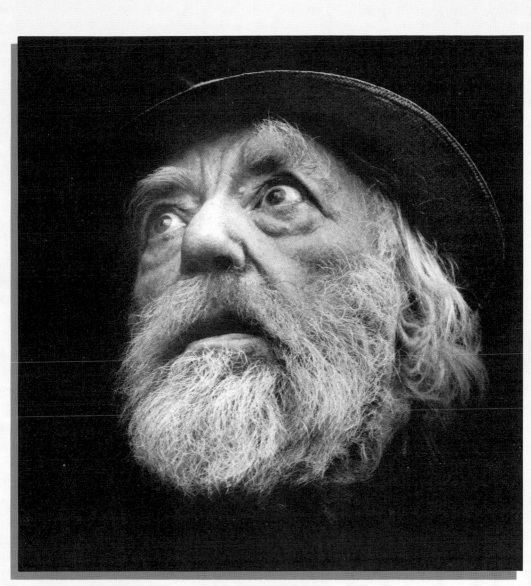

▲ Tonal contrast

Dramatic lighting such as this has great impact, gives your work a very professional look, and is extremely easy to achieve. I caught the painter Augustus John looking rather furtive, almost like a villain in some silent melodrama. The lighting was achieved by using a shaft of daylight from a nearby window, and by exposing for the highlight on his face the surrounding area in dif- fused light recorded as deep shadow. A low camera angle helped to increase his apparent stature and this also adds to the strength of the photograph.
□ *Hasselblad, 120 mm, Ilford HP5, 1/125 sec, f 11*

▷

▷ INTRODUCTION

▶ Composing in color

Simple blocks of strong color, mainly blue, yellow and white, make a bold statement in this unusual portrait, where the subject's head is obscured by an umbrella. Although much advice is given about avoiding the high, midday sun for pictures because it produces unflattering shadows, it can be ideal for intensifying color, an effect that I enhanced by the addition of a polarizing filter to the camera lens. □ *Hasselblad, 60 mm, Ektachrome 64, 1/250 sec, f16*

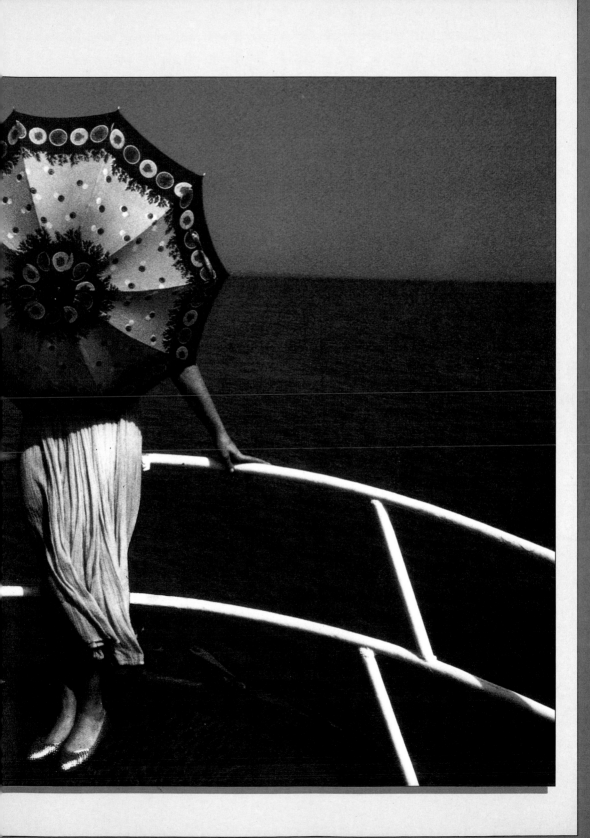

CAMERAS
AND LENSES

□ *Pentax, 85 mm,*
Kodak Tri-X, 1/125
sec, f 5.6

The painter and
teacher Carel Weight.
□ *Hasselblad, 80 mm,
Kodak Tri-X, 1/60 sec,
f 16*

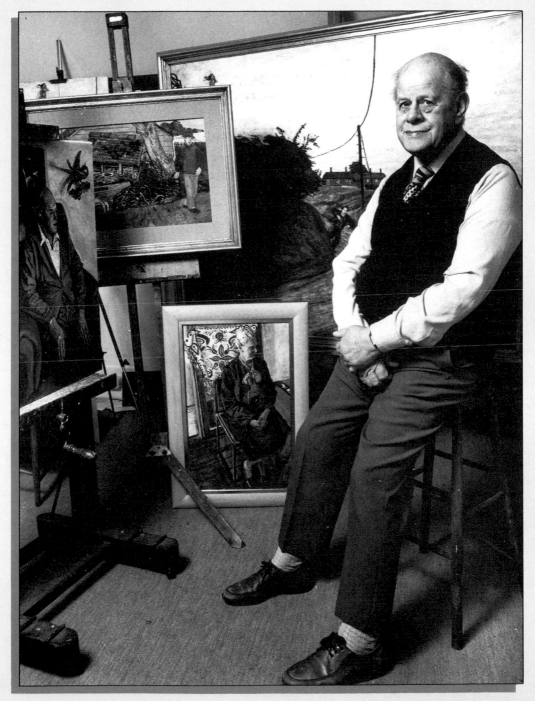

CAMERA FORMATS

▼ Vertical framing
One of the advantages of the rectangular format is that you have a choice of framing. Vertical framing is often referred to as the portrait format because, as you can see, it is easy to fill the frame with the head and shoulders alone.
□ *Pentax, 85 mm, Ektachrome 64, 1/125 sec, f8*

Because of the proliferation of camera types and models, choice can be difficult. If, for example, you think that most of your portrait work will be candids taken outdoors, then you should consider the 35 mm format – either compact or SLR. If, on the other hand, you intend to concentrate on studio portraits, you should consider a medium-format camera. Much will depend on the final size of your images, since the larger the original, the better the enlargement.

Leaving aside differences in image quality between 35 mm and medium-format cameras, you next need to consider how comfortable the cameras are to handle. The modern trend with the 35 mm format is towards miniaturization – SLRs and, in particular, compacts are now smaller and lighter than was thought possible only 10 years ago.

▲ Square format
Using a rollfilm camera that gives a square image can be more demanding when it comes to composing your shots, since you must ensure that all of the surroundings form part of the information about the subject you want to convey.
□ *Hasselblad, 80 mm, Ektachrome 200, 1/60 sec, f 11*

◄ Horizontal framing
Where the background is important to the main subject, you will find that horizontal framing allows you extra flexibility. Here, the glimpse of village life behind the child brings the shot to life.
□ *Pentax, 35 mm, Ektachrome 64, 1/250 sec, f 8*

This, to a degree, also applies to medium-format cameras, but their box-like shape is still more suited to a tripod.

The last two camera formats to be mentioned represent the extremes of image quality: large-format, sheet-film cameras are almost exclusively used in the studio and produce images of superb definition, while disk and 110 cameras, although convenient for record shots, produce a negative size so small as to make them unsuitable for the serious photographer.

THE 35 mm COMPACT CAMERA

For the portrait photographer, the 35 mm compact format represents the most 'basic' camera that can be considered. At its most sophisticated, however, a compact camera can rival, or even surpass, most 35 mm SLRs in its degree of automation but, because of a limited choice of lenses, it does not have the same flexibility.

Features to look for

The least expensive compacts have fixed lenses and no means of focusing. The built-in lens of between 35 mm and 40 mm, combined with a small, fixed aperture, ensures that depth of field is enough to render everything sharp.

Moving up the range, the majority of compacts now feature completely automatic focusing, although manual focusing using either the zone system of distance symbols (see right) or a distance scale, is still available. When considering a compact camera, make sure that its film-speed range will accommodate the type of film you normally use: it is not uncommon to find that only ISO 100 and 400 are suitable.

To compensate for any of these limitations, you will find on many compact

▼ Parallax error
The scene you see through the viewfinder window is slightly different to the view seen by the lens. This can lead to framing errors when subjects are positioned too close to the camera. Most compacts have framing lines visible in the viewfinder to indicate the actual subject area covered by the

lens. Other information can include confirmation of focus.

Many compact viewfinders also show a range of symbols indicating subject distances from the camera. This system is accurate enough when combined with the extensive depth of field associated with wide-angle lenses preset at a small aperture.

◄ Further refinement
Compacts reach a new level of refinement, versatility and ease of use with this camera, which, apart from the usual automatic features, also has a 35-70 mm power-assisted zoom lens. The built-in flash is programmed to adjust its output to match the focal length of the lens at the time of exposure.

SEE ALSO
CAMERA FORMATS 18-19
LENS PRINCIPLES 32-3
HIGH AND LOW KEY 156-61

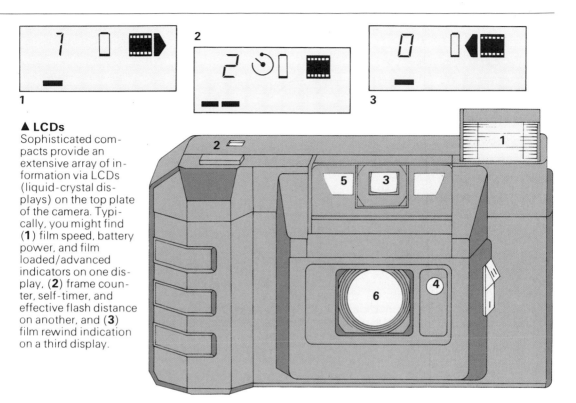

▲ LCDs

Sophisticated compacts provide an extensive array of information via LCDs (liquid-crystal displays) on the top plate of the camera. Typically, you might find (**1**) film speed, battery power, and film loaded/advanced indicators on one display, (**2**) frame counter, self-timer, and effective flash distance on another, and (**3**) film rewind indication on a third display.

models a DX-film-recognition system that automatically sets the film speed on the camera, a good range of automatically set shutter speeds between, typically, 1/30 and 1/500 sec, automatic film advance and rewind via a built-in motor, and a backlight compensation control.

Built-in flash

Automatic flash is another feature found on the majority of compact cameras. It is, however, something that you need to treat with a degree of caution in most portraiture. Frontal flash nearly always produces flat lighting and unflattering facial shadows when used as the main or sole source of illumination. Also, with flash positioned close to the lens, red-eye is always a danger. Built-in flash can be valuable, though, as fill-in light.

With some fully automatic models, you will need to cover the camera's light sensor, to make it believe it is darker than it really is, in order to make the flash pop up and to trigger the flash circuits.

Camera features
1 Flash
2 Shutter release
3 Viewfinder window
4 Light sensor window
5 Autofocus window
6 Lens

IMPORTANT FEATURES

● Look for an extensive range of ISO speeds.

● Models with a choice of focal length settings are more versatile.

● Manual exposure override can be important in some situations.

● A facility for off-camera flash is helpful.

● A fast lens of at least f 2.8 is necessary for low-light situations.

● Make sure that autofocus models have a focus lock.

● The battery compartment must be easily accessible.

THE 35 mm SLR CAMERA

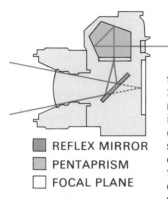

- ■ REFLEX MIRROR
- ▨ PENTAPRISM
- ☐ FOCAL PLANE

▲ What is SLR?
The mirrored internal surfaces of an SLR are essential in order to present a correctly orientated image on the focusing screen. The reflex mirror itself inverts the upside-down image projected by the lens, while the mirrors in the penta-prism correct the image left to right. As you press the shutter-release button, the reflex mirror flips up-wards, allowing light from the subject to fall on the film.

The 35 mm SLR (single lens reflex) camera offers the serious photographer a flexibility and con-trol over the medium that compact cameras, at their present level of technology, cannot rival. The range of SLRs available is immense, from budget models that are perfectly suitable for the inexperienced photographer to sophisti-cated cameras that form part of extensive systems which include a wide choice of interchangeable lenses, viewfinders, focusing screens, and other ancillary equipment. All models have semi-auto-matic exposure, fully automatic exposure, or a choice of modes, including manual operation.

At the heart of all SLRs, however, is the reflex viewfinder arrangement, which allows the photographer to view the exact image that will appear on the film. The aperture is kept open during viewing to give the brightest possible screen, closing to its preselected size at exposure.

Reflex viewing
The feature that distinguishes 35 mm SLRs from compacts is the reflex mirror situated behind the lens. This mirror reflects light taken in through the lens to the mirrored internal surfaces of the pentaprism and then out through the viewfinder window via the focusing screen (see above left).

▶ LCDs
When choosing a multimode SLR, make sure that the LCDs are clear and offer the facilities you are likely to use. For sport, or any fast-moving action photography, a mode offering a fast shutter-speed bias (**1**) would be helpful; when depth of field is para-mount, then you would need a small aperture bias (**2**). When, however, you need to set a precise aperture, look for a facility that will then set the required shutter speed for correct ex-posure (**3**).

▼ Aperture-priority system
In this, the camera sets the shutter speed to match the chosen aperture. This gives control over depth of field, allowing you to emphasize the main subject of the photograph.

▲ Averaged metering
This is the most basic type of automatic metering. The camera takes an average of the light values over the entire image. In a scene with a combina-tion of very strong sun-light and areas of deep shade, however, this can lead to exposure problems.

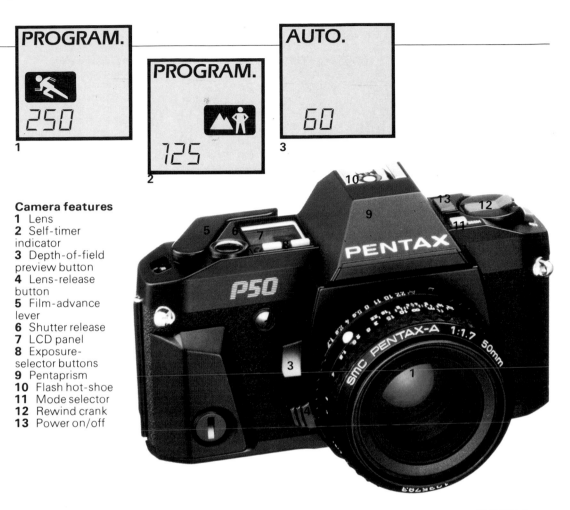

Camera features
1 Lens
2 Self-timer indicator
3 Depth-of-field preview button
4 Lens-release button
5 Film-advance lever
6 Shutter release
7 LCD panel
8 Exposure-selector buttons
9 Pentaprism
10 Flash hot-shoe
11 Mode selector
12 Rewind crank
13 Power on/off

▲ **Shutter-priority exposure**
Here, you set the shutter speed and the camera chooses the correct aperture — an option suited to mov- ing subjects, when fast shutter speeds are essential.

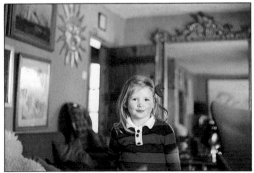

▲ **Multi-spot metering**
With multi-spot meter- ing, you can take sep- arate light readings of individual elements of the scene. The system is particularly useful for contrasty subjects with strong highlight and shadow areas.

▷

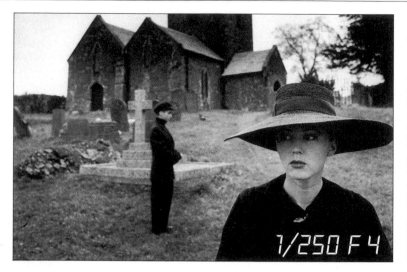

1/250 F 4

◀ Data backs ·
For many SLR models you can buy data backs as accessories. Basic versions will imprint certain information, such as the aperture, shutter speed, time, and date, on the edge of each frame. More sophisticated backs will also allow you to preset exposure values for up to nine frames in advance. Another feature found on some backs is a device that allows you to set a time interval of up to many hours between individual frames.

This arrangement means that the view seen through the viewfinder is exactly that which will appear on the film, no matter what lens is mounted on the camera. At the moment of exposure, the reflex mirror swings out of the light path, the aperture closes down to the size preselected by the photographer, and the shutter opens to reveal the film.

The only major drawback with the reflex viewing system – and this also applies to medium-format SLRs – is that at the actual moment of exposure the viewfinder blanks out as the mirror swings out of the light path. At shutter speeds of about 1/125 sec or briefer, this is hardly noticeable, but at shutter speeds longer than about 1/60 sec this can cause problems, especially when panning the camera to follow a moving figure, such as a runner, for example.

Exposure systems

Virtually all SLRs have some form of built-in TTL (through-the-lens) exposure meter system. At the most basic level, this will simply indicate on the screen that not enough light is available for the shot after the aperture and shutter speed have been set. The shot can still be taken (perhaps for deliberate creative effect) or the photographer can adjust the settings until a 'correct' exposure is indicated.

Alternatively, cameras can operate on a shutter- or aperture-priority basis – the photographer sets the value of one and the camera automatically chooses the appropriate value of the other to give a correct exposure in the prevailing conditions. Top-of-the-range models offer additional automatic options, some of which are shown on the left. A facility for manual override is also usually provided.

IMPORTANT FEATURES

● Choose a model with a manual-override option.

● Look through the camera before buying and ensure that the focusing screen display is clear and logical.

● Consider whether you need a standard lens, or a zoom would be of more use.

● On some models, the reflex mirror can be noisy and cause vibrations.

● With multimode cameras, make sure the options offered are of value to you.

● All controls should be conveniently positioned and feel comfortable to use.

● Although more expensive, the multi-spot metering system is to be recommended.

MEDIUM-FORMAT CAMERAS

▲ **Prism finder**
This prism finder is designed for manual exposure with TTL metering. It couples with the shutter-speed dial and aperture ring and gives an LED warning of over- or underexposure.

In many respects, medium-format, or roll-film, cameras can be thought of as scaled-up 35 mm SLRs. Their extra size is due to the wider film format and the film magazine that attaches to the rear of the camera body. It is this magazine, which incorporates a light-tight blind, that allows the film to be changed, even in mid-roll, and makes the format so popular with portrait photographers. In effect, it means that you can change between black and white and color film, slide and negative, or even instant picture film, at any point during a session.

Film formats

The rollfilm format describes three main picture sizes and two popular, and quite different, camera designs. In fact, though, the same film stock is used for all of them – 6 cm wide and known as either 120 or 220, depending on roll length. The different-sized images are achieved by slightly different framing masks found inside the camera body,

Camera features
1 Battery compart-ment and hand grip
2 Power on/off
3 LED display panel
4 Exposure mode buttons
5 Viewfinder window
6 Flash hot-shoe
7 Pentaprism head
8 Shutter-release button
9 Lens-release button
10 Lens

▲ **Sports finder**
Essentially a simple sighting de-vice that allows you to use the camera at eye level and to keep it pointed precisely at a moving image, as in panning.

▲ **Waist-level finder**
An adjustable magnifier for precise focusing is incorporated in this finder. Because you can use the camera at waist level, it is ideal for low-angle shots.

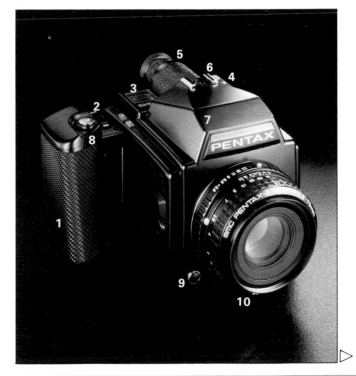

which, typically, produce image dimensions of 6×6 cm, 6×4.5 cm, or 6×7 cm.

Camera designs

The common rollfilm camera design is box shaped with a top-mounted focusing screen. This is shaded by a focusing hood that folds flat to protect the screen when it is not in use. The absence of the familiar 35 mm SLR pentaprism means that the image you see on the screen is the right way up but is reversed left to right. This may sound like a disadvantage, but when taking studio or location portraits you usually have sufficient time to concentrate on composition and you soon become used to this lateral reversal. For candid or action portraits, a pentaprism attachment is available that is fitted to the top of the camera.

One rollfilm camera, the Pentax 6×7 cm, is designed exactly like a 35 mm SLR. It has a fixed pentaprism but it does not have interchangeable film magazines.

Additional features and attachments

As with 35 mm SLRs, rollfilm cameras come packed with electronic circuitry, giving the photographer the choice of many programmed exposure modes or the option of complete manual control. Autowind or motor-drive attachments are also available for most models, but these can add significantly to the weight of an already heavy camera.

Because of the larger film format, the standard lens for rollfilm cameras is approximately 80 mm: 50 mm lenses are wide-angles and 120-200 mm lenses are considered ideal for portraiture.

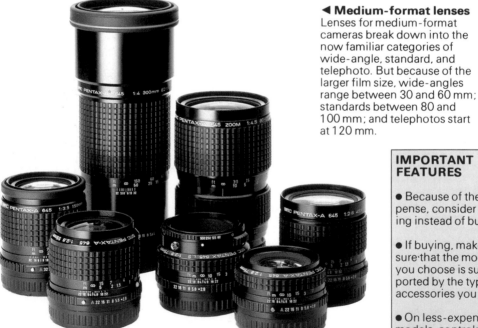

◀ Medium-format lenses
Lenses for medium-format cameras break down into the now familiar categories of wide-angle, standard, and telephoto. But because of the larger film size, wide-angles range between 30 and 60 mm; standards between 80 and 100 mm; and telephotos start at 120 mm.

IMPORTANT FEATURES

● Because of the expense, consider renting instead of buying.

● If buying, make sure that the model you choose is supported by the types of accessories you need.

● On less-expensive models, controls may be awkward to use.

● Pictorial quality is superb with this format, but film costs are high compared with 35 mm.

LARGE-FORMAT CAMERAS

There are two basic designs of large-format, or sheet film, cameras: the 4×5 in (10×12.5 cm) baseboard type and the larger, 8×10 in (20×25 cm) models that are mounted on a monorail attached to a tripod or other fixed support. The sizes refer to the dimensions of the film used.

Advantages and disadvantages

Although the baseboard type is portable and has a steadying handle fitted as standard, it is a heavy and an awkward camera to use and it is best supported on a tripod. Monorail types are almost exclusively used in the studio. Where sheet film cameras come into their own, however, is in terms of their unbeatable image quality. Because of the flexible bellows connecting the lens panel to the film holder-focusing screen, it is possible to alter not only the magnification of the image but also to change its apparent shape and position within the frame, giving you a great degree of control over perspective.

IMPORTANT FEATURES

● Not many of these cameras are made and their cost, therefore, is high.

● Decide whether the improvement in image quality possible with this format is worth the additional high cost of the film, processing, lenses, and all other accessories.

● If buying second-hand equipment, check the bellows for signs of wear.

● Pay particular attention to the focusing rails. These should be free-running and without kinks or signs of corrosion.

● Test all the camera movements to make sure operation is smooth.

Camera features
1 Lens
2 Lens panel
3 Baseboard
4 Extension rails
5 Cable release socket
6 Aperture control
7 Flexible bellows
8 Steadying handle
9 Focusing lock
10 Direct-vision optical sight with parallax correction marks

SEE ALSO
CAMERA FORMATS 18-19
THE 35 mm COMPACT CAMERA 20-1
MEDIUM-FORMAT CAMERAS 25-6
LENS PRINCIPLES 32-3
THE STUDIO 74-5

For the casual portrait photographer who is primarily concerned with making a simple record of people rather than worrying too much about quality, the disk camera and the 110 cartridge-loading camera are ideal. Both are easy to load and to use, have virtually no controls to adjust, and fit neatly into even the smallest pocket.

Disk cameras offer the user only one type of film – color negative – which comes as a 15-exposure disk that can be dropped into the camera one way round, so making incorrect loading impossible. Exposure is entirely automatic but some models offer a two-position focusing switch for near and far subjects.

The 110 camera tends to have less sophisticated circuitry than disk cameras. Focus is invariably fixed, as are the exposure settings, but some models do have manual zone focusing and weather symbol exposure control.

▲ Weather symbols
On some 110 cameras you will find a control ring marked with weather symbols. These allow you a fair degree of control over exposure. The f-stop scale below shows you how the symbols relate to the more usual aperture markings.

SEE ALSO
CAMERA FORMATS 18-19
THE 35 mm COMPACT CAMERA 20-1
INSTANT-PICTURE CAMERAS 29
LENS PRINCIPLES 32-3

110 camera features
1 Flash
2 Telephoto/wide-angle control
3 Lens
4 Shutter-release button
5 Viewfinder window

Disk camera features
1 Flash
2 Shutter-release button
3 Lens cover slide
4 Lens
5 Viewfinder window

INSTANT-PICTURE CAMERAS

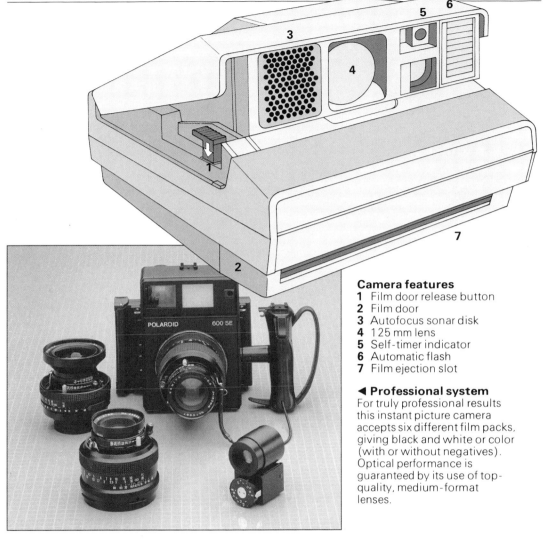

Camera features
1 Film door release button
2 Film door
3 Autofocus sonar disk
4 125 mm lens
5 Self-timer indicator
6 Automatic flash
7 Film ejection slot

◀ Professional system
For truly professional results this instant picture camera accepts six different film packs, giving black and white or color (with or without negatives). Optical performance is guaranteed by its use of top-quality, medium-format lenses.

There are two quite different instant-picture cameras on the market – one designed for the amateur and the other for the professional or business user.

Image System
For the amateur, Polaroid's Image System is the latest in a long line of point-and-shoot instant-picture cameras. The camera features autoflash with override and sonic autofocusing capable of handling subjects as near as 2 ft (60 cm). Exposure can be manually adjusted by using a lighter-to-darker scale and there is a self-timer. There is also a focus-override facility that can be used when shooting through windows, since glass will reflect the sonic signal and give a false focus setting.

Film for the Image System comes in packs of ten, giving plastic-coated pictures, without negatives, approximately 3.5×2.7 in (9×7 cm) on a card approximately 4×4 in (10×10 cm). Incorporated in each film pack is an electrical cell that powers all the camera's electronic functions. When you press the shutter release button, the exposed picture is ejected from a slot at the front of the camera. After about ▷

29

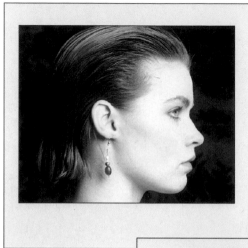

60 seconds the picture is fully developed and completely stable.

Professional instant-pictures

There is a limited range of instant-picture cameras designed with the professional in mind. These take a variety of different instant-picture films, with or without negatives, and can be used with medium-format lenses. They are ideal in the studio or when on location when you might need to check the lighting and composition before using an ordinary camera. They are also much used in survey work when a visual record to accompany a report is required.

▲ In the studio

If the subject is lit well, then results from the Image System camera compare favorably with 35 mm. In studio work it is often useful to be able to check the effects of your lighting scheme, and instant-picture photographs are a great boon.

▶ Exposure override

In most averagely lit scenes containing a roughly equal proportion of highlights and shadows, results from the Image System camera are adequate. With subjects such as these, however, you will need to use the exposure override to increase exposure.

SEE ALSO
CAMERA FORMATS
18-19
OTHER FORMATS
28
LENS PRINCIPLES
32-3
THE STUDIO 74-5

▼ Focus override

If using an autofocus instant-picture camera that targets anything positioned in the middle of the frame, you will need to override the focus control when your main subject is off-center. Some models, however, only allow you to set the focus control manually to infinity (for shooting distant subjects through glass) — so you will have to adjust your framing accordingly.

IMPORTANT FEATURES

● Bear in mind that with amateur instant-picture cameras you do not have a negative from which to make further prints.

● The cost of each print is high compared with other formats.

● Exposure control on most models is rudimentary.

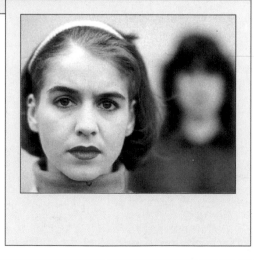

FLASH

Many compacts and both 35 mm and medium-format SLRs have a flash connector usually situated on the top of the camera. If the connector contains an electrical contact to fire the flash, it is known as a 'hot shoe'. Nearly all cameras also have a flash cable connector, which allows the flash to be positioned off-camera. Since the flash must fire when the shutter is fully open, all camera manuals indicate the shutter speed to set.

Degree of sophistication

Like cameras, flashguns vary in their degree of sophistication and versatility, from very simple, forward-facing units to swivel-head, variable-output models manufactured by camera companies and 'dedicated' for use with their cameras.

Once in the camera hot shoe, dedicated flashguns connect with the camera's circuitry, and are capable of delivering just the right amount of light, taking into account subject distance, the lens in use, the aperture selected, and the level of ambient light (for fill-in, for example), all without any calculation on the part of the photographer.

Non-dedicated flashguns feature front-mounted light sensors that measure the light reflected back from the subject and cut off output when sufficient light has been emitted. Also available are high-output, fast-recycling flashguns, often described as 'candlestick' units because of their shape. These can be battery operated or mains powered for virtually continuous flash when a motor-drive sequence is needed.

All of these flashguns ensure that the subject will not receive too much light, but you must still be careful of underexposure, especially flash fall-off.

SEE ALSO

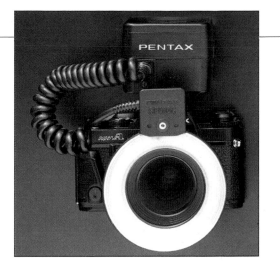

▲ **Ring flash**
A very specialised type of lighting unit sometimes used for portraiture is the ring flash. It consists of a circular lighting tube that fits right round the front of the camera lens. When fired, it delivers a completely shadowless illumination, which can be ideal for lighting the face.

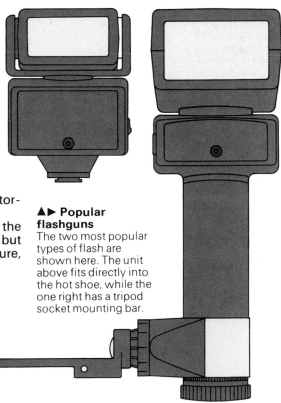

▲▶ **Popular flashguns**
The two most popular types of flash are shown here. The unit above fits directly into the hot shoe, while the one right has a tripod socket mounting bar.

LENS PRINCIPLES

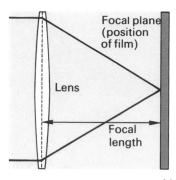

Focal plane (position of film)

Lens

Focal length

▲ Focusing the image

Lens focal length affects the size of the image recorded by the film — the longer the lens the larger the subject appears. Actual focal length is determined by measuring from the lens, when focused on infinity, to the focal plane, where light is focused.

The function of the camera lens is to collect light reflected from the subject and then to refract, or bend, it so that it comes to a point of focus at a predetermined place, known as the focal plane. It is at the focal plane that the film is positioned, held flat and tensioned in precisely this critical plane. For the viewing system of a reflex camera to work, the focal plane and the focusing screen must be exactly the same distance from the mirror.

Although from the outside a lens looks like a simple piece of glass, internally it is far more complicated. In order to produce the clearest possible image, nearly all camera lenses are made up of a series of glass elements, each with a different refractive index, or ability to bend light.

Lens aberrations

Each color component of the spectrum, as seen when light is split by a prism, has its own wavelength, which is refracted to a different degree when it enters the lens.

▶ Zoom movement

By using a reasonably slow shutter speed, you can achieve intriguing effects simply by changing the focal length of a zoom lens while the shutter is open.
□ Pentax, 70-210 mm, Kodak Tri-X, 1/8 sec, f 16

▼ A family of lenses

There is a vast range of lenses for the 35 mm SLR format. Major camera manufacturers produce their own lenses, but there are also many independent makers producing top-quality optics for all the popular cameras. The photograph here shows lenses ranging from a 600 mm telephoto to broadview wide-angles.

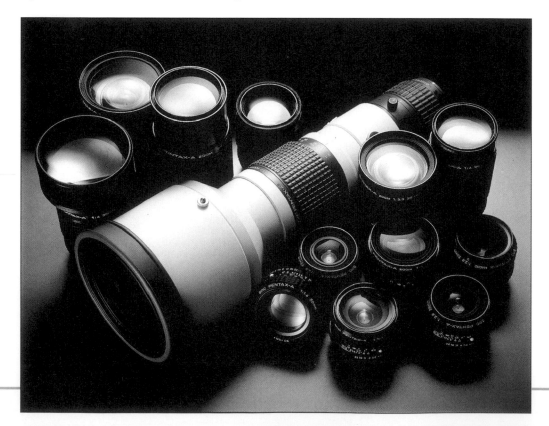

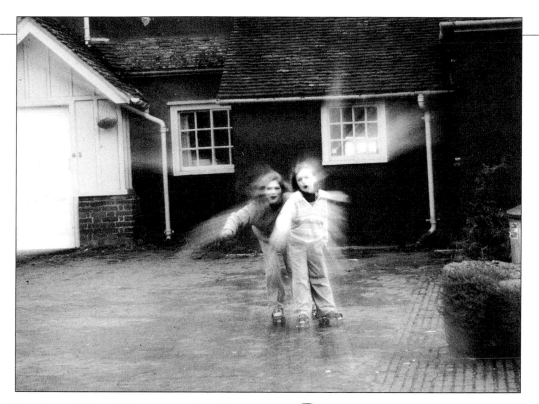

In order to bring all these wavelengths to a common point of focus, different types of glass elements are used. Again, in order to improve light transmission, and to correct other types of aberration, a mixture of concave and convex elements and lens coatings is employed.

Lens apertures

Inside the lens there is a series of adjustable blades that vary the size of aperture through which the light travels on its way to the film. The size of the aperture you select, via a ring calibrated in f-stops on the outside of the lens, not only affects exposure but also the zone of sharpness, known as the depth of field, associated with each f-stop. Very simple lenses, found on some cheaper compacts, have a single, fixed aperture.

f 2.8

f 4

f 5.6

f 8

f 11

◄ **Lens apertures**
Apart from shutter speed, the only camera/lens function that has an effect on exposure is the aperture control ring. Just as each successive setting on the shutter speed dial either halves or doubles the length of time the shutter remains open, so each successive f-stop either halves or doubles the size of the aperture in the lens. This is achieved by mechanical or electric linkages from the control ring to a series of movable blades set between the glass lens elements – as you turn the aperture ring to a higher f-number so the blades move in toward the center and reduce the size of the opening through which light enters the camera. The other effect of changing aperture is on depth of field – the zone of acceptably sharp focus surrounding the area actually focused on. As the size of the aperture is reduced, so this zone increases.

THE STANDARD LENS

Most photographers regard the 50 mm or 55 mm lens as standard because most use either a 35 mm SLR or 35 mm compact camera. In fact, the size of the 'standard' lens is different for the various camera formats, but the types of results obtained are not, and can be discussed irrespective of the camera you own.

The feature you will most notice when looking at results taken with a standard lens is that the image appears much as you saw the scene in reality – foreground, middle ground and background will all bear the correct relationship to each other. In order to fill the frame with a head-and-shoulders shot, you have to approach the subject quite closely. In portraiture, this can help the less self-conscious model by bringing out the performer in him or her.

50 mm standard lens, f 1.2

The major benefit you will find with a standard lens is speed. The speed of a lens refers to its widest aperture – the wider the aperture the faster the lens, and the more useful it is in low-light situations. Because standard lenses are made in such volume, purchasing a camera body with one fitted is the best way of obtaining a high-speed lens.

▶ Normal perspective
As you can see from this picture, a standard lens produces an image where perspective appears completely normal and close to that of human vision. The subject is not distorted and relates to the background as you would expect.
□ *Pentax, 50 mm, Ektachrome 200, 1/60 sec, f 4*

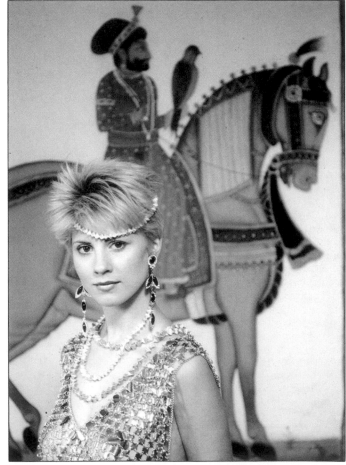

SEE ALSO

THE WIDE-ANGLE LENS

By contrast with the standard lens, which produces a normal-looking image, wide-angles do impart a certain 'presence' to the scene. Much, of course, depends on the type of wide-angle you use: moderate wide-angles (for the 35 mm camera format) fall within the range of 28 mm to about 40 mm and can be used in much the same way as standard lenses. However, as the focal length becomes shorter, and the angle of view correspondingly wider, deviation from the norm becomes more evident.

Uses and abuses
One of the most important applications of the wide-angle lens in portraiture is when working in confined interiors, where there simply is not room to move far enough back from your subject for a full-length shot. You will also find this type of lens of use outdoors when you want to fix your subjects firmly in their surroundings by showing a great deal of the location — foreground, background, sky and so on.

Move in close to a subject, though, with a lens wider than about 28 mm and you will start to notice something curious — parts of the face nearer the lens (the forehead and nose, for example) appear much larger than parts of the face farther away (the cheeks and ears). This may well be an effect you consciously seek for a more unusual interpretation of the subject. Even with good-quality lenses, edge distortion starts to become a problem with focal lengths shorter than about 24 mm. This is seen as a bowing of, in particular, any vertical lines positioned near the edges of the frame.

SEE ALSO

▼ Tapering lines
One of the most obvious effects of a wide-angle is that, when used from a low viewpoint pointing upwards, vertical lines seem to converge. Here, the distortion is not too severe, but it is possible to discern that the model appears to taper slightly — an effect that is more pronounced in the more distant wall seen behind.
☐ *Pentax, 28 mm, Ektachrome 64, x-sync, f 11*

28 mm wide-angle lens, f 2

THE TELEPHOTO LENS

For the majority of portrait photographs, a telephoto lens is used and, for the 35 mm camera format, the 85 mm or 90 mm lens is known as the portrait lens. Both outdoors and in the studio there are many advantages to using this type of lens. Many temporary home studios are not large and do double duty as other family rooms. One way of isolating your subject, then, is to use a short telephoto and frame tightly. You can also use its shallow depth of field to throw out of focus any distracting clutter. For the traditional head-and-shoulders shot and for close-up details of the face, this lens cannot be bettered.

Perspective effects

Telephoto lenses longer than about 135 mm are not recommended for portraiture. In general, telephotos enlarge distant objects, making them appear closer to near objects than they really are, and this effect can be seen when long telephotos are used for portraiture.

85 mm telephoto 'portrait' lens, f 1.4

▲ Compressed perspective
Here you can see the typically compressed perspective produced by a telephoto lens.
□ Pentax, 135 mm, Kodak Tri-X, 1/250 sec, f 16

135 mm telephoto lens, f 1.8

OTHER LENSES

If you are the owner of a 35 mm SLR you could find yourself apparently spoilt for choice when it comes to selecting lenses other than the moderate wide-angles and short telephotos already discussed. But, for portrait photography, most of the others can be discounted as being of little or no practical use.

Telephotos and wide-angles

One of the first lenses many photographers are attracted to is something in the range of 200-300 mm. While perfectly fine for many applications, such as natural history, some types of architectural photography, and surveillance work, this length lens produces an uncomfortably 'squashed' type of perspective not very flattering to the subject. For picking out individuals that cannot be approached in the normal way, however, the lens does have some application, but you might do better using a ×2 converter instead.

Extreme wide-angles, beyond about 24 mm, apart from being expensive, suffer from edge distortion and they take in so much of the scene that it is difficult to fill the frame with an acceptable portrait.

Zoom lenses

These lenses, if selected with care, do have positive advantages for portraiture. First, they are considerably easier to carry around, since one zoom can replace two or more prime lenses. Also, they give you the chance to fine tune the framing of the subject, allowing you to crop the image in the camera.

Zooms are available that bridge the focal length range of moderate wide-angle to short telephoto. But in order to obtain a lens that has sufficient speed for low-light situations you must be prepared to pay a lot of money.

28-135 mm zoom lens, f 4

▶ **Framing options**
The main advantage of a zoom lens is that you can adjust framing of the shot, as here, to include just the right amount of setting.
□ *Pentax, 28-135 mm, Kodak Tri-X, 1/60 sec, f 11*

EXPOSURE LATITUDE

Depending on the type of film you are using, and the type of light you are shooting in, there is likely to be a small range of aperture and shutter-speed combinations you can use and still produce a 'correctly' exposed image. ('Correct' exposure itself varies according to the effect you want.)

Slight underexposure will produce an image with good color saturation while still retaining subject detail. Slight overexposure will produce a bright image with only minor loss of detail in the lightest highlights. Even experienced photographers find it difficult to predict accurately what will be the deviation from what the meter determines as correct, and so bracketing exposures is a very commonly practiced technique.

Exposure variations most affect deep shadows and bright highlights and, since these are both by definition largely absent from low-contrast scenes, you will have more exposure latitude when photographing them. In such circumstances, a bracketed series of, say, three shots, at one-stop intervals either side of the metered setting, ought to be sufficient if you are using negative film. In contrasty light, however, and when using slide film, a bracketed series of five images, at half-stop intervals, is best. With negative film you will have a chance to amend slight exposure errors at the printing stage.

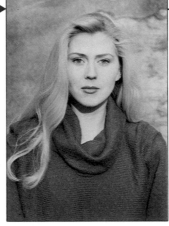

▲ □ Ekta-chrome 64, 1/60 sec, f 8

▶ □ Ekta-chrome 64, 1/60 sec, f 11

▲ □ Ekta-chrome 64, 1/60 sec, f 5.6

▶ □ Ekta-chrome 64, 160 sec, f 4

◀ Is there 'correct' exposure?

All you can really say is that some exposures are definitely incorrect. In this series of pictures, taken with the aperture progressively closed down a stop each time, you will see that the lightest version is so lacking in detail and color as to be rejected. The next, although still washed out, does convey a mood of balmy weather and heat. The next exposure is probably the most 'correct', with good subject detail and color saturation. The final shot is starting to lose detail in the shadows but the scene now appears slightly brooding and stormy, and color saturation is excellent.

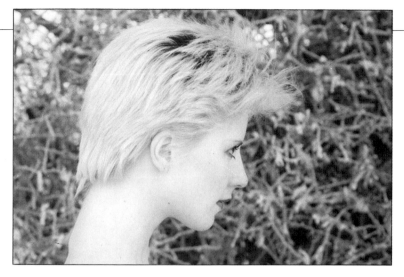

► **Light and airy**
The exposure latitude of modern films means that in many lighting conditions you will have a choice of exposures ranging over 3 stops before the image is either unacceptably light or dark. In this shot, I could have closed down another 2 stops and still produced an image that 'read' well.
□ *Pentax, 50 mm, Ektachrome 200, 1/60 sec, f 5.6*

► **Dark and somber**
Although this picture has an entirely different atmosphere compared with the one above, I used exactly the same film and the exposure settings were identical. The picture above was bathed in a soft, overcast light, which produced a very detail-revealing image, while here I took advantage of the high-contrast window light to give a darker, more somber interpretation.
□ *Pentax, 85 mm, Ektachrome 200, 1/60 sec, f 5.6*

SEE ALSO

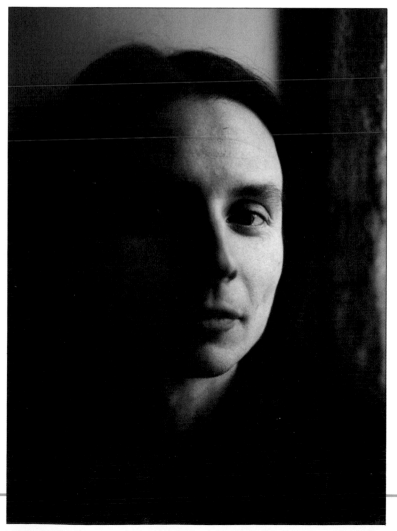

THE BASICS OF PORTRAITURE

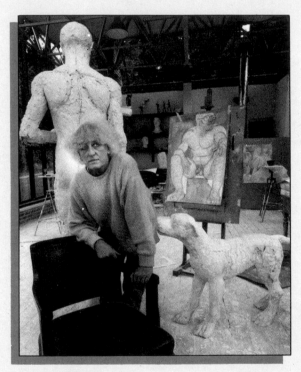

□ Pentax, 50 mm,
Kodak Tri-X, 1/60 sec,
f 11

☐ *Hasselblad, 80 mm,
Kodak Tri-X, 1/125
sec, f 11*

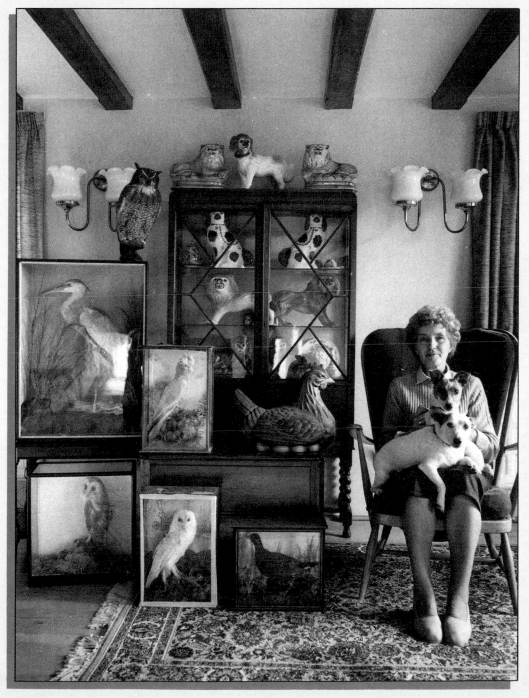

TYPES OF APPROACH

There is no one correct approach to portrait photography: much depends on the subject, the way that person wants to be portrayed, and the artistic decisions you need to make as photographer. Bear in mind though that the style of the portrait, either formal or informal, studio or location, should always be appropriate.

Studio or location

In general, it is fair to say that using a studio with a non-professional model brings an air of formality. In unfamiliar surroundings most people tend to freeze up, and it is the photographer's job to get them to relax.

Moving the camera into a person's home or place of work immediately brings about a change in the type of picture produced. Now you will have the chance to display something of your subject's personality and interests, expressed through his or her possessions and surroundings.

▶ **Theatrical pose**
For this photograph of two acrobats in their costumes, it was important to hint at their place of work – the circus big top. Although they appear rigid and unrelaxed, their stance perfectly echoes the exagger- ated gestures that all live performers adopt on stage in order to communicate with those at the back of the audience. The expanse of canvas provided very even illumination.
□ *Pentax, 50 mm, Ektachrome 64, 1/60 sec, f 8*

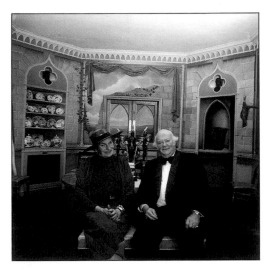

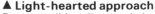

▲ **Light-hearted approach**
Even a traditionally posed pic- ture of a couple seated in front of the camera need not be too serious. This couple was obviously enjoying the whole procedure and had established a good rapport with the photo- grapher. Simple camera- mounted flash, bounced off the ceiling, was sufficient with the room sidelights on to pro- vide some warm highlights.
□ *Hasselblad, 80 mm, Ekta- chrome 64, 1/60 sec, f 8*

◀ **Using props**
Surrounded by their posses- sions, subjects are likely to be far more relaxed, as in this shot, where the garden gnome, above all, provides a humorous slant to the scene.
□ *Hasselblad, 80 mm, Ekta- chrome 64, 1/60 sec, f 8*

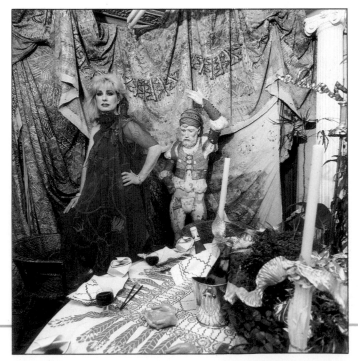

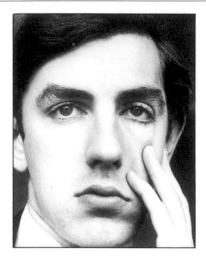

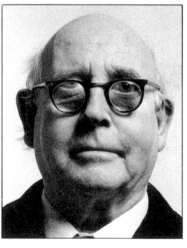

◀ Comic relief
With a subject like comedian Peter Cook in front of the lens, the distinction between formal and informal portraiture becomes very hazy. These are early portraits of mine and I found that the best policy was just to let him entertain me while I concentrated on the camera. Peter loves to make people laugh and this comes through in the shots.
☐ *Pentax, 85 mm, Kodak Tri-X, 1/60 sec, f 4*

▼ Relaxed personality
With the novelist Angus Wilson I discovered a very relaxed, natural person. I found conversation with him came easily and all through the photographic session we talked of each other's work and of things we liked in common. With many different types of subject, establishing this friendly rapport is vital to taking successful portraits.
☐ *Pentax, 85 mm, Ilford HP5, 1/125 sec, f 5.6*

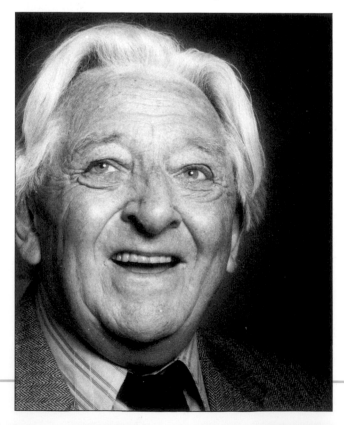

▲ Varying the viewpoint
I found with award-winning children's book illustrator Edward Ardizzone, a slightly low camera angle most appropriate – the type of view a child might have of him.
☐ *Pentax, 35 mm, Kodak Tri-X, 1/60 sec, f 8*

▶ Artist in situ
Portraits are often more revealing when taken on the subject's home ground. Here, the most appropriate background for artist John Bellany was one of his canvases.
☐ *Hasselblad, 80 mm, Kodak Tri-X, 1/60 sec, f 4*

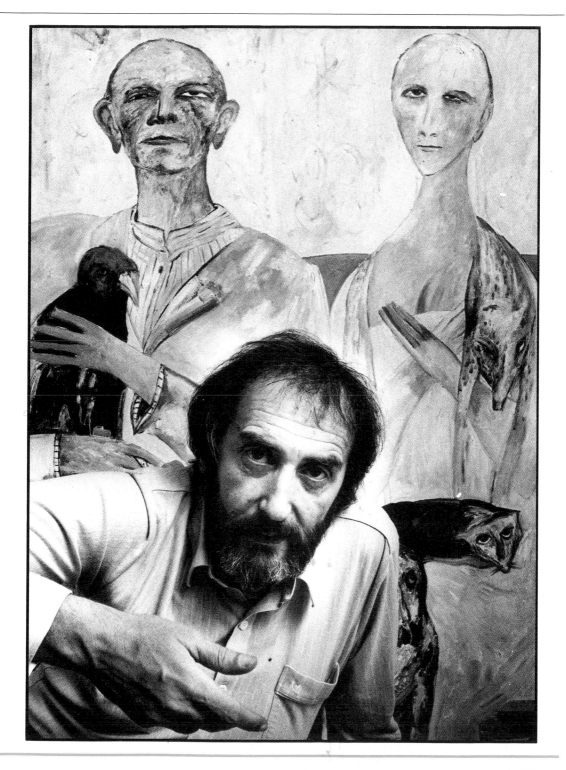

MOOD AND EXPRESSION

One of the main reasons people become interested in portrait photography, apart from the recording of family and friends, is that the human face is such a changeable and expressive indicator of feelings and moods. It really can be very rewarding to come away from a portrait session knowing that in your camera, just waiting to be developed, is a set of photographs that really provides an insight into the character of the person you have been working with.

To achieve this end, however, requires that you, as photographer, strike up a rapport with your sitter. This is even more important when shooting in the studio, where it is likely your sitter will feel ill at ease. But even when working on location, you must engineer the situation so that the person reacts to you — in other words, starts to express his or her mood through facial expressions and general body language. To capture this successfully, however, means that you need to use the

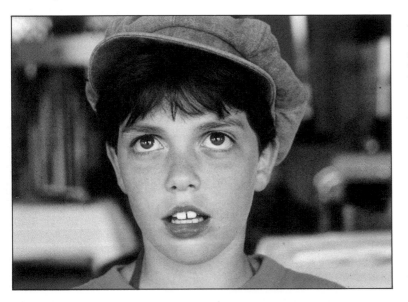

◀ Quiet beginnings
This 9-year-old girl had reached the self-conscious age, and when I arrived she was terribly wooden and unrelaxed.
□ *Pentax, 85 mm, Ektachrome 200, 1/125 sec, f 4*

▶ Explosive ending
You can see from these pictures how mood and expression can vary. In this shot, the girl has lost all her shyness and is having a thoroughly enjoyable time.
□ *Pentax, 85 mm, Ektachrome 200, 1/125 sec, f 4*

▶ The session continues
Tense she may have been to begin with, but after a short while she started to unwind. To start the transformation I talked and joked with her and got her to start relating to me and the situation. After that, it was like water bursting from a dam, and there was no holding her back.
□ *Pentax, 85 mm, Ektachrome 200, 1/125 sec, f 4*

changeable and fleeting quality of light as your ally.

The moods of natural light

Although what we describe as natural light is illumination from a single source — the sun — it is capable of producing an extremely diverse range of effects. Even during the course of a single day, lighting quality can vary from the soft, diffused light of a mist-shrouded morning to the harsh, yet detail-revealing, light of mid-day, when the sun is more directly overhead.

Most portrait photographers rely on natural light for their pictures. An exercise that anybody can try involves nothing more than taking a series of photographs of the same model, framed in much the same way, but under different lighting conditions. Start early in the morning and carry on through to late afternoon so that you can more fully understand the variability of sunlight.

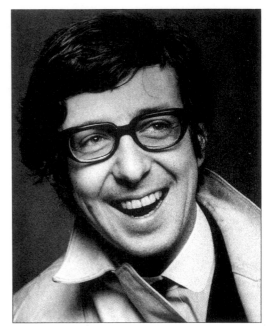

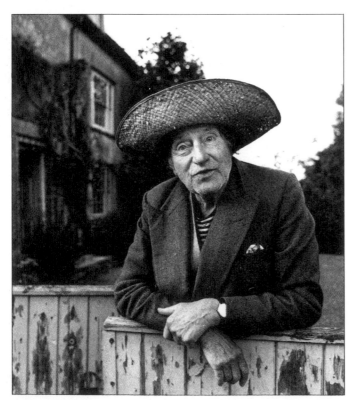

▲ A relaxed attitude
I had to set the lights carefully for this picture. My subject had basically a very relaxed attitude and an easy smile, which helped. By tilting the angle of the glasses correctly I avoided any reflections that would have obscured his eyes.
□ *Pentax, 85 mm, Kodak Tri-X, 1/60 sec, f 8*

◀ Highlighting the face
For this outdoor portrait of the artist Duncan Grant, I used diffused fill-in flash and a wide aperture in order to bring the face out of gloomy, overcast light.
□ *Pentax, 50 mm, Kodak Tri-X, x-sync, f 5.6*

▶ Candid approach
With this lovely lady I was spoilt for choice when it came to facial expressions. She was in the middle of an animated conversation with a few of her friends when I took this shot.
□ *Pentax, 85 mm, Kodak Tri-X, 1/30 sec, f 2.8*

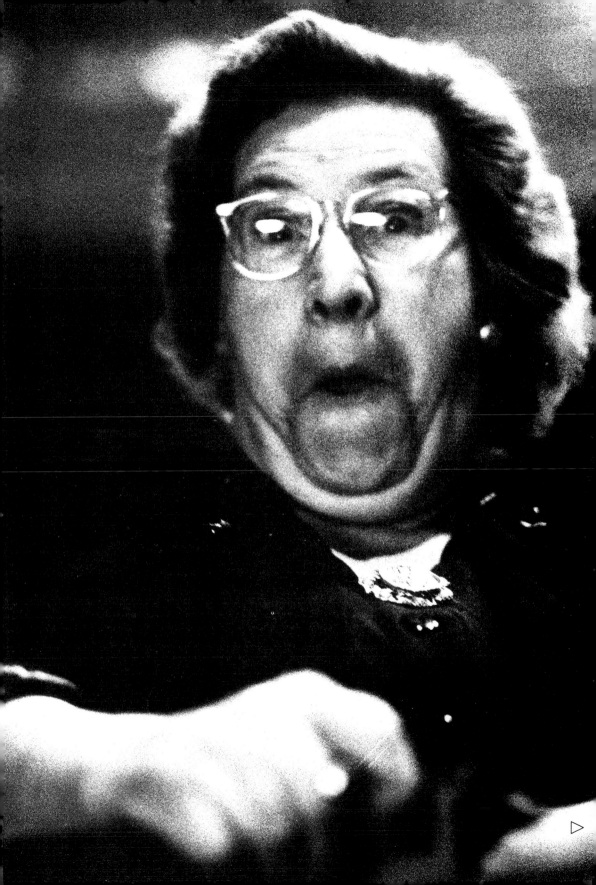

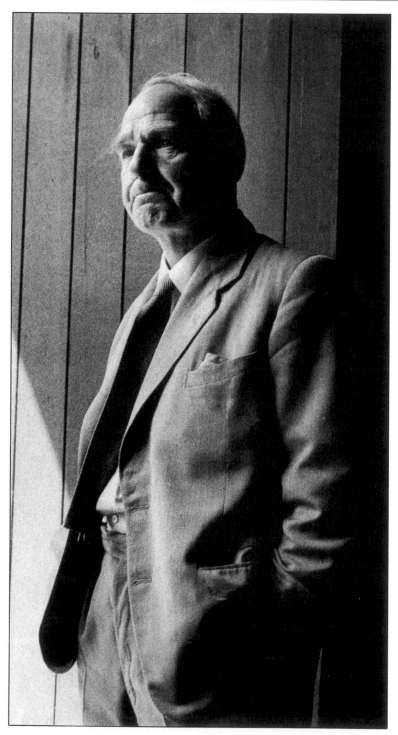

◀ Introspective moments

Close relationships give an insight that strangers would find hard to capture, as with sculptor Henry Moore, a friend for more than 30 years. I always found him relaxed and he was quite used to having my camera pointed at him.

□ *Pentax, 50 mm, Il-ford HP5, 1/60 sec, f 8*

▶ Lucky break

This picture was taken in the Tate Gallery, London, when the sculptor Alexander Calder was setting up an exhibition. I asked for him and then his head popped up through the muslin.

□ *Pentax, 85 mm, Kodak Tri-X, 1/125 sec, f 4*

▶ Artist at work

The natural light in Graham Sutherland's studio was perfect for photography. The artist felt completely at ease there, sur-rounded by his can-vases and other familiar possessions. Generating this re-laxed atmosphere can be the hardest part of portrait photography.

□ *Pentax, 50 mm, Kodak Tri-X, 1/125 sec, f 5.6*

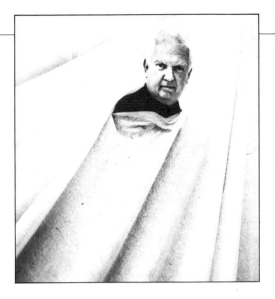

▶ Friendly encounter
A portrait session with friends, in this case the sculptor Elizabeth Frink, is often relaxed and productive.
□ *Pentax, 35 mm, Kodak Tri-X, 1/60 sec, f 11*

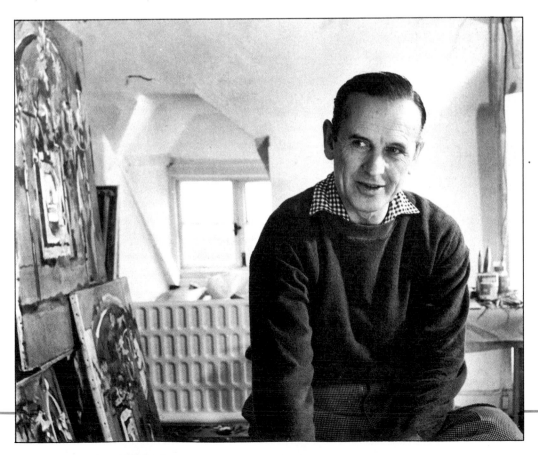

REVEALING CHARACTER

One of the most difficult tasks in portrait photography is trying to reveal the character and personality of your model or subject. First, you have to overcome the natural inhibition most people feel in front of the camera. Second, and more importantly, you need to strike up a rapport with them, so much depends on your approach.

There is also much scope here for candid portraiture. Camera shyness will not be a problem if people are unaware of the camera. Even in the studio, though, given enough time to grow accustomed to the surroundings, most people will relax and start to behave normally.

It is not possible to lay down rules about how you should play your part as photographer — it will change from session to session. Some people, for example, will remain wooden unless cajoled and directed, while others will freeze up if treated that way.

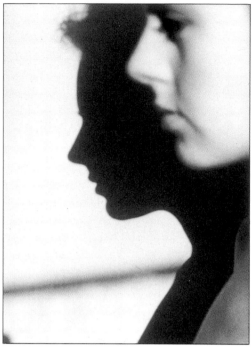

◄ Rounded personality
My subject was very nervous, so I swapped from a telephoto to a moderate wide-angle in order to establish closer contact. Constant talking, joking, and coaxing finally won him over.
□ *Pentax, 35 mm, Ilford HP5, 1/60 sec, f4*

▲ Candid approach
Using a long lens during a break in shooting, I carefully focused on the model's shadow and the resulting picture gives a soft image with a hard outline.
□ *Pentax, 135 mm, Kodak Tri-X, 1/60 sec, f2.8*

◄ Children
When photographing children, results are nearly always better if you keep it simple. For this shot, a wooden rocking horse resulted in a natural study of children at play.
□ *Pentax, 85 mm, Kodak Tri-X, 1/125 sec, f8*

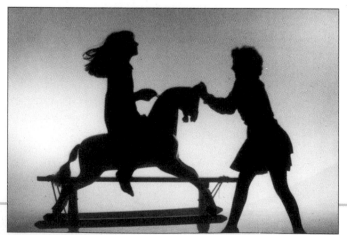

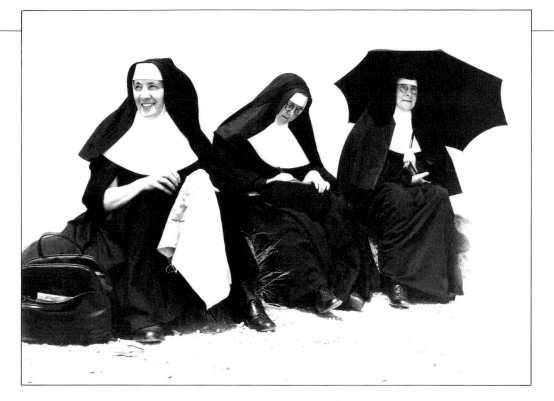

▲ Chance happenings

It was one of those unrepeat-
able scenes when I came
across these three nuns sitting
on a beach on a hot day by the
coast. Each one was engrossed
in her own activities, yet
seemed part of a perfectly
unified group.
□ *Pentax, 85 mm, Ilford HP5,
1/250 sec, f8*

▶ Studied pose

People can express their per-
sonality through all manner
of things. Here, clothes, hair,
and expression all combine to
show the intensity and con-
centration of the guitarist.
□ *Hasselblad, 80 mm, Kodak
Tri-X, 1/60 sec, f 2.8*

SEE ALSO

TYPES OF APPROACH 42-3
MOOD AND EXPRESSION
46-51
CANDID PORTRAITS 54-9
USING SHAPE 66-7

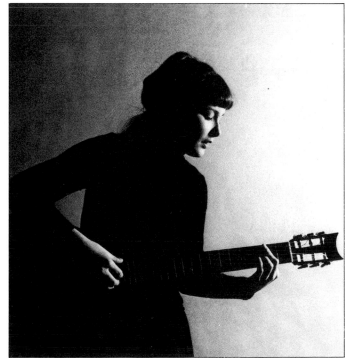

CANDID PORTRAITS

The secret of successful portrait photography lies in being properly equipped and well prepared — and this is especially true for candid portrait photography.

It is vital to know your equipment thoroughly before setting out. Time spent fumbling with camera controls and lens settings means lost opportunities. Ideally, if you are using a manual camera, set your lens to about f 8 or smaller (unless this results in impossibly slow shutter speeds) and prefocus on where you expect your subject to be. Compacts, because of their unobtrusive size, level of automation, and quiet operation, can have an edge over SLRs, although the fixed lens can be a disadvantage in certain circumstances.

Deciding on lenses

With SLRs, 35 mm and medium format, you need to make a decision about which lens to use. For candids of strangers, a long lens will give you that distance you need so as not to intrude. Conversely, using a wide-angle lens produces an intimate closeness that gives the impression that you are among the crowd. Wide-angle lenses also produce an extensive depth of field at all apertures, making focusing less critical. Beware, however, of possible edge distortion with extreme wide-angle lenses.

Different approaches

Most people, when they think about candid photographs, assume that what is meant is taking pictures without the subject being aware of it. This is certainly one approach, but it is not the only one.

Another way is to take candids by arrangement: make an appointment to visit a location, which could be a school, store, play group, or an artist's studio, in order to record the activity there. You will find that, very soon, your subjects will forget about you being there and just get on with their normal behavior. Flash will usually be inappropriate in these situations, since it creates its own, artificial, environment, so take plenty of fast film.

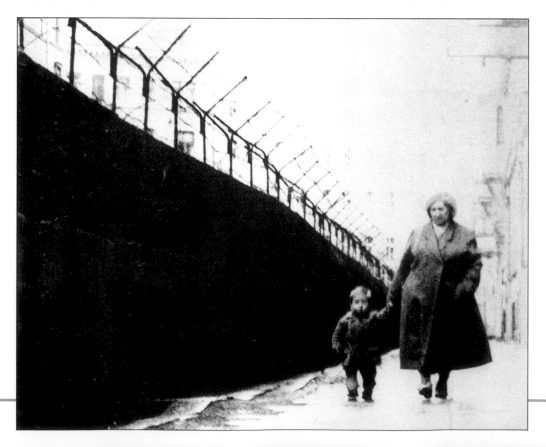

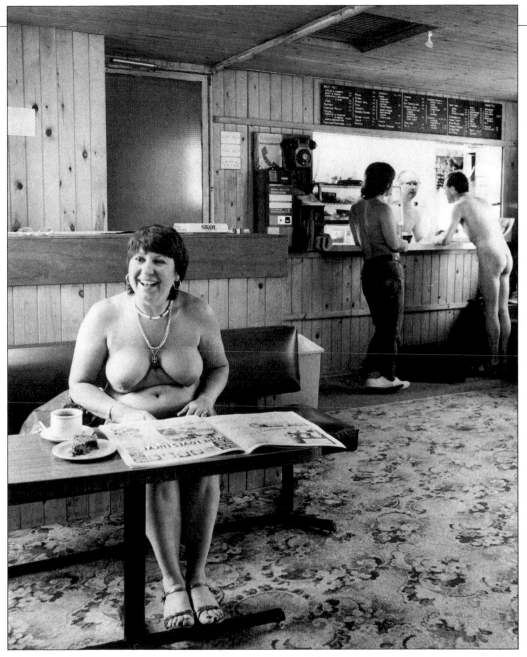

◄ Likely background

With such an emotive symbol as the Berlin Wall as a background, I just waited for a person to walk by to give the picture atmosphere as well as scale. Berliners are well used to photographers at the Wall, and do not really react any more.
☐ *Hasselblad, 80 mm, Kodak Tri-X, 1/60 sec, f 8*

▲ Nudist camp

Visiting an informal nudist camp restaurant reception area provided a relaxed, informal atmosphere where nobody cared how you were dressed. Daylight was strong enough for a small aperture to be used, so I prefocused the lens and took a quick snap.
☐ *Pentax, 125 mm, Kodak Tri-X, 1/60 sec, f 8* ▷

◄ A day at the seaside
The sun may be hot enough to shelter from under an umbrella but, as yet, modesty still prevails and the dress definitely stays on. The opportunity for pictures at such places as this is endless. Portrait groups arrange and rearrange themselves constantly and a variety of lenses, between 28 mm and 135 mm, will allow you to vary the pace of shots.
☐ *Pentax, 135 mm, Ilford HP5, 1/250 sec, f 11*

► Overview
I like this picture because it shows three distinct groupings of people, each seemingly oblivious to the others. Also, it gives the viewer some idea of the layout of the setting. In order to include enough information I used a wide-angle.
☐ *Pentax, 28 mm, Ilford HP5, 1/125 sec, f 11*

► The direct approach
This trio of ladies was not in the least put out when I took their picture. I did not want to ask permission beforehand in case it disturbed them and spoilt the composition.
☐ *Pentax, 85 mm, Ilford HP5, 1/125 sec, f 8*

◄ The family gathers
Here, I relied on the fact that people are not surprised to see passers-by carrying cameras at the beach. I framed the picture looking more directly down the path, only swinging the camera at the last moment to include this family gathering.
☐ *Pentax, 50 mm, Ilford HP5, 1/250 sec, f 8*

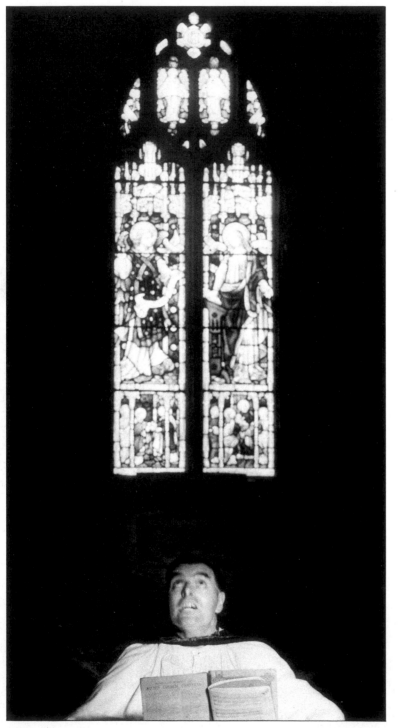

◀ Capturing the spirit

Although cameras are not normally allowed in church, modern compacts are so small and quiet that they do not intrude. The only light I had for this candid portrait was that streaming through the stained-glass window behind. But it was enough to capture this angelic chorister in full voice. I exposed for the face and a shutter speed of 1/30 sec resulted in some subject movement.
□ *Pentax, 35 mm, Kodak Tri-X, 1/30 sec, f 3.6*

▶ Music and dance school

Rehearsals at the local music and dance school provided me with a good opportunity for candid pictures. Because I was working indoors, and using existing window light only, I used ISO 400 film. Even so, most of the time I found I had to use my standard and wide-angle lenses wide open at apertures of between f 2 and f 1.4. Flash would have destroyed the mood.
□ *Pentax, 50 mm, Kodak Tri-X, 1/60 sec, f 2*

SEE ALSO

THE 35 mm COMPACT CAMERA 20-1
THE 35 mm SLR CAMERA 22-4
MEDIUM-FORMAT CAMERAS 25-6
THE WIDE-ANGLE LENS 35
THE TELEPHOTO LENS 36
ON LOCATION 116-17

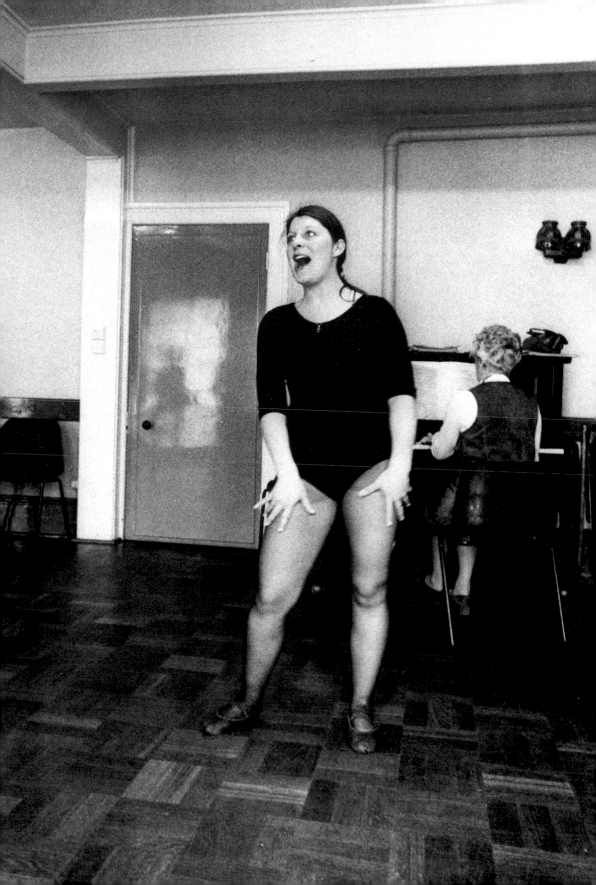

▲ Tonal range
When the tonal range of your picture is limited, as in the profile here, you need to ensure that sufficient difference exists to separate your subject from the background. The effect is high key and appealing but needs handling with sensitivity.
☐ *Pentax, 85 mm, Kodak Tri-X, 1/125 sec, f 2.8*

In the same way as framing the whole figure is vital to the balance and flow of the composition so, too, is the position of the subject's head within the frame when you are taking a head or head-and-shoulders portrait. It is important to remember that head shots need not fill all the available space — positioning your subject in an unexpected and small part of a larger scene can add immeasurably to the impact of the shot.

Nearly all portraits are taken from approximately the same height, with the camera supported at head height. As a result, pictures all have much the same character to them.

As an experiment, next time you are conducting a portrait session, purposely take at least some of the pictures with the subject obviously off-set in the frame. This in itself will not be sufficient to generate interest, so ensure that the rest of the frame contains elements that add to the composition as a whole. If you use a rigid camera case, stand on it to gain height; or simply squat down and shoot upward, especially if this brings a worthwhile background into shot.

▼ Central framing
A basically centrally framed head-and-shoulders shot can be made more interesting by asking the subject to incline his or her head (or by angling the camera) and, thereby, introduce a little additional tension to the composition. Making use of the picture diagonal is also a worthwhile innovation.
☐ *Pentax, 35 mm, Ilford HP5, 1/60 sec, f 4*

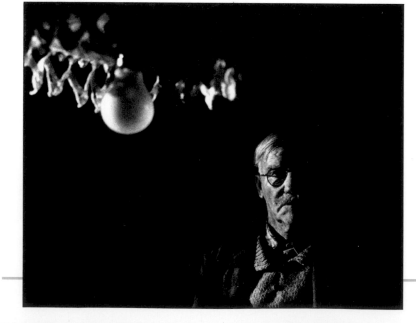

◄ Low-key effect
For this head-and-shoulders shot I wanted to introduce a puzzle by implying that the unlit light bulb in the foreground was somehow responsible for the light falling on the man's face. To bring the bulb into shot I had to crouch on a chair and use an aperture that just gave enough depth of field. The actual light was daylight from the left.
☐ *Hasselblad, 80 mm, Kodak Tri-X, 1/30 sec, f 5.6*

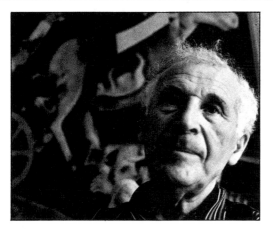

◄ Off-center framing
In this picture, the off-center placement of the painter Marc Chagall needed careful lighting. In order to include his painting, I used the maximum depth of field possible. The natural light gave a better atmosphere and the highlight balances a much larger shadow area.
□ *Hasselblad, 120 mm, Kodak Tri-X, 1/30 sec, f 11*

▼ Lowering the horizon
One of the advantages of experimenting with different framing, either high or low, is the changing effect it has on the horizon line. For the picture of Henry Moore, I stood on my camera case and shot down at him, and so included the skeletal forms of an avenue of winter trees.
□ *Pentax, 50 mm, Ilford HP5, 1/60 sec, f 11*

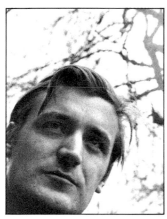

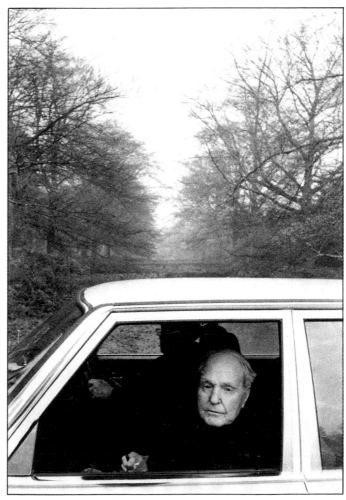

▲ Diagonal line
This shot of the poet Ted Hughes gains impact through the tight cropping at the chin and the placement of the head on the frame diagonal. The composition has been strengthened by shooting from an exaggeratedly low camera angle close in to the subject.
□ *Pentax, 35 mm, Kodak Tri-X, 1/125 sec, f 4*

SEE ALSO
REVEALING CHARACTER 52-3
VIEWPOINTS 62-5
CLOSE-UPS 68-71
USING EXTERIORS 118-21

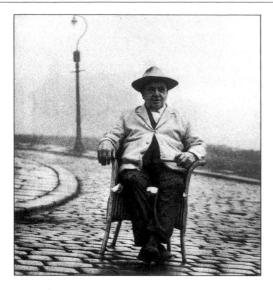

By seeking a variety of viewpoints it is possible to capture all manner of apparent changes in the appearance of your subjects. Many photographers shoot nearly all their pictures from the same height – standing upright with the camera raised to the eye. Very few make the conscious effort to utilize the potential for visually more exciting images by simply exploring other viewpoints for the subject, ranging from ground level to an elevated camera position.

High and low viewpoints

You can increase the apparent stature of a person by lowering the position of the camera. Not only does this make him or her appear taller but you also imply that that person has a certain authority because the camera is being looked down on.

▶ Viewpoint and shape
I chose a ground-level viewpoint to isolate the farmer and his dog against a neutral-toned sky and to emphasize the triangular composition formed by his splayed-out legs. This concentrates attention, as does the farmer's gaze, on the hands peeling potatoes.
□ *Pentax, 28 mm, Kodak Tri-X, 1/250 sec, f 5.6*

▲ Appropriate setting
A slightly low viewpoint for this portrait makes the figure a strong shape in relation to the cobbled road. Percy Shaw, inventor of road markers known as cat's eyes, and now a multimillionaire, did not change his simple way of life, and this is what I tried to convey.
□ *Hasselblad, 80 mm, Kodak Tri-X, 1/125 sec, f 11*

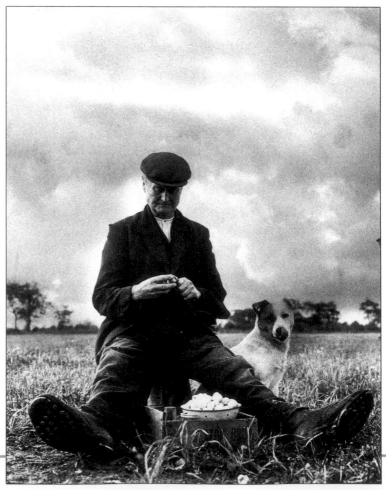

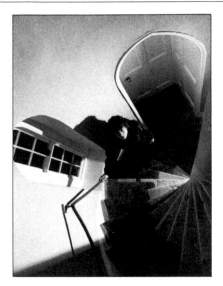

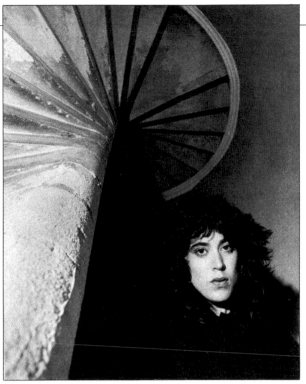

▲▶ Contrasting viewpoints
A spiral staircase, such as the one I used for these two pictures, makes an excellent setting for investigating the effects different viewpoints have on the way the subject is portrayed. As well as providing an interesting setting, with sweeping curves, sharp angles, and areas of highlight and shadow, you can use the stairs to gain height and look down on your subject or to lower the camera below the subject's eyeline.
□ *Both: Pentax, 50 mm, Kodak Tri-X, 1/30 sec, f 8*

▶ Lens and composition
The impact of this picture has much to do with the unusual viewpoint, with the head dead center in the frame and the torso foreshortened. The composition was helped by the use of a telephoto lens to crop in close and slightly flatten perspective.
□ *Pentax, 135 mm, Ilford HP5, 1/125 sec, f 4*

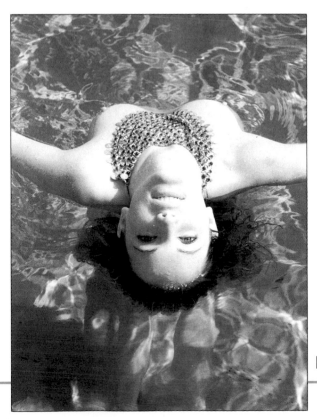

▷

▲▶ Reinforcing the effect

In this shot, an elevated camera position has made the subject's head appear slightly larger. The tilt of the head has been reinforced by the position of the floodlight used to light the face, as shown in the diagram above.
☐ *Pentax, 135 mm, Kodak Tri-X, 1/60 sec, f4*

SEE ALSO

USING SHAPE 66-7
A SENSE OF SCALE 168-9
THE STRENGTH OF PATTERN 180-1

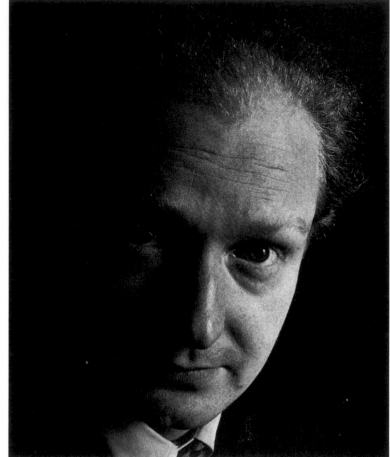

You can achieve the opposite effect by raising the camera above the subject's eye level. In this way you will create a feeling of isolation and greater separation, as well as apparently diminishing their stature.

You will also find that high and low viewpoints have a marked effect on all the major compositional elements, such as line, perspective, pattern, and shape — just lifting the camera up, for example, could well reveal repeating shapes in the setting that would be totally lost from a lower camera position. A low viewpoint, however, is ideal for accentuating sweeping lines going into the frame, and by pointing the camera sharply upward, and using a wide-angle lens, you can make objects appear to taper.

▶ Masking the light source

For this picture I arranged a single floodlight above and to the rear of the subject, as can be seen in the diagram. Then, by dropping down low, I used the subject's own body to mask the light source. This left just one side of the face lit and a slight rim effect on the shoulder and hand.
☐ *Pentax, 50 mm, Kodak Tri-X, 1/30 sec, f4*

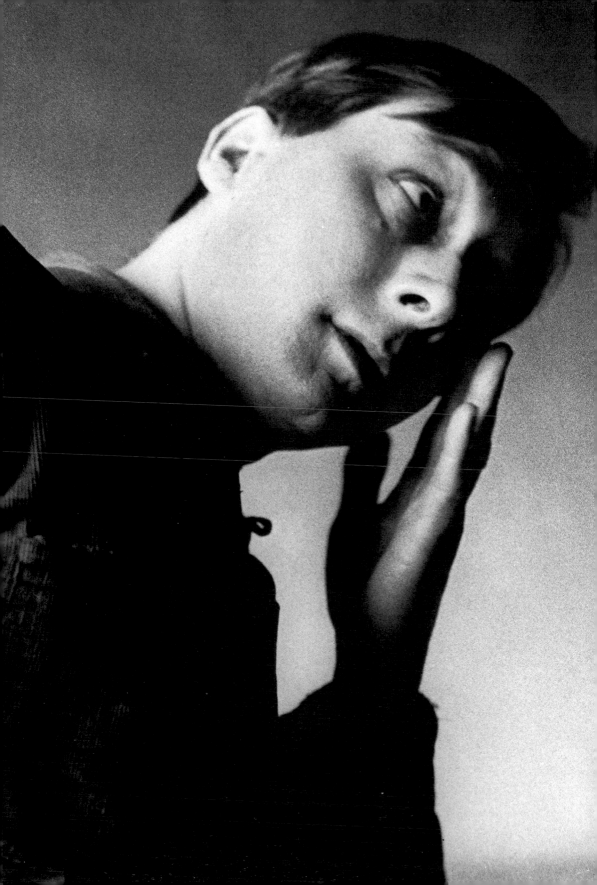

USING SHAPE

Just as individual colors and color combinations can subtly determine our feelings about certain scenes, so, too, can shape influence our reactions. Rounded, undulating, or flowing shapes imply calmness and serenity, while jagged, sharp, or irregular shapes almost always set up tension in a picture.

Controlling the effect

Shapes of all sorts occur naturally as part of practically any scene in which you might choose to pose your subjects. On location it is a matter of using the camera selectively, framing the shot so as to include some shapes while excluding others. But if you are working at home or in the flexible environment of a studio, then you can decide how you will dress the set in older to create a particular mood.

Shapes in scenes can also be controlled by your choice of lens and camera angle. As with all types of photography, in portraiture, if time and circumstances permit, it is always worthwhile to move round your subject, looking through the camera viewfinder to see how your impressions of the scene change. Take advantage of the

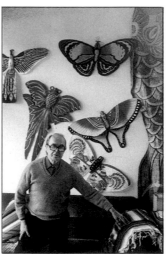

▲ **Arranged shapes**
The strong shapes and colors of the kites on the wall challenge the dominance of the subject, Michael Rothenstein, who was positioned so that his body did not obscure them.
□ *Pentax, 28 mm, Scotch 1000, 1/60 sec, f4*

◄ **Natural shapes**
The gnarled and twisted shape of a dead tree takes on the appearance of a giant hand, cradling the subject.
□ *Pentax, 85 mm, Ektachrome 200, 1/125 sec, f8*

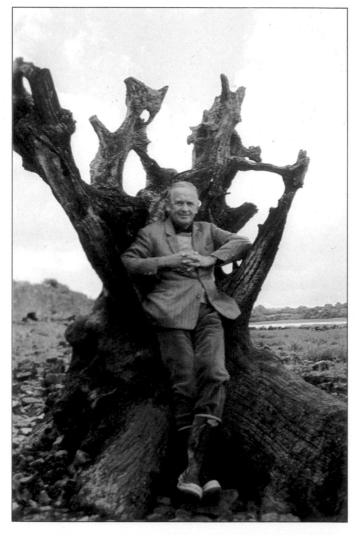

▲ Subject as shape
Here I used a low camera angle and a wide-angle lens pointed sharply upward in order to make my subject, Barbara Hepworth, seem almost larger than life.
□ *Hasselblad, 60 mm, Ektachrome 64, 1/60 sec, f 5.6*

terrain or the nature of the room in order to gain height and look down on your subject, or lie flat and look upwards.

Using wide-angle lenses has the effect of increasing the apparent distance between shapes. Used from a low viewpoint, they also create a dominant, tapering image. Telephotos, on the other hand, tend to compress shapes, underlining strong relationships between forms.

Shape, of course, is not only a feature of the environment, whether natural or man-made. Your subjects themselves can be posed to form interesting shapes.

SEE ALSO
THE WIDE-ANGLE LENS 35
THE TELEPHOTO LENS 36
VIEWPOINTS 62-5
THE ROMANTIC SETTING 130-5
USING WIDE-ANGLE LENSES 182-3

CLOSE-UPS

There are both advantages and disadvantages to taking close-up portraits. On the positive side, you do not usually require complicated lighting schemes, and unwanted backgrounds or other potentially distracting elements in the scene are excluded by the simple act of closing in on your subject. On the negative side, you lose many of the variations afforded you by framing your subject in different ways. The closer in you move, the more important becomes the image format itself and the edges of the frame.

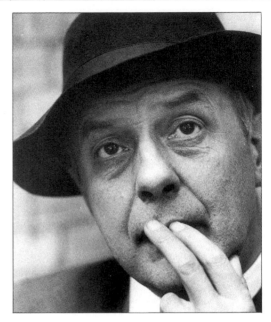

▶ Lost in thought

This photograph of the English poet, and former Poet Laureate, John Betjeman, has caught him in a very relaxed, pensive mood. He has been perfectly framed by his hat and hands, both of which help concentrate attention on his face and, in particular, his eyes. Light was provided by overcast daylight through a window directly in front of him.
□ *Pentax, 85 mm, Ilford HP5, 1/60 sec, f 4*

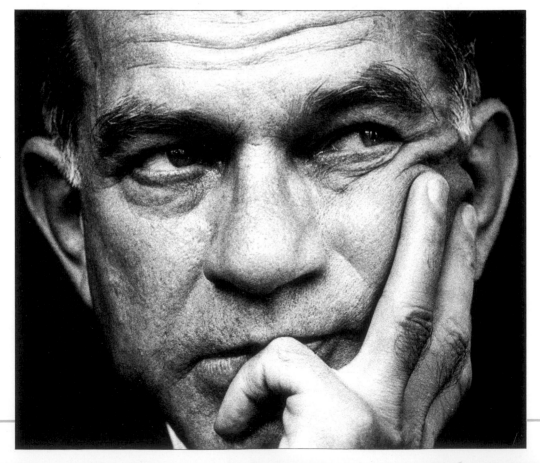

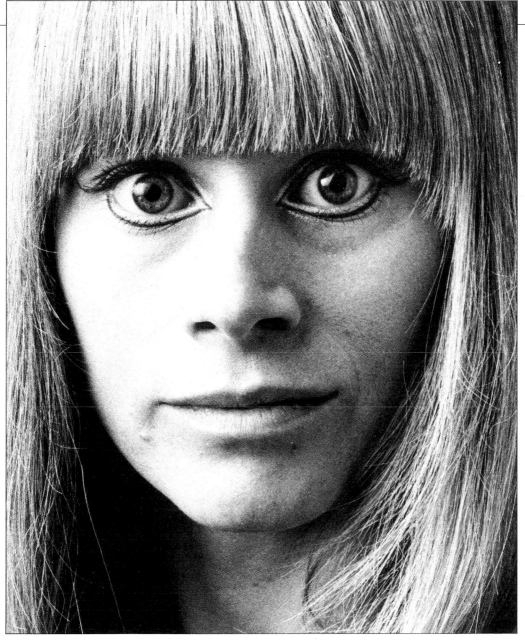

◄ High-contrast light
For this portrait of US Senator Fulbright, I wanted to show the strength of character of this often outspoken critic of the administration. The best type of lighting seemed to be off-camera flash, undiffused in order to create a more stark, contrasty, and powerful image.
☐ *Hasselblad, 120 mm, Kodak Tri-X, 1/250 sec, f 5.6*

▲ Hair as frame
Close-ups of faces that exclude the background totally need particular care if interest is to be maintained. In this picture of the actress Rita Tushingham, her large, saucer-like eyes seem to draw you into the picture, which is neatly framed by cropping in close on her long hair and heavy fringe.
☐ *Pentax, 135 mm, Ilford HP5, 1/60 sec, f 5.6*

▷

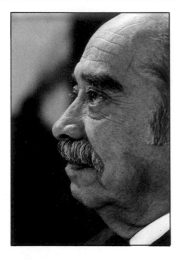

▲ Full profile
When shooting a portrait in profile it is important to leave sufficient space in front of the face to prevent the picture feeling cramped. A small aperture and a telephoto lens ensured that the background did not intrude.
☐ *Pentax, 135 mm, Ektachrome 64, 1/60 sec, f 2.8*

With framing as tight as this, wide-angle lenses would produce unacceptably distorted images, and a standard lens will not focus sufficiently close to fill the image area completely with just the face. In effect, this leaves the telephoto lens and, in order to avoid compressing the facial features to an unacceptable degree, you should, ideally, use a lens of about 85 to 135 mm.

Self framing
With so little of the environment to work with, it becomes increasingly important to use the only ingredient at your disposal as a framing device: the subject. Notice in two of the photographs on the previous page how hands have been used to frame the face, creating strong lines that lead the eye into the picture. Hats, too, make effective frames for the face, either wide-brimmed or close-fitting. In the third shot, an almost perfect frame has been provided by cropping in on the heavy fringe and longer hair on each side of the face. The effect is indeed powerful. The pictures shown on these two pages are different in that they rely more on the format edges to confine the face. Closing in too much, however, can appear uncomfortable.

▶ Flash fill-in
In this picture, the background is lit by natural daylight and the face by camera-mounted flash. The result is a portrait with great impact.
☐ *Pentax, 85 mm, Ektachrome 64, x-sync, f 4*

▼ All-round lighting
The lighting for this portrait of historian A. P. Herbert was achieved by posing him in his glass conservatory.
☐ *Pentax, 85 mm, Ektachrome 64, 1/250 sec, f 4*

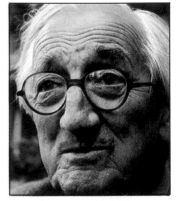

◀ Background detail
Close-ups do not have to exclude the setting completely. Often, just a hint of background detail helps to throw your subject into sharper relief.
☐ *Pentax, 135 mm, Ektachrome 64, 1/250 sec, f 4*

SEE ALSO

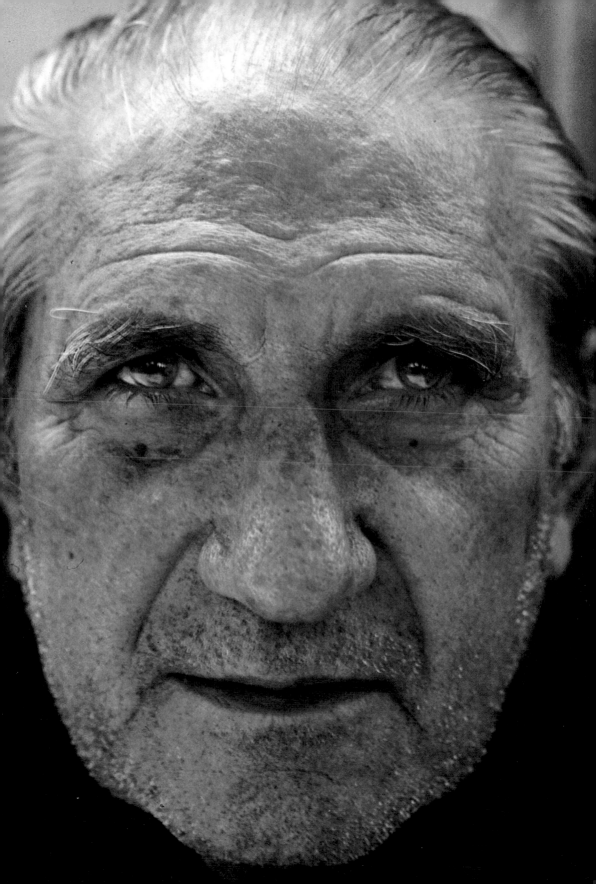

IN THE
STUDIO

☐ *Hasselblad, 80 mm, Kodak Tri-X, 1/125 sec, f 16 (studio flash)*

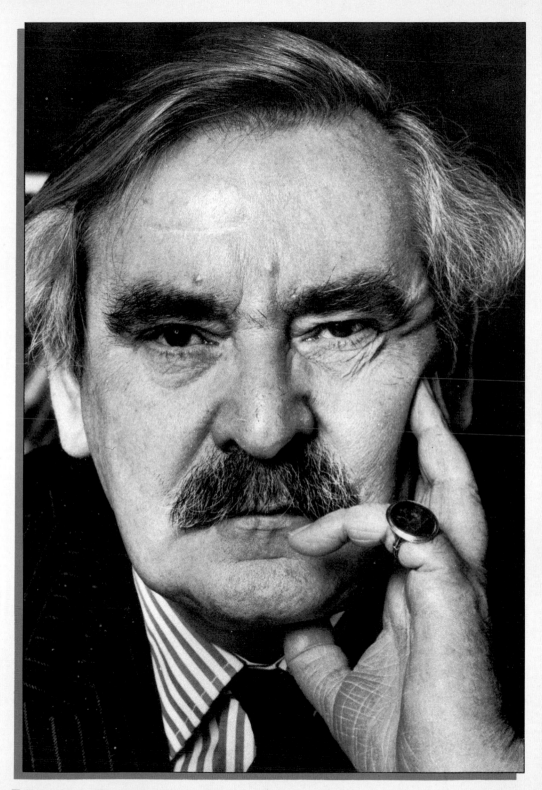

□ Hasselblad, 120 mm, Ilford HP4, 1/125 sec, f 11

THE STUDIO

It does not matter how well equipped your studio is if the type of pictures you can take is restricted for lack of space. When shooting portraits, for example, you should be able to place enough distance between the camera and the subject to take a full-length portrait using a short telephoto of about 85 mm. In practice, this works out at about 15 ft (4.5 m).

In addition to this basic space requirement, you will also need sufficient room to vary your lighting set-ups, or to position simple background papers and props. This means that the studio should ideally be about 12 to 15 ft (4.25 m) wide. A high ceiling, painted matt white, is also important, so that light can be bounced off it and fall, evenly diffused, on the subject without creating unwanted color casts. Walls that are matt black or dark gray, however, allow you the most complete lighting control. But for most purposes matt white will suffice. If there is roof light or side window light, then white opaque blinds are useful, giving you extra control and allowing the studio to be used for either daylight or artificial light photography.

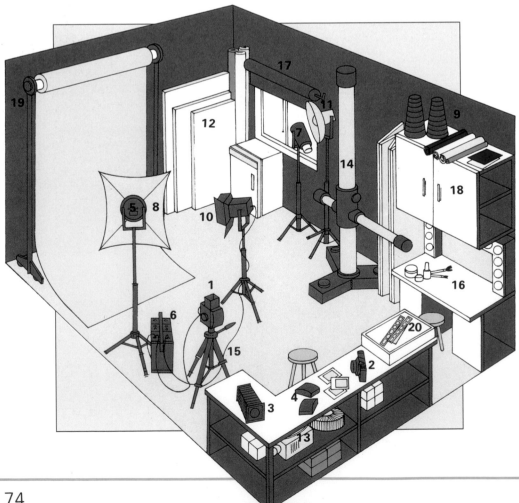

▼ The temporary studio

Many people do not have the space to convert one room of their home into a permanent studio. But when choosing a space to serve as a temporary studio, the same general principles apply (see opposite). If you are going to use natural light for your work, think of the position of the windows in relation to the sun — sunlight should enter the studio obliquely. But greaseproof paper fixed over windows will, even in strong sunlight, allow a soft, directional light to enter your space, which is ideal for portraiture if handled correctly. The main studio area should be kept as uncluttered as possible. If space is tight, you will need to build cabinets and cupboards along one wall.

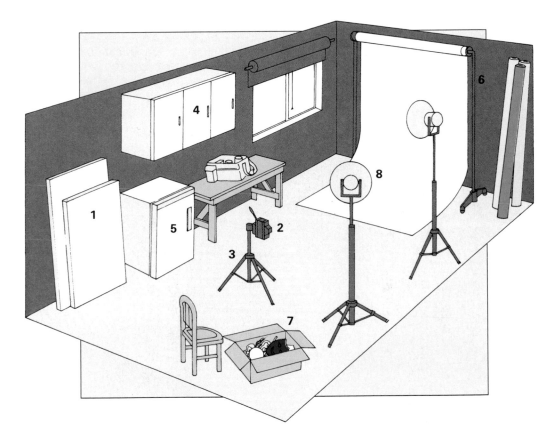

◀ **The permanent studio**
1 Medium-format camera
2 35 mm camera
3 Large-format camera
4 Film backs, film
5 Studio flash
6 Flash power pack
7 Photospot
8 Umbrella diffuser
9 Snoot, scrims and light filters
10 Barn-doors
11 Photoflood
12 Reflectors
13 Projection unit
14 Camera stand
15 Tripod
16 Make-up area
17 Light-tight blind
18 Equipment cupboard
19 Stand for paper backdrop
20 Lightbox

▲ **The temporary studio**
1 Reflector boards
2 35 mm camera
3 Tripod
4 Equipment cupboard
5 Refrigerator for film storage
6 Stand for paper backdrop
7 Assortment of props
8 Tungsten lamps

▼► Controlling the light beam

Whether using studio flash or tungsten light, you can still retain complete control over the strength and spread of light. Dish-shaped reflectors (**1** and **4**) are the most commonly used, with the deeper dishes giving the narrower beams. For a more concentrated beam of light, you can fit a snoot (**2**) to the front of your lighting unit. This attachment is ideal for lighting a very specific part of your subject or adding catchlights to the eyes. For a controlled beam of light, barndoors (**3**) are ideal. You can adjust the flaps independently for precise control of the light beam. For a general, diffused lighting effect, direct your light into a special reflective umbrella (**5**).

There will be times when you want total control over lighting, and this means excluding daylight altogether and making use of either studio tungsten lighting or daylight-balanced studio flash.

Tungsten lights and accessories

Many amateurs considering buying studio lights for the first time tend to opt for tungsten photoflood bulbs. Perhaps this is because it is a natural progression from using domestic tungsten as supplementary light for their work, especially in black and white photography, where you do not have to worry about color temperatures. For color slides, you will have to use tungsten-balanced film or the correct blue-colored lens filter. With color negative film, any color casts occurring can be corrected during printing.

The chief advantage of using tungsten is that the light is continuous. This means that you can immediately see how your lighting arrangements will look in the final picture. As you move the lights around the set, shadows will appear and disappear and you can make infinite fine adjustments until you are satisfied. On the negative side, tungsten lamps burn hot, making them uncomfortable to be under for any length of time. Also, as a precaution, check

▲ Slave unit
Slave units plug in, via a standard jack plug, to secondary flash units and trigger them in response to light emitted by the shutter-synchronized flash head.

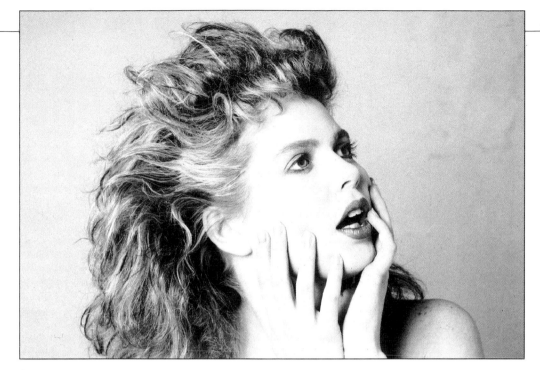

▲ Precise lighting
Once in the studio, you can start to produce shots like this, where the balance of light and shade, catchlights in eyes and highlights on hair are all precisely within your control. And equipment costs need not be high.
□ *Pentax, 85 mm, Kodak Tri-X, x-sync, f 8*

any paper diffusers regularly to make sure they are not dangerously hot.

Studio flash

These lighting units work on the same principle as camera flash: a synchronization lead connects the shutter to the lights, which deliver an instantaneous burst of daylight-balanced light when the shutter is fully open. The lighting heads themselves are supplied by a mains-powered, heavy-duty power unit, which allows for variable flash output.

The greatest problem people have with flash is that it is difficult to predict the lighting effect you are going to achieve. Good-quality flash heads, however, contain a low-power tungsten modeling light, which does not affect exposure but does allow you to see the strength and direction of any shadows that will be created when the main flash heads fire.

▶ Inverse square law
When setting lights and determining exposure (without the aid of a meter), you need to bear in mind the inverse square law, which states that the intensity of light, of the type emitted by flash and tungsten units, quarters each time you double the distance from the source, as you can see in the diagram above.

SEE ALSO

BASIC LIGHTING

You do not need a lot of equipment in order to produce professional-quality studio photographs. Basic space requirements to allow you sufficient distance from your model to use a portrait lens, and sufficient space behind and to the sides to permit different lighting set-ups, have already been discussed. For all the pictures on these two pages, you would need only two floodlights and a spot.

First of all, set up the background and connect lights to their power source. Place a chair or stool in the appropriate position. If possible, place the model 6-7 ft (2 m) away from the background to give yourself room to light it separately.

Move each light in an arc taking in the front and sides of your model and monitor the results through the camera. Mark the position of each light when you are happy with the effect. As you add new lights, or as the model alters pose or expression, you may have to alter the position of lights already set.

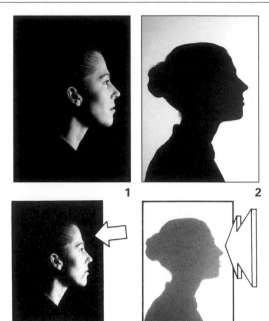

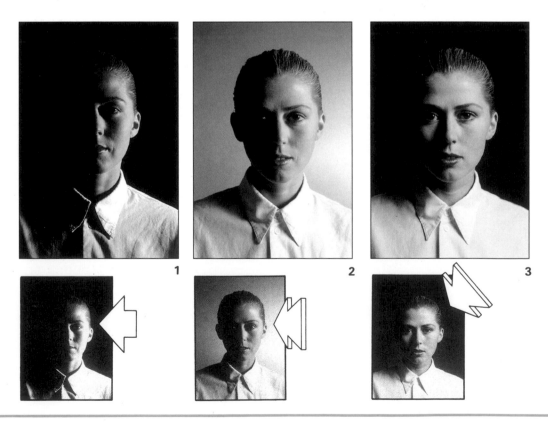

◄ Dramatic alternatives

Both these shots, although dramatically different in their approach, were taken using a single light. In the first version (**1**), I positioned a spotlight in front of the model and took the picture in profile. For the next one (**2**), the camera and model were in the same positions, but I directed a floodlight at the background instead.
□ *Both: Pentax, 85 mm, Ektachrome 160T, 1/125 sec, f 4*

◄▲ Rimlighting

An often used studio technique to separate the model from the background is rimlighting, where the light comes behind the figure. Because I wanted to keep lighting simple, I compromised and used studio flash slightly to the rear in order to give some rimlight as well as modeling light.

◄ Changing effects

In the first picture of this sequence (**1**), I directed a studio flash at the side of the model's head. For the second one (**2**), the light was more to the front and some has spilled over and lit the background. For the last shot of the sequence (**3**), I raised the angle of the light to plunge the background into darkness again.
□ *All: Hasselblad, 120 mm, Ektachrome 64, 1/60 sec, f 5.6*

SEE ALSO

◄▲ Distance from background

The importance of having a flexible amount of studio space is demonstrated here. In the shot above left, the model was 6 ft (2 m) from the rear of the studio and flash from the front was sufficient to illuminate the background. In the version left, I simply positioned her twice as far from the background and kept the lighting basically the same.
□ *Hasselblad, 120 mm, Ektachrome 64, 1/60 sec, f 5.6*

LIGHTING AND EXPRESSION

Light is the photographer's basic tool. When working in the studio you have a choice between the continuous emissions of tungsten, the instantaneous burst of flash light, and either daylight with reflectors or daylight and flash. All of these can be put to good use when trying to record the ever-changing expressions on the faces of your subjects.

Tungsten light is easier to use since you can see the effect it is producing. Flash needs more experience in balancing the overall appearance of the light, but built-in modelling lamps and a flash meter will allow you a fair degree of accuracy.

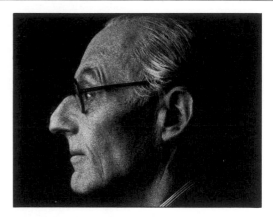

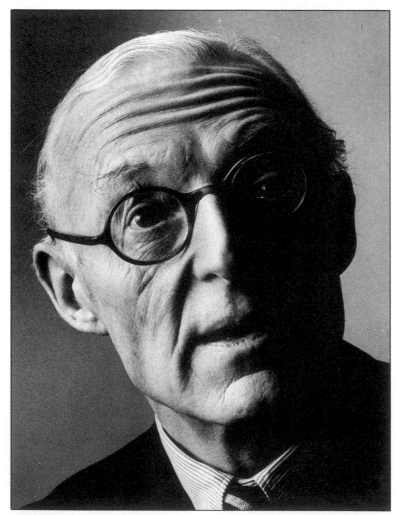

◀▲ Tungsten light
For these two portraits of Francis Bacon, inventor of the fuel cell, I used a tungsten lighting set-up consisting of one floodlight pointing slightly downward at the face and another lighting the background. The intention was to capture an expression that hints at the depth and uniqueness of his work.
☐ *Pentax, 85 mm, Ilford HP5, 1/60 sec, f4*

▶ Flash lighting
The energy and tenacity that characterizes teacher and author Germaine Greer were more suited to flash. I used a studio flash and umbrella reflector to the left of the camera pointing at the face.
☐ *Hasselblad, 150 mm, Kodak Tri-X, x-sync, f5.6*

SEE ALSO
THE STUDIO 74-5
STUDIO LIGHTS
AND FLASH 76-7
BASIC LIGHTING
78-9

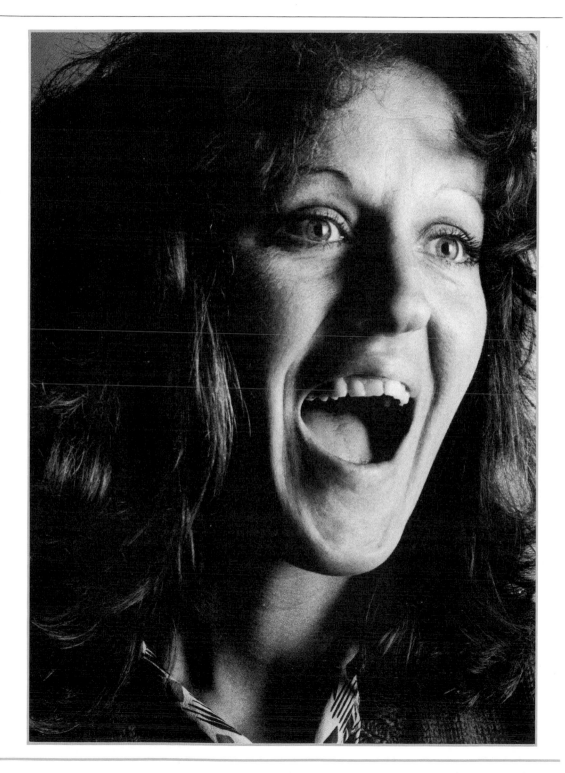

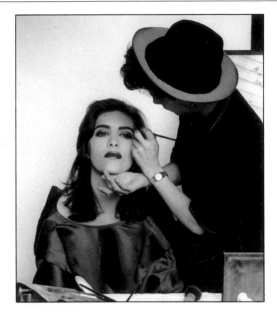

Usually the make-up plan will be chosen not only to suit the model but also to complement the clothes that the model will be wearing, or to convey a particular atmosphere or mood. In general, it is the more rounded, symmetrical face that forms the best 'canvas' for the make-up artist. Such models are particularly suitable for fashion and advertising shots in which the make-up itself is the subject of the photograph.

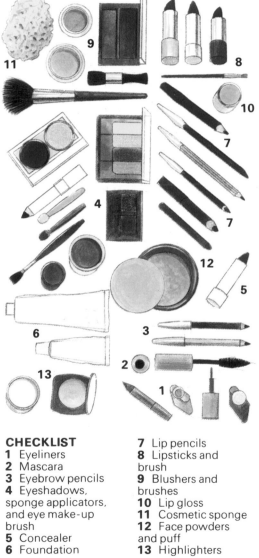

Since the aim of most portrait studies is to present the subject as truthfully as possible, only a minimum of make-up is usually required. Minor skin blemishes can be hidden with a small amount of foundation lotion or cream, and a dusting of face powder prevents reflections from foreheads and bald patches, giving a more flattering effect. Shooting with a soft, diffused light and using soft focus helps to minimize signs of age in older subjects.

The art of make-up

It is in the specialized worlds of fashion and glamor photography that make-up has developed into an art in itself, one which often completely transforms a model's looks. Professional make-up artists undergo a long period of training, but an understanding of basic techniques can be useful when working with amateur models. Using eyeshadows and shading techniques, eyes can be made to look larger and set further apart, eyebrows can be colored and shaped for greater emphasis, and lips made fuller. By highlighting cheekbones, or filling in the cheek areas, the make-up artist can model the shape of the face, making it more angular and dramatic, or creating a fuller, more rounded effect.

CHECKLIST
1 Eyeliners
2 Mascara
3 Eyebrow pencils
4 Eyeshadows, sponge applicators, and eye make-up brush
5 Concealer
6 Foundation
7 Lip pencils
8 Lipsticks and brush
9 Blushers and brushes
10 Lip gloss
11 Cosmetic sponge
12 Face powders and puff
13 Highlighters

Stages of application

Although the exact procedure for applying make-up will vary with each model and the effect aimed for, the following sequence illustrates a typical basic routine that should be sufficient in most situations. Before any application of make-up can begin, however, the model's skin must be thoroughly cleaned of any traces of grease or of previous make-up, using a deep cleansing lotion followed by toner.

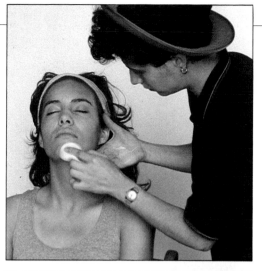

▶ Concealer and foundation

After applying moisturizer, concealer, in the form of sticks, creams, and cakes, is applied to mask any minor skin blemishes. It is available in a range of shades to match most skins and should be applied sparingly and blended gently into the skin. Next comes the foundation, usually in lotion or cream form. This gives a uniform complexion to the model and is smoothed gently on to the face and neck using a sponge. Again, a variety of shades is available.

▶ The eyes

Make-up for the eyes falls into three basic categories: shadows, liners, and mascara. The line of the eyelashes is emphasized with pencil and then the upper lids are shaded with a combination of eyeshadows or highlighter. Shading can also be used along the line of the lower lashes. Mascara, in cake form or the more familiar wand, can accentuate the eyelashes themselves, making them appear thicker and longer, and an eyebrow pencil or powder gives definition to the eyebrows.

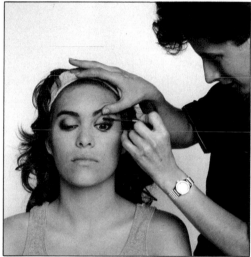

▶ The lips and cheeks

The general appearance of the lips is defined first with a lip pencil, which gives the most concentrated color. The overall color of the lips is then provided by lipstick or lip gloss. Toners and blushers can be applied to the cheeks to give just a delicate hint of color. Blushers in powder form can be used after face powder has been applied, but cream blusher should always be used before.

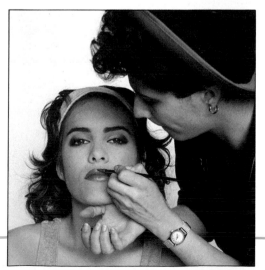

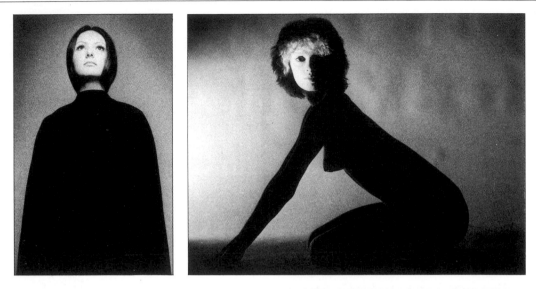

Having your own studio (even a temporarily converted spare room) gives you the opportunity to really come to terms with many of the challenges posed by lighting. The added benefit is that, once acquired, you will be able to apply this knowledge to most photographic situations, whether artificially or naturally lit. Also, in the studio it is possible to work at your own pace, trying new ideas or combinations of older ones, without worrying about the changeable nature of daylight.

An easy way of making your pictures stand out and catch the viewer's attention is by using studio lighting in a very selective manner. Instead of trying for a fully detailed portrait, use light to emphasize key areas of the composition and allow the rest of the picture, more or less, to look after itself.

By doing this you will, of course, be introducing a high level of contrast, and so you need to ensure that your subject is prominent enough not to become lost in the shadows.

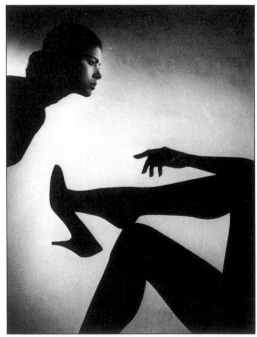

Equipment needs

All the pictures on these two pages could be taken using a maximum of three lights — two floodlights and a spot. In addition, you will need some way to restrict the beams coming from the lights: sometimes even a spotlight illuminates too much.

SEE ALSO
STUDIO LIGHTS AND
FLASH 76-7
BASIC LIGHTING 78-9
HIGH-CONTRAST
LIGHTING 152-3

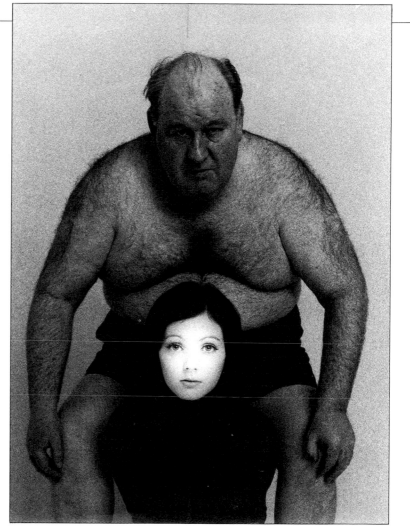

◄ Correct attire
In the picture far left, one floodlight illuminated the background and another the face. Draping the model entirely in black and shooting from a low angle, gave great presence to the figure.
☐ *Pentax, 28 mm, Kodak Tri-X, 1/60 sec, f 5.6*

◄ Spot metering
By directing a spotlight on to the model's profile, and allowing light to spill on to the background, a very dramatic effect is created. Exposure was calculated by taking a spot reading from the girl's lit profile.
☐ *Pentax, 85 mm, Kodak Tri-X, 1/125 sec f 8*

◄▼ Semi-silhouette
For this shot I used two floods for the highlight on the background and a spotlight with snoot to light the model's face, as can be seen in the diagram below.
☐ *Pentax, 50 mm, Ilford HP5, 1/60 sec, f 4*

The most commonly used attachment for restricting the beam of light is a set of barn doors. It consists of four flaps that fit around the outside of the lighting head: each flap can be swung into position individually in order to mask the light beam selectively. Another often-used attachment is a snoot – a conical arrangement narrowing to a small hole at the front that allows only a very narrow beam to emerge. If you do not want to buy these attachments, it is relatively easy to make a cone of cardboard and simply tape it to the lighting head. If you are using tungsten lamps, check periodically that the cardboard is not getting dangerously hot.

▲ Darkroom technique
For this effect I used a diffused spot to light the girl's face and thus increase tonal separation between the two figures. During printing, I lightened her face further by giving it only 50 per cent of the exposure received by the rest of the print.
☐ *Pentax, 85 mm, Kodak Tri-X, 1/15 sec, f 5.6*

STUDIO FANTASY

Although pictures such as these look like fun, preparation time is considerable. This session started at 9.00 in the morning with the arrival of the model. By 11.00 am the make-up artist was happy with his handiwork and the dresser could get started. If the helmet had not covered so much of her hair, then we would have had to add up to half an hour more for repairing the damage done simply by getting dressed. As it was, the model was ready to step on to the set shortly after 11.30.

Experienced studio photographers can do a lot of the preparatory work, such as setting up lights in their approximate positions, while the model is being 'transformed'. An outfit such as this, however, because of its highly reflective surfaces, is apt to destroy even the best-laid plans. After examining the problems created by excessive glare and trying three or four lighting schemes, the actual photography commenced at 1.00 in the afternoon.

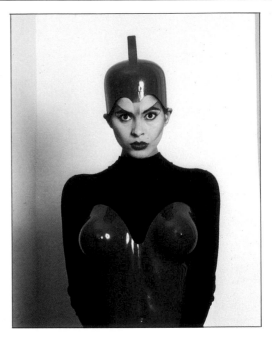

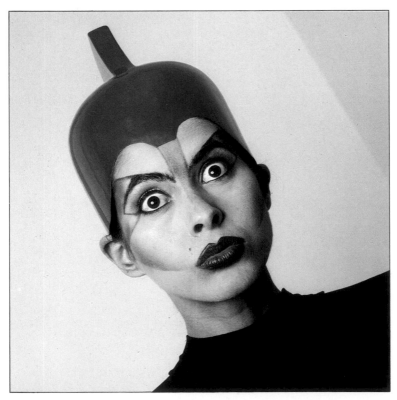

▲ Middle distance
Although well lit and correctly exposed, this middle-distance shot does not show enough of the setting or, alternatively, of the model's expression.
☐ *Hasselblad, 120 mm, Ektachrome 64, 1/60 sec, f 4*

◄ Close-up
By moving in for a close-up I have lost the impact of the costume but the shot benefits from the model's exaggerated facial expression.
☐ *Hasselblad, 120 mm, Ektachrome 64, 1/60 sec, f 4*

▲▶ Long shot

This is the shot I like best. Showing the whole figure makes best use of the fantasy-type costume, which works extremely well with the pose the model has adopted. Also, the niche in the wall is the ideal setting, completing the fantasy atmosphere. All of these three pictures were taken with studio flash bounced off the ceiling, as shown in the diagram above.

☐ *Hasselblad, 120 mm, Ekta-chrome 64, 1/60 sec, f 4*

SEE ALSO

THE 35 mm SLR CAMERA
22-4
MEDIUM-FORMAT
CAMERAS 25-6
STUDIO LIGHTS AND
FLASH 76-7
LIGHTING AND
EXPRESSION 80-1

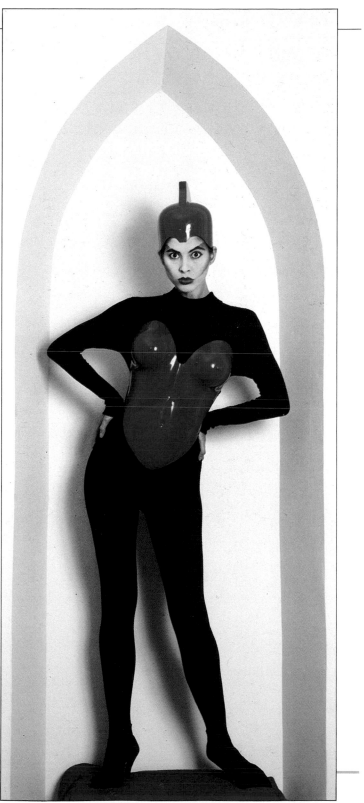

PORTRAIT
THEMES

☐ *Pentax, 85 mm, Kodak Tri-X, 1/125 sec, f 8*

□ *Hasselblad, 80 mm, Kodak Tri-X, 1/60 sec, f 8*

A THEMATIC APPROACH

Portrait photographs that offer the viewer some insight into the character of the sitter are often easier to accomplish if you have in mind a particular theme to focus on before starting out. Portrait themes are as numerous as there are photographers, but some of the more achievable ones for the amateur are: different people all involved in the same sort of activity or profession, people and their possessions, people strongly associated with their environment, and people working at their particular hobbies. The theme you choose will undoubtedly reflect your own interests, but the success of the pictures will depend not only on your ability but on the freedom sitters will allow you to experiment and roam within their homes or workplaces. Learn as much about them beforehand as you can – the work they do, the pictures they paint, the gardens they cherish, or the books they write. To make contact with these people, the photographer needs tenacity and self-confidence coupled with politeness and tact. Taking their interests as the prime consideration, however, should result in that essential co-operation.

▲▶ Studio set-up
For this portrait of the cartoonist Illingworth, I used a long lens to concentrate attention on his face and lit the background with a floodlight, as shown above. A spotlight on the right brought out all-important facial details.
□ *Hasselblad, 120 mm, Ektachrome 64, 1/60 sec, f 5.6*

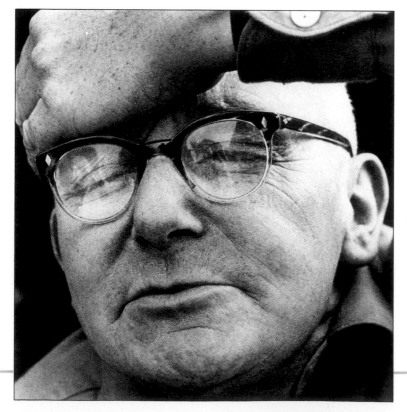

◀ Natural light
Utilize the type of light and setting best suited to your subject. For this study of cartoonist Giles, we moved outdoors into an area that gave a soft, directional light filtering between two buildings. This provided good modeling and produced a relaxed atmosphere ideal for a portrait session.
□ *Hasselblad, 120 mm, Kodak Tri-X, 1/250 sec, f 8*

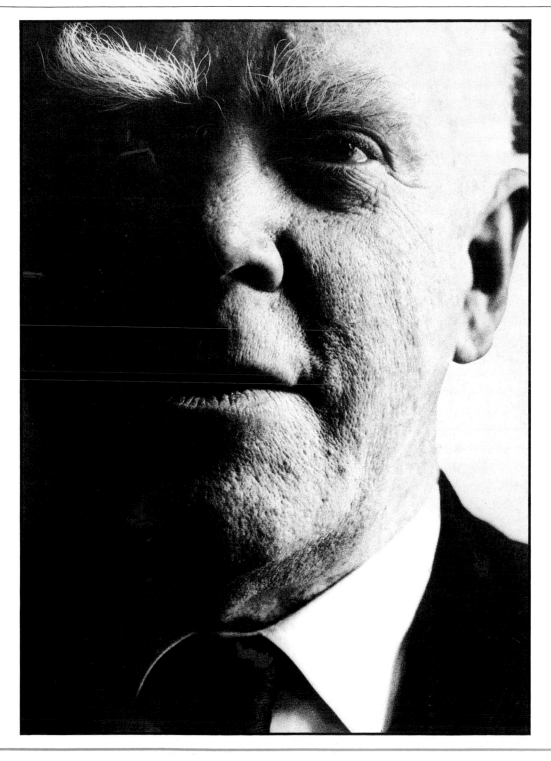

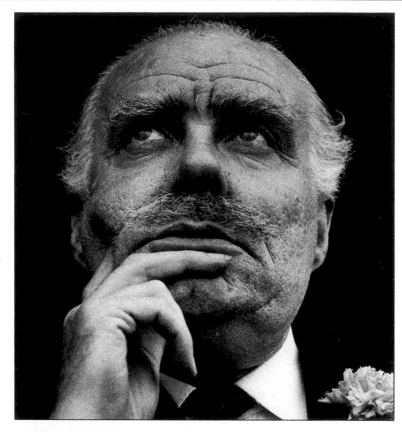

▼ Three-quarters view
This framing makes the face of political car-toonist Low shade off into darkness, empha-sizing the fleeting atmosphere of this study. The cupped hand, seemingly as disembodied as the head, is also a factor in achieving this.
☐ *Pentax, 85 mm, Kodak Tri-X, 1/125 sec, f 5.6*

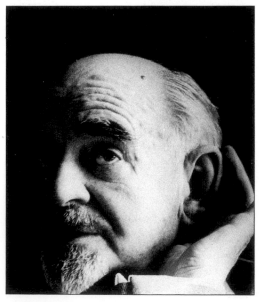

The photographs on this page and opposite are all of press cartoonists. There is no use pretending that access to people such as these is easy, and your first approach should be by letter via the publication their work appears in.

In your letter, explain fully who you are, why you want to take the pictures, how the pictures will be used, and how much time you estimate the session will take. Be realistic here: nothing is more annoying than setting aside 45 minutes for something that ends up taking hours.

If contact is established, arrange either to travel to the subject's home or place of work or, if you prefer and he or she is willing, your home or studio could be the venue. Things will go more smoothly if you can meet them before the session and survey the location. Once you have been successful with one person, it will give you more credibility with others.

◄ Close framing

Moving in close, to almost fill the picture area, and a low view-point magnified the strong presence of Osbert Lancaster. The subtle detail of the carnation picked out against a uniformly black background emphasizes the style and elegance of the man.
□ *Pentax, 85 mm, Kodak Tri-X, 1/60 sec, f 8*

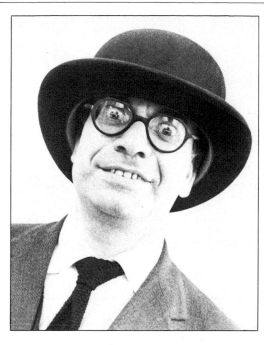

◄ Eccentric appearance

Vicky thrusts his head into an overly large bowler hat that a victim of one of his cartoons had sent him. Supposedly a 'big head', Vicky has turned the portrait into a joke.
□ *Hasselblad, 80 mm, Ilford HP5, 1/125 sec, f 8*

SEE ALSO

A THEMATIC
APPROACH 90-1
CIRCUS
PERFORMERS 94-5
PEOPLE AT WORK
104-5

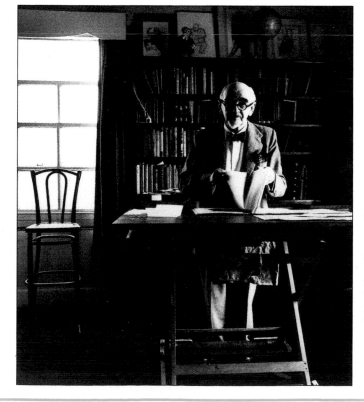

◄▲ Intersection of thirds

This portrait of Low derives its restrained atmosphere from a geometric interpretation of the scene. The diagram above shows how the cartoonist is situated on an important vertical line and his head at an intersection of thirds.
□ *Hasselblad, 80 mm, Kodak Tri-X, 1/125 sec, f 5.6*

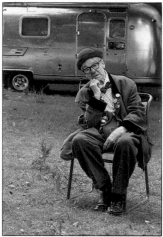

Compared with the difficulties of gaining access to people such as cartoonists, you will find circus folk altogether more approachable. By their very nature, they tend to be self-publicists and are likely to welcome the sympathetic attention of the camera.

Before starting on a theme such as this, you will need to obtain permission from the management. If granted, start off with a few simple portraits and show your subjects the results. With luck, you will be able to build up a relationship from there and good pictures will follow.

Circus acts are often family affairs, so part of your coverage should include family portraits. Likewise, always try to include all members of the same act, even if unrelated, in a group shot. Circuses mean dressing up, so you will have plenty of scope for colorful and unusual shots.

▲ Snatching a rest
This circus clown had been in the business since he was a boy and knew how to pace himself. Between performances, moving scenery, maintaining props, and so on, he would find a sunny spot and just sit and relax.
□ *Pentax, 50 mm, Ektachrome 64, 1/250 sec, f 11*

▶ Practice makes perfect
One of the wonderful things about the circus is that it never stops — there is always activity of one sort or another and all of it seems fascinating to an outsider. I saw the sword swallower practicing his act and he put on a private performance to impress me.
□ *Pentax, 135 mm, Ektachrome 64, 1/125 sec, f 8*

▶ Family act
It is common in the circus for members of the same act all to be in the same family, as with this group of acrobats. The caravan is their home and they wanted their picture taken in front of it. A homely touch is the potted plant on the table on the right.
□ *Pentax, 28 mm, Ektachrome 64, 1/60 sec, f 4*

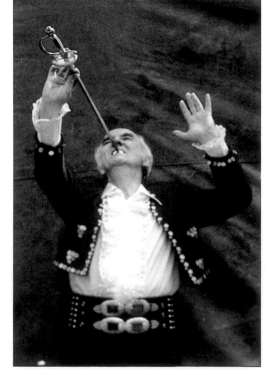

▶ Boosting light levels
Always take the opportunity to create a little humor — people in bizarre costumes doing perfectly ordinary things, such as taking some light refreshment, for example, usually make for good pictures. Night was falling when I took this picture, so I used on-camera flash to boost light levels.
□ *Pentax, 50 mm, Ektachrome 64, x-sync, f 11*

SEE ALSO
PEOPLE AND OCCUPATIONS 92-3
LONG-TERM THEMES 96-9
COUNTRY LIFE 102-3
PEOPLE AT WORK 104-5

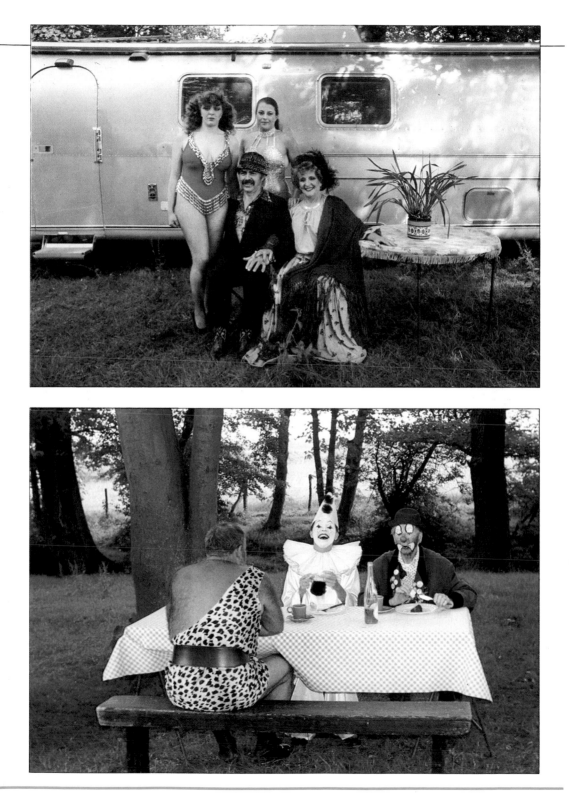

LONG-TERM THEMES

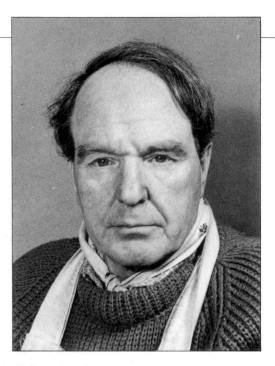

The camera is a unique recording instrument: point it at virtually any subject, press the button, and you capture forever a frozen instant of time. But how much more meaningful those images can be is made plain when you see a progression of pictures of the same person taken over a long period, recording not only the passage of the years but also that person's life's work and leisure interests.

Who makes a good subject?
Anybody is a suitable candidate for this type of photographic approach. The pictures here, and on the two pages overleaf, are of the great British sculptor Henry Moore, sadly now dead. But the object here is not to reflect fame for its own sake; rather it is to make a record that communicates more than any single shot could ever hope to achieve and to explore a chosen theme — a process that should bring pleasure to both parties.

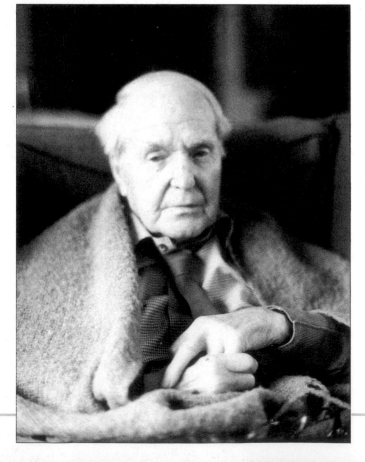

▲ Artistic prime
This picture shows Henry Moore in his vigorous middle years, when his work was already highly acclaimed.
☐ *Pentax, 50 mm, Kodak Tri-X, 1/125 sec, f 4*

▶ Lost in thought
As we had become firm friends, there was no awkwardness at all when I brought the camera out for this picture. I do not think that he was even aware that I had taken it.
☐ *Pentax, 135 mm, Ilford HP5, 1/60 sec, f 5.6*

◀ Twilight years
My intention here was to emphasize the gentle nature of the man so I used an open aperture to soften the already diffused light entering from a window on the left.
☐ *Pentax, 50 mm, Kodak Tri-X, 1/60 sec, f 2.8*

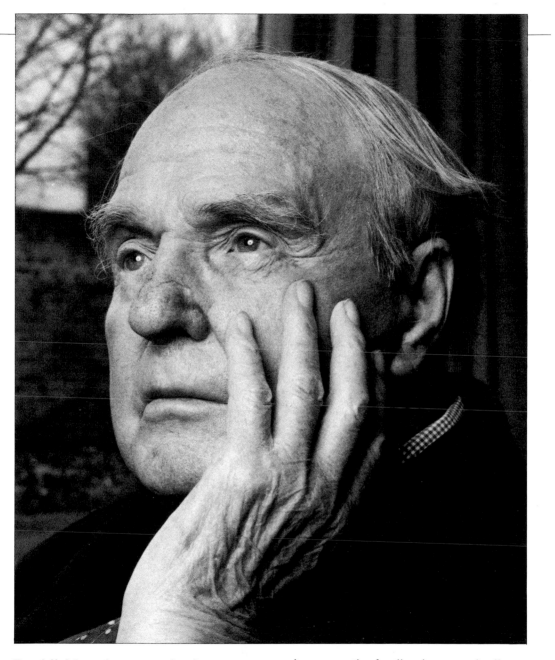

Establishing the ground rules

A series of pictures comprising a long-term project such as this will be of somebody you have easy access to — perhaps a member of your family or a close friend. Interest needs to be maintained over a very long period if the photographic record is to be complete.

In a way, the family photograph album goes some way to fulfilling the objects of projects such as this, but usually an album is not totally satisfactory, since it chronicles certain aspects only — vacations and special occasions such as graduations, weddings, and so on. But here, events are not our main concern. It is often the quiet, ▷

introspective moments and those times when your subject is engrossed in some ordinary activity and his or her guard is down that will provide the best insight into character and most poignant memories.

Types of coverage

There is no particular need to try for candid pictures. In order to ensure that you obtain the shots you are after, it may be necessary to enlist the active support of your subject. Also, the self-consciousness that can result from pointing a camera at somebody may be worth capturing in itself.

Over the years you could build up a sizable portfolio of pictures — too many to be really appreciated. So, right from the beginning, be reasonably selective in what you take and certainly in what you include in the project. And with so many pictures you will want to show a good range of different approaches to the subject — close-up and distant shots, formal and informal, posed and unposed, and indoors and outdoors.

Bear in mind that your pictures should record not only your subject's leisure activities but also his or her more active moments.

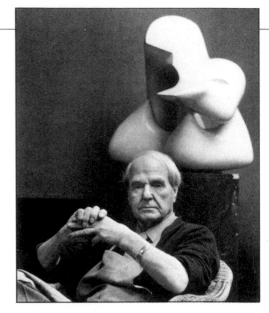

▼ Adopting a pose
Henry Moore posing in front of a newly completed sculpture is the traditional way of portraying the man and his work.
☐ Pentax, 28 mm, Kodak Tri-X, 1/500 sec. f 8

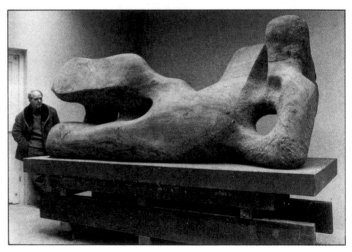

▲ Scale and perspective
When considering a long-term project involving a pictorial record of a person's life, it is important to include shots, such as these above, that show the viewer important aspects of the subject's work. These two are of particular interest because they show the scale of the sculptures created by Henry Moore — in one (top) he appears completely dominated by the reclining figure, while in the other (above) he is the most prominent element.
☐ Top: Pentax, 85 mm, Kodak Tri-X, 1/125 sec. f 11
☐ Above: Pentax, 28 mm, Kodak Tri-X, 1/60 sec. f 5.6

▲ Varying the approach
For this shot posing Henry
Moore alongside the shadow
cast by one of his works gave a
new slant to the subject.
□ *Hasselblad, 80 mm, Kodak
Tri-X, 1/500 sec, f 8*

◄ Relaxed pose
Even after all the years I knew
him, Henry Moore was still at
his most relaxed when posing
with one of his sculptures.
□ *Pentax, 120 mm, Kodak
Tri-X, 1/125 sec, f 8*

SEE ALSO
PHOTOGRAPHING
ELDERLY PEOPLE 106-9
ON LOCATION 116-17

PRIDE OF POSSESSION

Since the principal aim of portraiture is to reveal something of the character of the subject, the depiction of that person's prized possession — their home, for example — must help considerably in conveying personality.

This approach to portrait photography means getting out of the studio. And since you will have to cope with the unexpected, you should have with you as a minimum a wide-angle lens, moderate telephoto lens, and a standard lens, as well as a few rolls of spare film.

Found subjects

Usually you will find that people are only too willing to show their possessions to the camera. There is, after all, an element of pride involved. Much, though, will also depend on your approach: a bold, confident invitation to pose will often produce better results than a surreptitious, snatched candid shot. Some people will, of course, be self-conscious, but that in itself can make for good pictures. Other people, by the way they dress or behave, court the attentions of the photographer.

Covering yourself

Although many of the pictures of this type are repeatable, for those that you just come across it is best to shoot more film than you think you need. In many cases, your first shot will be the one you finally decide is best, but if you have the time then bracket exposures a half and one full stop either side of the metered reading to guarantee a good result.

◄ All dressed up
This Edwardian-type character was a snappy dresser in his top hat and tails posing in front of his suburban vine-clad house. He would have looked equally at home in front of a country manor house.
☐ *Pentax, 50 mm, Kodak Tri-X, 1/250 sec, f8*

► Be it ever so humble . . .
No awkwardness here in front of the camera. Only the cool sophistication shows through as the owner of this magnificent castle-like home adopts an appropriate pose.
☐ *Hasselblad, 60 mm, Kodak Tri-X, 1/125 sec, f11*

SEE ALSO
EXPOSURE
LATITUDE 38-9
ON LOCATION
116-17

COUNTRY LIFE

Adopting a theme for at least some of your portraiture is even more fulfilling when it represents a valuable documentary statement. A good example of such a theme might be the disappearing way of life of our rural areas. The impact of mechanization and technological advance, as dramatic as it has been in the great industrial centers, has had a devastating effect on country life, where whole communities of farmers and farm workers have simply faded away. Some of those who do remain feel themselves to be the guardians of past traditions and may be willing subjects for your camera.

As is often the case with portraiture, much depends on how you make your initial approach. You will achieve far more if you are fully committed to making a sensitive photographic record of individuals' lives and interests before they are gone forever. You will inevitably be working on location, so restrict your equipment to a minimum — two camera bodies, three lenses (or a wide-ranging zoom), spare film and batteries, filters, flash, camera and lens cleaning equipment, and a tripod.

▼ Available light
Bright, late-morning light and whitewashed walls combined to create a soft, form-revealing illumination for this touching portrait of an elderly farmer and his wife.
□ *Pentax, 50 mm, Kodak Tri-X, 1/60 sec, f 5.6*

▶ Farmer's wife
To bring out the modelling on this gentle woman's face, and emphasize the delicate way she is holding the pigeon, I reinforced weak sunlight with diffused flash.
□ *Pentax, 85 mm, Kodak Tri-X, x-sync, f 8*

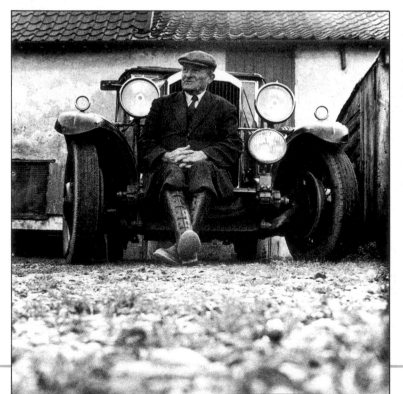

◀ Wide aperture
Restricting depth of field by using a wide aperture has thrown out of focus a potentially distracting foreground detail.
□ *Pentax, 50 mm, Kodak Tri-X, 1/60 sec, f 2.8*

SEE ALSO
PEOPLE AND OCCUPATIONS 92-3
CIRCUS PERFORMERS 94-5
PEOPLE AT WORK 104-5

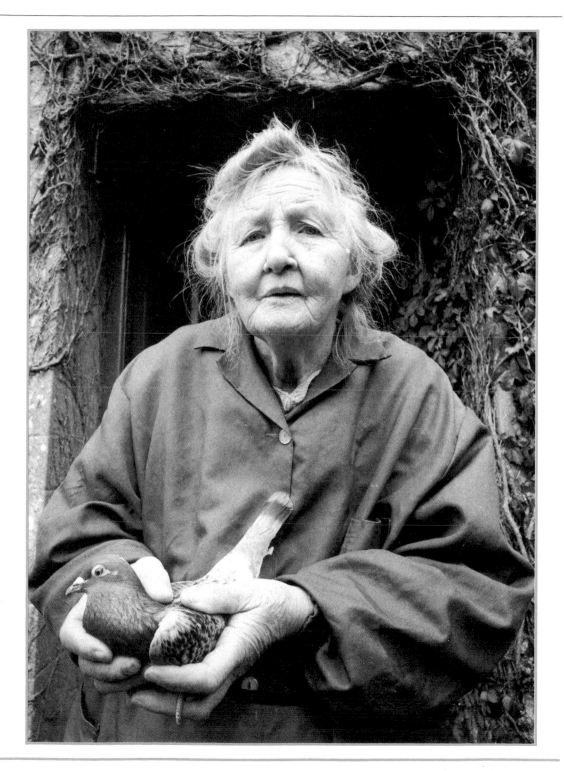

PEOPLE AT WORK

One of the problems associated with portrait photography is that people tend to freeze up as soon as you point the camera at them. One way round this is to tackle them when they are feeling completely relaxed or confident in what they are doing: often, this is when they are at work and feeling more in charge of the situation. Another approach is to try for candid pictures using a long lens. But then you miss out on the interaction between subject and photographer that, in many cases, marks the difference between a record shot and a revealing portrait.

If what you are trying to achieve is a generally interesting portfolio of pictures, as well as featuring people as the main subject, then it will help if you can research and then track down people who have unusual types of occupation. Not only will your pictures benefit from the effort you put in, but you may also find that your pictures have some historic value as many of the old crafts and working practices are being replaced by automated, soulless machines operating in sterile environments.

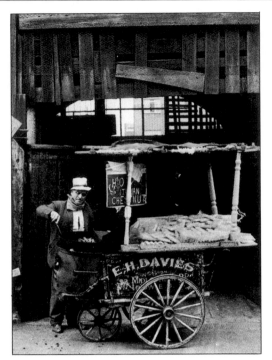

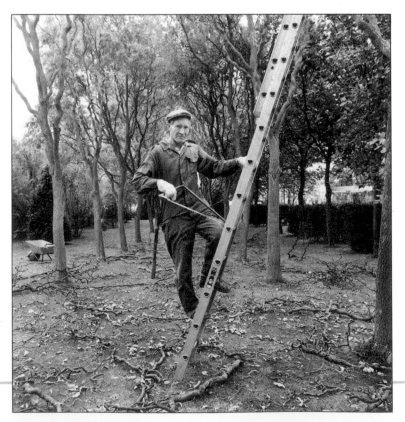

▲ Vanishing sight
Pictures of characters such as this chestnut vendor with his hand cart are important, since such trades are fast disappearing from the urban scene.
☐ *Pentax, 35 mm, Kodak Tri-X, 1/60 sec, f 16*

◄ Country pursuit
I was walking through parkland when I saw this tree surgeon, who was only too pleased to pose.
☐ *Pentax, 50 mm, Kodak Tri-X, 1/125 sec, f 11*

SEE ALSO
CANDID PORTRAITS 54-9
PEOPLE AND OCCUPATIONS 92-3

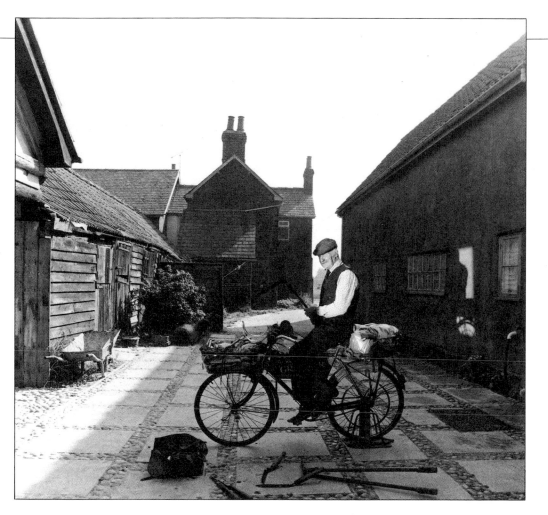

▲▶ Creating a highlight

To create a highlight on this knife sharpener, I set up a floodlight in the doorway of a nearby building, as shown in the diagram.
□ *Pentax, 50 mm, Kodak Tri-X, 1/60 sec, f 11*

◀ Dying craft

Modern generations cannot conceive of spending their working lives like this elderly weaver.
□ *Pentax, 85 mm, Kodak Tri-X, 1/60 sec, f 4*

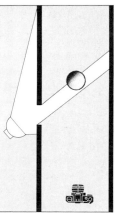

PHOTOGRAPHING ELDERLY PEOPLE

Taking portraits of either the very young or the very old presents a challenge to the photographer. With elderly people, gone are the physical attributes that are generally regarded as attractive – firm skin, clear eyes, and lustrous, flowing hair. Instead, you will have before the lens, etched in your subjects' faces, a mirror reflecting their many years and a wealth of experiences. The results of your endeavors need be no less beautiful simply because the magic ingredient of youth is no longer present – you will be amply rewarded in other ways.

Studio or location

From a photographic viewpoint, if you use a long lens, of up to about 135 mm, and allow the subject's head and shoulders to fill the frame, then, as the pictures here and on the following two pages show, it does not matter much if you are in a studio, working in your subject's or your own home, or outdoors.

In general, you will find that the elderly prefer the security and comfort of their own homes, so get together a basic, yet flexible, kit of equipment that you can take

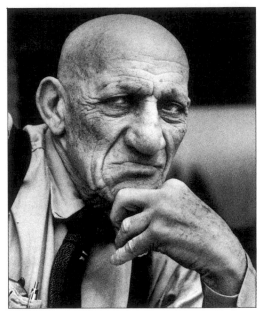

▲ Craggy countenance
Sharp, angular lines, sunken eyes, and a completely bald head combine to give this picture an almost sculptural quality.
☐ Pentax, 85 mm, Kodak Tri-X, 1/125 sec, f 5.6

▶ Strong profile
With only one side of the face to light, con-trasty window light is no problem. Also, it helped to throw the background into shadow.
☐ Pentax, 100 mm, Ilford HP5, 1/60 sec, f 8

with you. If you can visit the location before the session, you will be able to gauge your needs quite accurately. When-ever possible, you should avoid pointing lights directly at people's faces, so you will have to rely heavily on bounced or reflected light for your illumination.

Look at the layout of the place, too, to see if there is the option of outdoor pic-tures. A balcony will do if there is no garden. If you need power for lights, then make sure that points are conveniently located or take sufficient extension leads with you.

◀ Emphasizing the subject
For this portrait I pur-posely selected a wide aperture in order to

render the background out of focus.
☐ Pentax, 85 mm, Kodak Tri-X, 1/250 sec, f 2.8

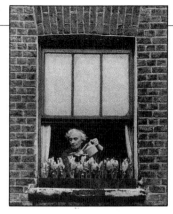

▲ Isolating the subject
Using a long lens has given the figure added prominence and minimized a distracting setting.
□ *Hasselblad, 150 mm, Kodak Tri-X, 1/125 sec, f 8*

◄ Confining the subject
In this shot, the door and doorway effectively confine and frame the woman and children.
□ *Pentax, 50 mm, Kodak Tri-X, 1/250 sec, f 16*

► Derelict facade
The broken glass adds a sad note to this picture of the poet Adrian Henri and the Liverpool house he was born in.
□ *Hasselblad, 80 mm, Kodak Tri-X, 1/125 sec, f 4*

◄ Balancing tone
Here, the doorway and the window help to balance the dark tonal mass of the two figures.
□ *Pentax, 28 mm, Kodak Tri-X, 1/125 sec, f 11*

► Converging verticals
An already massive window is made to appear even larger by shooting up with a wide-angle.
□ *Pentax, 28 mm, Ilford HP5, 1/60 sec, f 8*

SEE ALSO

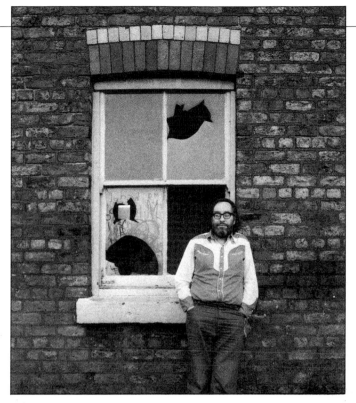

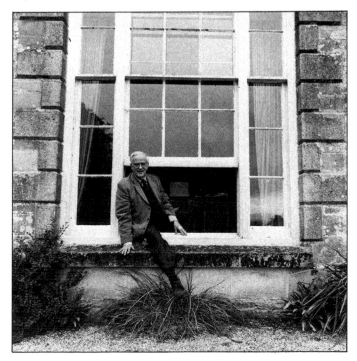

THE MUSIC MAKERS

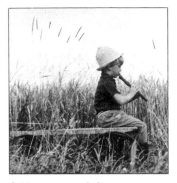

▲ Young musician
A low camera angle captured
this boy, lost in the pleasure of
making music.
□ *Pentax, 85 mm, Kodak
Tri-X, 1/60 sec, f 8*

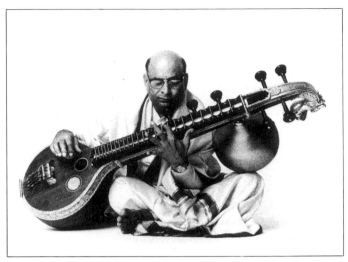

▲ Sitar player
A neutral setting in-
creases the level of
concentration the
viewer is able to give
the details in a shot.
□ *Pentax, 50 mm,
Kodak Tri-X, 1/60 sec,
f 5.6*

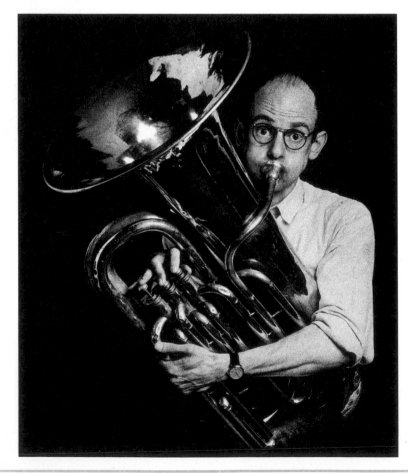

◄ Hard blow
Unintentional humor
has been created in
this close-up of a tuba
player, with his bulg-
ing cheeks and slightly
popping eyes.
□ *Hasselblad, 80 mm,
Kodak Tri-X, 1/125
sec, f 8*

► Musical prop
Although the model
could not play, side-
lighting has produced
a dramatic version of
blowing her own
trumpet.
□ *Pentax, 50 mm,
HP5, 1/125 sec, f 11*

SEE ALSO
VIEWPOINTS 62-5
SILHOUETTES 148-9
PROPS 170-1
CHILDREN 174-5

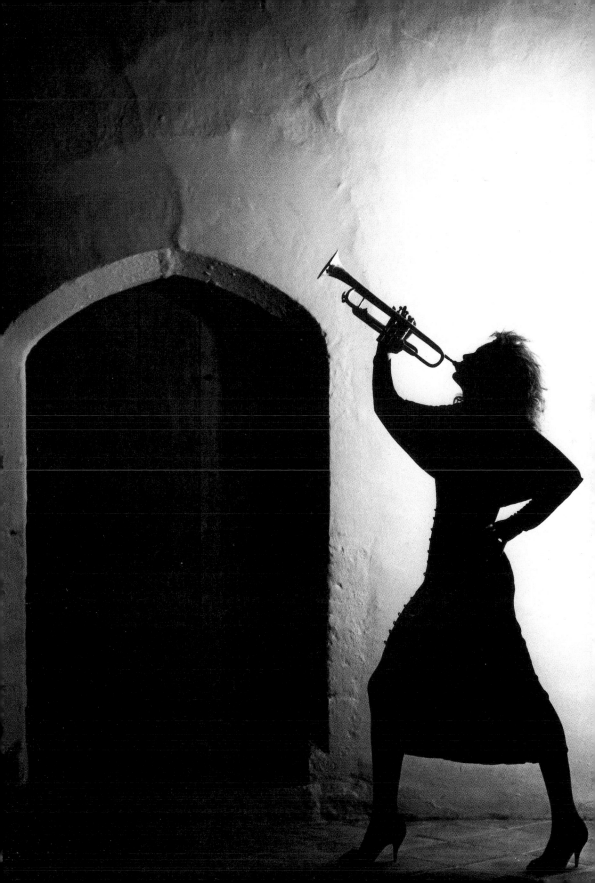

LOCATIONS

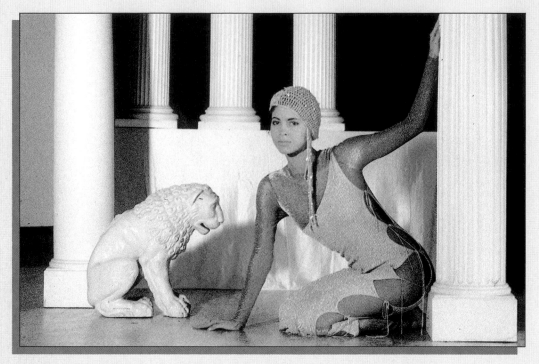

☐ *Pentax, 85 mm, Ektachrome 160T, 1/125 sec, f 11*

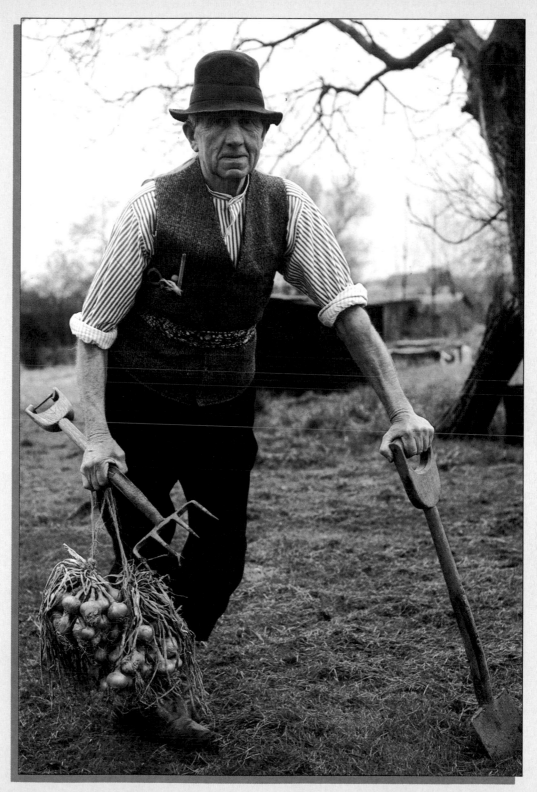

□ Hasselblad, 80 mm, Ektachrome 64, 1/125 sec, f 11

ON LOCATION

For the photographer, sessions on location bring an informality that is often hard to achieve in the studio. Subjects tend to be more relaxed and resulting shots may reveal fresh aspects of their personalities.

However, outside the studio you no longer have complete control over the photographic environment and quality of light becomes a major factor.

Location work

A sturdy equipment bag is an essential for serious location work. It should be lightweight for easy carrying, and made of weatherproof material padded with foam to protect equipment from accidental shocks. As well as ample space for cameras, lenses, filters, and packs of film, there should be pockets to carry odds and ends, such as notebooks, adhesive tape, cleaning agents, and spare batteries. In addition, most bags have straps for carrying a small collapsible tripod. For more ambitious location shoots, the equivalent of a modest studio will be needed, with portable lighting arrangements of varying sophistication, all of which can be rented by the day.

▼ Rigid case
A rigid alloy case is preferred by some photographers. Lined with foam, it offers greater protection to equipment than the type shown opposite. Also, better made types can be used as a platform to give you added height. They are, however, heavier to carry about and usually less adaptable to the changing needs of your equipment.

▲ Reading between the lines
One of the pleasures of location work is the freedom it gives you to grab pictures such as this one. These three young men certainly knew how to extract maximum value from a single daily newspaper.
□ *Pentax, 135 mm, Kodak Tri-X, 1/250 sec, f 11*

Location checklist
1 Camera with standard lens and motor drive
2 Shutter release cable
3 Lens cap
4 Wide-angle lens
5 Flash
6 Light meter
7 Tripod in case
8 Filters in case
9 Blower brush
10 Umbrella
11 Cardboard reflector
12 Spare camera body
13 Telephoto lens
14 Short telephoto
15 Spare film

SEE ALSO
THE 35 mm SLR CAMERA 22-4
FLASH 31
THE STANDARD
LENS 34
THE WIDE-ANGLE LENS 35
THE TELEPHOTO LENS 36

USING EXTERIORS

Portrait photographs that show just a simple likeness of your subject are very different in mood, and in what they tell you, from those taken in an environment relating to the person's lifestyle. Once you place a person in context – at school, college, or at play, for example – the image is at once richer and more complex, and so is likely to sustain the viewer's attention for a longer time. You do, though, have to ensure that the photograph still fulfils the function of a portrait, in that the person or persons portrayed are recognizable as particular individuals. The danger is that you will produce a shot of an exterior with people in it, rather than a picture of people in an exterior setting. This is a fine line you have to draw.

▼ Tree house
Children at play lose themselves in a world of their own and so make ideal subjects for a candid approach. The children here in their tree house took on an almost magical charm in the misty light. But beware of underexposure as the meter tends to see misty conditions as being brighter.
□ *Pentax, 135 mm, Ektachrome 200, 1/60 sec, f 8*

▲ School days
These Kings College schoolboys are dressed in traditional top hats and tails. Framed by the chapel, however, they do not look out of place. For shots such as this, the actual setting is vital for the success of the shot, and you need to use the right lens in order to balance the composition.
□ *Pentax, 50 mm, Ektachrome 64, 1/60 sec, f 16*

Important factors
Choice of lens, viewpoint, and lighting are the main factors that determine how your photograph will be viewed. Even in quite elaborate settings, adopting a high or low camera angle will help to draw attention to your main subject while still maintaining the feel of the place. It is also useful to create a strong contrast, either of color or tone, between your subject and setting.

In such situations, the angle of view of a standard lens is probably best: a wide-angle lens might make your task more difficult, unless you move in very close. With telephotos, of course, the much narrower angle of view of the lens means that you will exclude much of the setting.

▶ Tonal contrast

You can often generate additional interest in a picture by simplifying the elements. Here, I silhouetted the teacher, in cap and gown, against the outdoor scene. Although the view from the window takes up only a small part of the composition, it is important in conveying the atmosphere of the setting.
☐ *Pentax, 50 mm, Ektachrome 64, 1/125 sec, f 11*

▼ Pipes solo

In some portraits, the setting is of prime importance. In this case the idea was to promote Scotland in a poster, so the shot had to include a piper and a castle.
☐ *Hasselblad, 60 mm, Ektachrome 200, 1/500 sec, f 8*

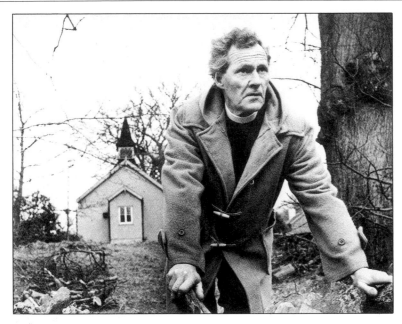

◀ Careful framing
In this portrait of the poet and vicar R. S. Thomas, I chose an outdoor setting with his church in view behind.
□ *Pentax, 35 mm, Ilford HP5, 1/60 sec, f 11*

▶ Garden setting
This setting could not have been more appropriate for the writer and horticulturist Vita Sackville-West — the Sissinghurst garden, Kent, that she made so famous.
□ *Pentax, 50 mm, Kodak Tri-X, 1/125 sec, f 11*

▼ Back to nature
The artist Graham Sutherland was pruning his apple trees when I arrived. As he often used natural forms as inspiration for his work, I took some shots in an attempt to convey this.
□ *Hasselblad, 120 mm, Kodak Tri-X, 1/60 sec, f 5.6*

▶ Tonal values
I posed authoress G. B. Stern in her frost-covered garden. Being a formidable lady, I thought her figure would appear stronger if contrasted with a basically high-key scene.
□ *Hasselblad, 80 mm, Kodak Tri-X, 1/60 sec, f 8*

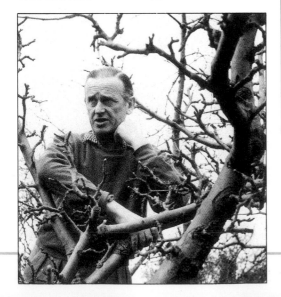

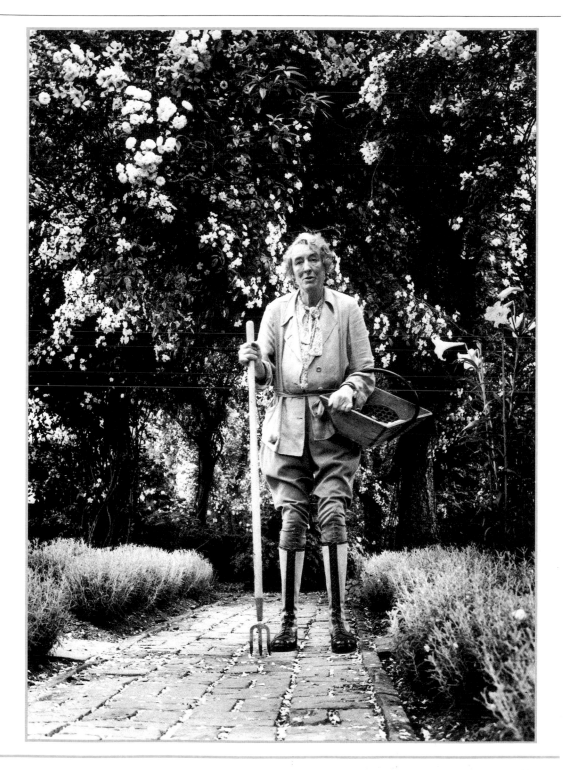

USING INTERIORS

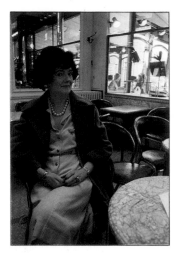

As is the case when you use exterior settings for your portraits, interiors (other than a studio) also add considerably to the complexity and interest of the photograph. Also, you stand a better chance of capturing your subject in a more characteristic attitude. But there are still basic decisions to make about whether the shot should be formal or informal (or a combination of both), posed or candid — problems that often resolve themselves once you start.

Points to consider
Unless you intend to rely on artificial tungsten lighting and exclude daylight, which may rob the picture of some of its spontaneity, you must be wary of introducing too much contrast, which often happens when window light is the only source of illumination. One way round this is to use supplementary light in the form of flash to reduce any excessive shadow areas.

Another major factor is the color of your surroundings. In the studio, you will have white- or neutral-colored walls, but on location you may have to deal with the problem of color cast. Another source of color cast is mixed light sources.

▲ Mixed light
The domestic-type tungsten light used for this portrait has produced an easily recognizable orange color cast. Note, however, that the view outside, reflected in the mirror behind the subject, shows true colors.
□ *Pentax, 85 mm, Ektachrome 64, 1/60 sec, f8*

► Simple setting
The characteristic exuberance of David Hockney is nicely balanced by the simplicity of the furnishings and decor of the room in which the painter wanted to pose. He is well used to being photographed and so did not need much directing from me. The size of the chair, though, gives some insight into his larger-than-life personality.
□ *Hasselblad, 80 mm, Ektachrome 64, x-sync, f4*

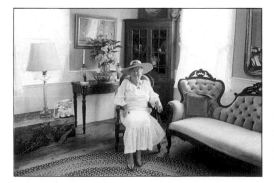

▲ Between windows
Light levels were no problem here due to the large windows in the room. Another factor working in my favor was a white building opposite, which reflected back sufficient light from the shadow side to prevent any deep shadows.
□ *Pentax, 28 mm, Ektachrome 64, 1/60 sec, f5.6*

▲ Supplementary light
This farmhouse room was just too deep for enough light to reach the far end, where I had posed the owner and her dog. To supplement the available light, I used flash in line with the window light so as not to introduce conflicting shadows.
□ *Pentax, 50 mm, Ektachrome 200, x-sync, f4*

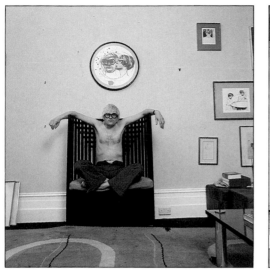

▲ Moody light
Sometimes you will find that low light levels and prominent shadow areas combine to produce the right mood for the subject and setting. The subdued lighting, coming solely from a side window, was perfect for this unusual bedroom portrait of the painter Allen Jones.
☐ *Pentax, 50 mm, Ektachrome 64, 1/30 sec, f 4*

▲▶ Formal surroundings
The rigid formality of this setting dictated to me the way the photograph should be posed. The size of the room, however, did create some problems, and I had to use two flash units either side of the room to give overall equal light, as shown right.
☐ *Pentax, 28 mm, Ektachrome 200, x-sync, f 8*

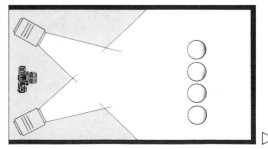

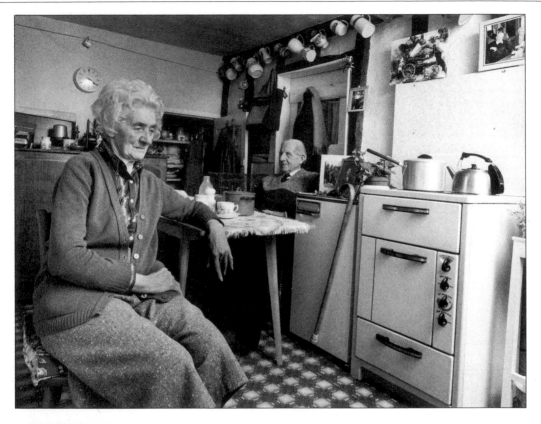

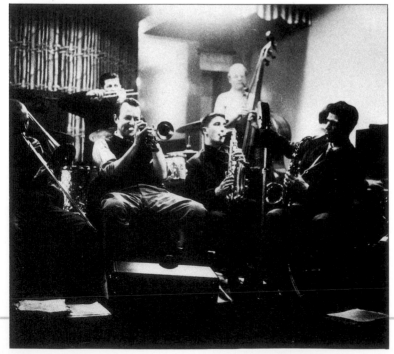

▲ Revealing insights
Portraits of people at home can be very revealing. Here, we can see that this couple have a modest lifestyle, but they obviously have great pride in their appearance and that of their home.
□ *Pentax, 28 mm, Ilford HP5, 1/60 sec, f 4*

◀ Subdued lighting
With this group portrait of a jazz band at rehearsal, the natural light was important to convey the relaxed informality of the players.
□ *Pentax, 50 mm, Kodak Tri-X, 1/60 sec, f 4*

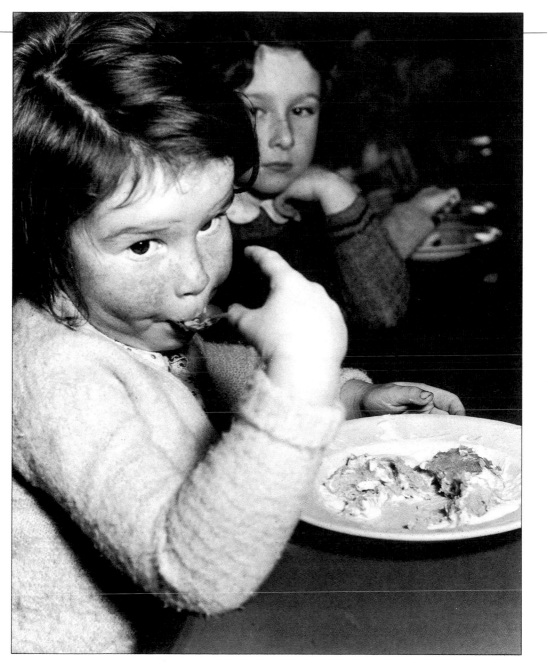

▲ School dinners
Sometimes you want to suggest the interior setting without letting it intrude too much. Using a long lens will help you remove extraneous information, as will a shallow depth of field. Also, with a telephoto you can stand well back and not intrude.
□ *Pentax, 85 mm, Kodak Tri-X, 1/60 sec, f4*

SEE ALSO
SELECTIVE LIGHTING 84-5
USING EXTERIORS 118-21
HIGH-CONTRAST
LIGHTING 152-3
FLASH LIGHTING 154-5

DOMINANT SETTINGS

Perhaps the prime objective of portrait photography is to convey to the viewer something of the personality of the subject, to go beyond the technical exercise of simply producing a good likeness. And one of the best ways of achieving this is to show your subject in a strong setting.

Composing the shot
Advice is often given on the benefits of avoiding cluttered pictures, where the attention of the viewer is drawn in different directions and the subject therefore 'diluted'. In many cases, though, the setting has a lot to add to the photograph.

Giving emphasis to the subject in a setting is a matter of composing your shot correctly: moving the camera a little to the left or right, up or down, can bring new elements into the frame and produce a tension that is so often missing in straight portrait pictures. An important part of the photographer's role is to use the camera's focusing screen to experiment with the various components of the shot. What you eventually decide to retain or discard will have much to do with the atmosphere you wish to create.

▶ **Dominant foregrounds**
Much of the character of the artist, Eduardo Paolozzi, is reflected in this photograph. He has a powerful physical presence and this is suggested by his sculpture, which, although dominating the foreground area of the picture, does not deflect attention from him.
☐ *Pentax, 85 mm, Ektachrome 200, 1/30 sec, f 8*

◀ **Emphasizing the foreground**
Using a wide aperture in this subdued natural light has emphasized the foreground shoes, making them the dominant element in the scene.
☐ *Pentax, 50 mm, Ektachrome 200, 1/60 sec, f 2.8*

▲ **Proper placement**
By carefully positioning the elements it is possible for even a small subject to become the focus of attention. The formality of this man's pose is echoed by the sparse formality of the room itself, decorated with memorabilia reminiscent of a bygone age. He has been placed where window light can cast even illumination.
☐ *Pentax, 28 mm, Ektachrome 64, 1/30 sec, f 5.6*

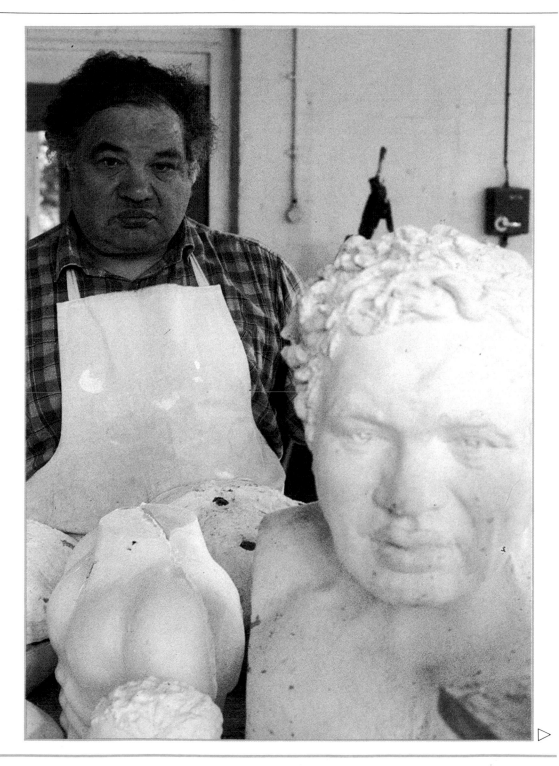

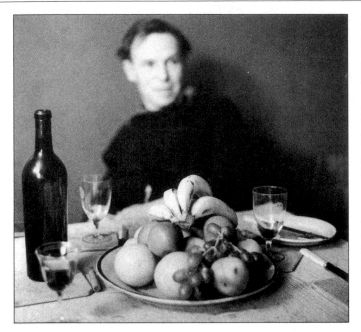

◄ Depth of field
One way to emphasize elements of a picture is to use a limited depth of field to throw everything else into soft focus.
☐ *Pentax, 50 mm, Kodak Tri-X, 1/60 sec, f 1.4*

► Men of science
The impact of the setting emphasizes the dominant role of these two Nobel Prize winning scientists, Bragg and Porter.
☐ *Pentax, 35 mm, Ilford HP5, 1/30 sec, f 8*

▼ Camera position
To illuminate the setting for this shot, and still give the impression of light coming from the ceiling lights, I bounced the light from six studio flash units off the walls and ceiling.
☐ *Pentax, 28 mm, Kodak Tri-X, x-sync, f 8*

Using line
Line can represent an extremely dominant feature in the setting, helping to draw the viewer's eye precisely where you want to fix attention. Strongly vertical lines tend to emphasize the height of the picture; horizontal lines, on the other hand, produce a static composition, fixing attention on anything placed at their junction.

Color and tonal contrast
Bright colors and dark tones seem to come forward in a picture, while more muted colors and lighter tones tend to recede. Notice in the example on the opposite page of a nearly empty lecture theatre, how the eye is drawn initially to the central figure, dressed in a dark-toned suit. The contrast between his suit and the lighter-toned seats is enough to demand our attention. It is only later that the eye starts to explore the bizarre gadgetry present in the setting.

When deciding on how to arrange the picture, be careful of using settings that are flat toned. Apart from offering little visual interest, a light-toned figure in a dark-toned setting will appear disconnected, almost floating in the environment.

SEE ALSO	SIMPLE SETTINGS
VIEWPOINTS 62-5	136-7
USING INTERIORS	HIGH-CONTRAST
122-5	LIGHTING 152-3

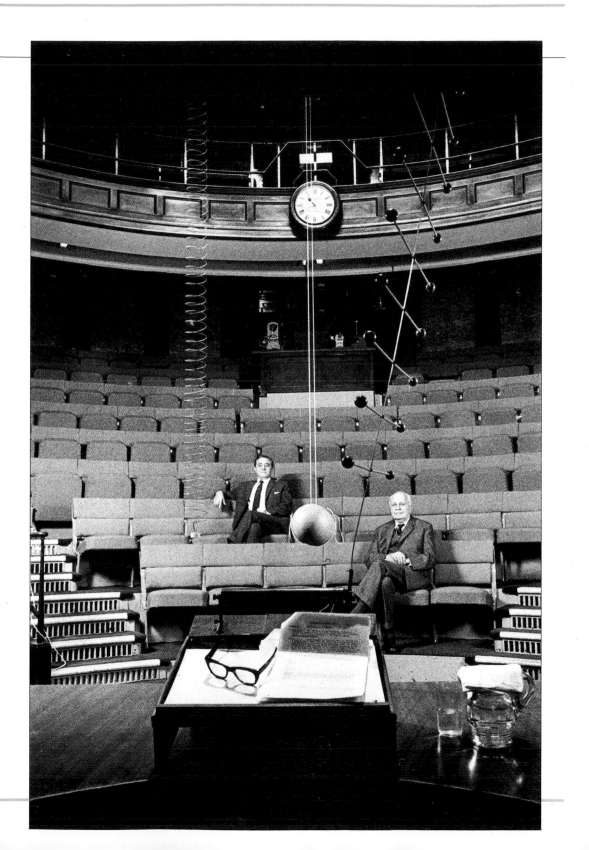

THE ROMANTIC SETTING

R omantic settings conjure a very specific mood and they often have an air of mystery about them. But the predominant quality in what is popularly regarded as 'romantic' is that of softness. This has as much to do with line and color as with lighting quality. But romantic imagery also depends on your subjects and the way they present themselves to the camera, for a hint of innocence is necessary, too.

Line and color
In general, flowing, continuous lines make for softer images. Sharp, discontinuous, or jagged lines create tension, and that is definitely to be avoided. If you are posing the shot, then think about using loose-fitting garments that will fall into sweeping folds and so accentuate body lines.

Water is often associated with romantic settings, and here you have the opportunity to use reflections — slow-moving or slightly disturbed water will produce wavy, flowing patterns, echoing and repeating the shape of your subjects.

▲ **Young innocents**
Here, I wanted to show an idyllic scene where dreams of romance, peace, and harmony prevailed. The composition gives prominence to the setting, relegating the figures to a secondary role but giving the imagination free rein to suggest the likely relationship.
□ *Hasselblad, 80 mm, Ektachrome 64, 1/125 sec, f 8*

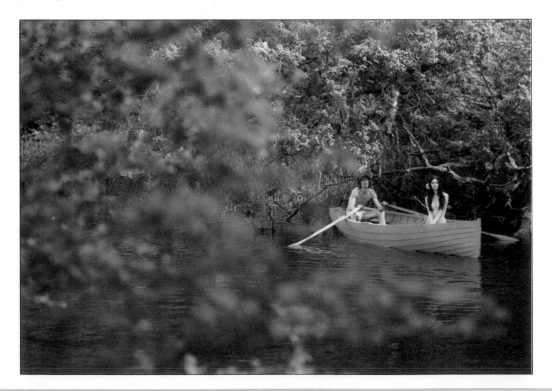

▶ Classic imagery
This shot draws heavily on classic romantic tragedy. The set was nothing more than a small, inflatable swimming pool with a few inches of water – just enough to submerge the model partially. What took most time was decorating the pond with flowers and water plants.
□ *Hasselblad, 120 mm, Ektachrome 64, 1/125 sec, f 2.8*

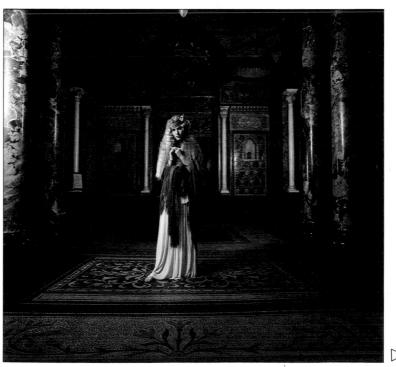

◀ Selective focus
As in the shot above, I used foliage close to the lens and out of focus in order to frame the subjects. With the highlight missing, however, the overall effect is much cooler then before.
□ *Hasselblad, 80 mm, Ektachrome 64, 1/60 sec, f 5.6*

▶ Soft lighting
If the window area is large enough, window light can produce a perfect type of illumination for romantic imagery. Here, however, I reproduced this type of effect using diffused flash.
□ *Hasselblad, 80 mm, Ektachrome 200, 1/15 sec, f 16*

▷

▼ Nostalgic scenes
I took this picture at the annual horse parade held on Regent's Park Road, London. Although a modern picture, the family posed on the back of a horse-drawn cart summons up all the romance we tend to associate with that bygone age, when the pace was more leisurely.
☐ *Pentax, 135 mm, Ilford HP5, 1/60 sec, f 8*

▶ Fairy-tale setting
What could be more romantic than having the beautiful Benedictine abbey of Mont-Saint-Michel as a background for your picture? The composition is strengthened by the pyramidal form of the man and bicycle echoing the shape of the building behind.
☐ *Pentax, 35 mm, Kodak Tri-X, 1/60 sec, f 4*

▶ Sunny days
This picture sums up
many of the elements
of romantic imagery,
both in terms of sub-
ject and setting. The
setting is private and
secluded and the
foliage almost intim-
ately close. The model
is young and, because
she appears to be un-
aware of the camera,
vulnerable, with the
fabric of her night
gown drawn tightly
across her thighs.
□ *Hasselblad, 80 mm,
Kodak Tri-X, 1/125
sec, f 11*

Colors are usually best if they harmonize rather than contrast. Try also to restrict your color palette to the lighter shades — oranges, reds, and yellows bring to mind sunny, relaxed settings; blues, cooler, more delicate, moods. Alternatively, for an added touch of fantasy, mismatch your light source or film stock, or use a colored filter, in order to produce an overall color cast in the scene.

The quality of light
Just as color contrasts should be avoided so, too, should contrasty light. Much better, and more appropriate, is the soft daylight of early morning and early evening, when there is diffuse, even illumination and often a warm glow to the air.

When the sun is high and harsh, try posing your subjects under a leafy canopy so that the light is broken and dappled. Filters can often help with contrasty light: soft-focus filters will outline your figures in a shimmering mist while leaving the center clear. Equally effective is an ordinary plain-glass filter with its edges smeared with petroleum jelly.

▲ Informal filter
I softened this hard and slightly contrasty image by holding a piece of translucent paper near the lens.
□ *Pentax, 85 mm, Ektachrome 64, 1/125 sec, f 5.6*

▶ Repeating filter
A repeating filter has helped to soften the definition of the woodland setting in this shot.
□ *Pentax, 50 mm, Ektachrome 64, 1/250 sec, f 2.8*

▶ Projecting your personality

There is nothing in the setting here or in the lighting that creates a romantic atmosphere. The shot works though because of the mood projected by the model, and the addition of a single rose.
□ *Pentax, 85 mm, Ektachrome 160T, 1/60 sec, f 2.8*

▼ Soft focus

This image of a tranquil lake-side setting has been enhanced by smearing a little petroleum jelly on a plain-glass filter. This has diffused and spread the light from the foreground foliage and the effect is very much like that of a painting.
□ *Pentax, 50 mm, Ektachrome 64, 1/125 sec, f 8*

SIMPLE SETTINGS

Although elaborate settings, if they add information about, or are relevant to, the sitter, can be used to great effect in portraiture, so too can simple ones. Here, the viewer of the photograph is not being given any extra clues, but this can be compensated for by the fact that attention will be firmly directed to the subject.

Maintaining interest

With so little to distract the viewer, you need to ensure that what is present is sufficient to warrant close scrutiny. Color itself can have great pictorial appeal, as can shape, form, and texture. But if you are working in black and white, your palette will consist of shades of gray, ranging from pure white to dense black. If rendered fully, however, they can be a visual feast.

In large interior rooms, such as the example below, in order to bring out the texture in the walls, you will have to light them separately from the subject. For the texture of stone, sidelight is best, which would not necessarily suit the subject.

The position of the camera is obviously vital to the success of your pictures. Even in a cluttered environment, adopting a high or low camera angle can help to throw your subject into sharp relief.

▶ Architectural feature
Although an extremely simple setting — an empty, stone-lined room — greater prominence is given to the subject by positioning him at one of the corners of the patterned tiled floor.
□ *Pentax, 28 mm, Kodak Tri-X, 1/8 sec, f 16*

▼ High camera angle
For this shot, I wanted the viewer to perceive the isolation of the young child selling the potatoes from an old basin. To achieve this, I stood on my camera case and so framed her against the dark-colored, plain paved floor.
□ *Pentax, 50 mm, Kodak Tri-X, 1/250 sec, f 11*

▶ Lines of perspective
Here I have used the parallel lines of the boards making up the floor and ceiling to give the picture a feeling of space. This has been further emphasized by using a wide-angle lens.
□ *Hasselblad, 60 mm, Kodak Tri-X, 1/60 sec, f 16*

SEE ALSO

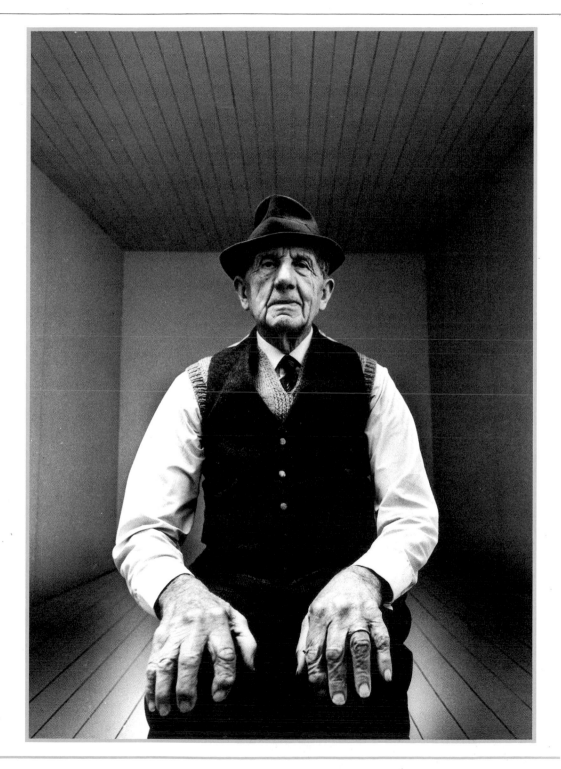

T raveling to different parts of the world and even, to a lesser extent, to different parts of your own country, sharpens your awareness of your surroundings. When you first arrive is the time to start taking pictures as it is then that you will see and notice the unfamiliar most clearly — it is surprising how quickly the foreign sights, sounds, and smells start to become commonplace.

Be prepared
Obviously when traveling you will not have access to your familiar photographic supplier, so make sure you have plenty of film. In most countries you will be able to purchase extra film, but in hot countries in particular the shelf life of photographic emulsions can be drastically shortened.

▼ Street hawker
Colorful characters such as this artist selling his work on the streets of Venice are used to being photographed. Always try for a different slant, though. In this case I made sure that only his head and feet were visible from behind the canvas.
☐ *Pentax, 28 mm, Ektachrome 64, 1/250 sec, f 8*

► Sitting pretty
Camel drivers probably make as much money posing for tourists' cameras as they do by providing a means of transport. But it is the apparently roguish grin on the camel's face that lifts this picture out of the ordinary.
☐ *Pentax, 85 mm, Ektachrome 200, 1/60 sec, f 5.6*

▼ Unusual headwear
Foreign travel often sharpens your awareness of the different and unusual, but even so it is not every day that you see a woman with a birdcage jammed on her head and a rabbit crammed inside. Bizarre portraits such as this are too good to miss.
☐ *Pentax, 135 mm, Ektachrome 64, 1/125 sec, f 16*

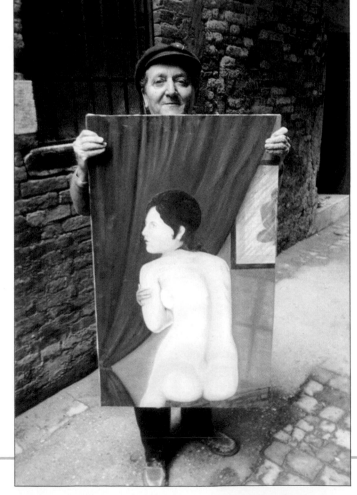

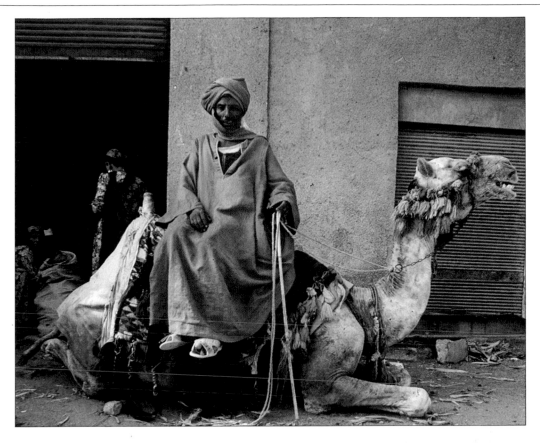

With this in mind, if possible store unused film in a refrigerator (not the freezer) but make sure you allow a few hours for it to come up to room temperature before loading it into the camera.

Compacts, apart from having limited, or no, choice of focal lengths, make ideal traveling cameras. SLR owners need to temper their desire to cover all options by considering the weight of equipment involved: certainly take a telephoto for enlarging distant scenes and figures and a wide-angle for broad panoramas showing people more in context. A single zoom lens, though, could achieve both types of shot.

▲ **Willing subject**
This Italian woman was obviously proud of her motor scooter and was pleased to pose.
□ *Pentax, 50 mm, Ektachrome 64, 1/125 sec, f 8*

SEE ALSO	54-9
THE 35 mm SLR	ON LOCATION
CAMERA 22-5	116-17
CANDID PORTRAITS	

LIGHTING
TECHNIQUES

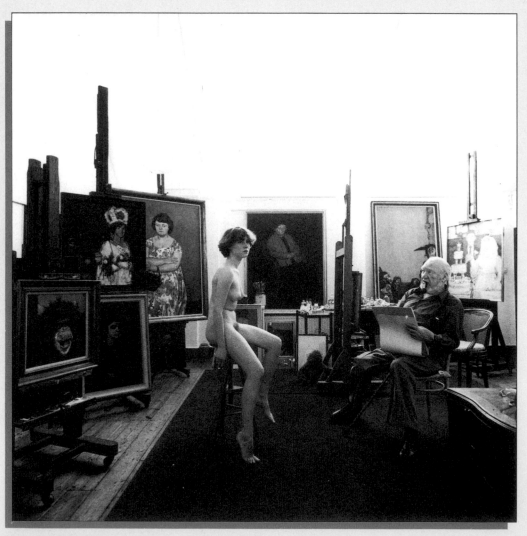

□ *Hasselblad, 60 mm, Kodak Tri-X, 1/60 sec, f 16*

□ *Hasselblad, 120 mm, Ilford HP5, 1/125 sec, f 11*

BASIC INGREDIENT

With sophisticated TTL (through-the-lens) metering systems now built into practically all types of camera, obtaining a technically correct exposure is not a particular problem. But this alone does not make for good photographs.

Interpreting and manipulating the basic ingredient of photography – light – can be likened to painting. Everybody is capable of applying color to a piece of paper or canvas, even if it is simply following an outline mass produced and printed with guidelines on where and which colors should be used, as with painting by numbers. The skill comes in blending, selecting, refining and adding those almost indefinable touches that indicate that you are in control of the medium.

▶ Beach exposure
Judging the quality and level of light in beach scenes can be difficult, since light meters tend to read the scene as being brighter than it really is.
☐ *Pentax, 85 mm, Ektachrome 64, 1/125 sec, f11*

▼ Window light
Natural light is wonderfully versatile, even when used as the sole source of light indoors, as these three pictures demonstrate. All pictures were taken with a Pentax and 50 mm lens, using Ektachrome 200 film.

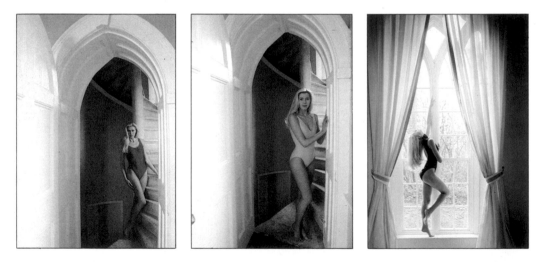

▶ Light on water
The light for this shot is particularly appealing. The pool is indoors and so light is first filtered through a glass-covered roof before being broken up into fluid patterns by the action of the moving water.
☐ *Nikon, 35 mm, Ektachrome 64, 1/125 sec, f11*

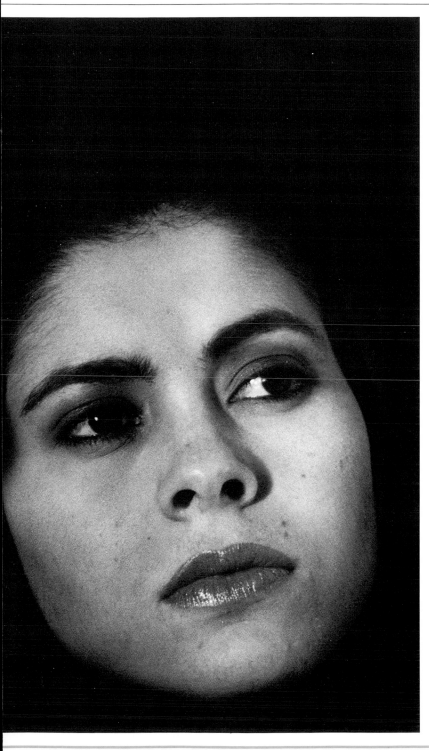

◀▲ Detailed close-up
Dramatic lighting is frequently a product of contrast — a detailed highlight in an otherwise dark or somber setting has immediate impact, as in this double portrait. But the lighting set-up could not have been simpler. All I used was a single spotlight set at about 45° to the couple, positioned so that the light glanced across the faces but left the background unlit. To soften and spread the light just a little, I placed a home-made diffuser of tissue paper in front of the light, as shown in the diagram above.
□ *Pentax, 135 mm, Kodak Tri-X, 1/30 sec, f 4*

SEE ALSO
MEDIUM-FORMAT
CAMERAS 25-6
CLOSE-UPS 68-71
STUDIO LIGHTS
AND FLASH 76-7
LIGHTING AND
EXPRESSION 80-1
SELECTIVE
LIGHTING 84-5

LOW-LIGHT PORTRAITS

Bright, well-lit portraits are revealing, descriptive, and detailed. You need to use your light source, whether the illumination is from the sun, flash, or studio lights, to create a lighting scheme that is balanced with good shadow detail.

Image contrast

The term contrast refers to the tonal difference between the lightest and darkest parts of the picture, from black to white. In extreme cases, if contrast is too high for the film to cope with, you will need to decide whether to expose for the high-lights and allow the shadows to go solid or to expose for the shadows and allow the highlights to burn out. Choice of film is important here, since certain brands are more able to hold detail in both the highlight and shadow areas than others. Buying and using many brands, under differing lighting conditions, is the only way to find out.

Portraits in low light, as with all other types of photography, are easier to achieve if you plan for them in advance. In this type of situation you really appreciate your standard lens. For most photographers, the standard lens will be the 'fastest' they own; in other words, the one with the largest aperture, usually ranging between f 2.8 and f 1.2. The difference between f 1.4 and f 1.8, for example, might not sound very great, but f 1.4 will transmit twice as much light.

In practical terms this means that, with an SLR where you use the light coming in through the lens to view the image, the image seen through an f 1.4 lens will be twice as bright on the focusing screen. Also, a wide maximum aperture gives an extremely shallow depth of field, which will throw into relief any figure that is in focus.

▶ Matchlight
This effective and evocative portrait was taken by the light of a match.
☐ *Pentax, 50 mm, Ektachrome 200 (pushed 1 stop), 1/8 sec, f 1.2*

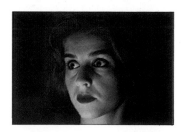

▶ Oil lamp
Because of the low-temperature oil lamp, I used tungsten-balanced film here.
☐ *Pentax, 50 mm, Scotch 640T, 1/30 sec, f 2*

▶ Fluorescent light
Because of the spectrum emitted by fluorescent light, it is nearly impossible to obtain accurate color pictures.
☐ *Pentax, 85 mm, Ektachrome 200, 1/15 sec, f 4*

Film speed
When planning low-light portraiture another consideration is film speed; the faster the film the less light it requires in order to produce an image.

Until recently, high-speed film (with ISO numbers higher than 400) produced a very coarse grain

▶ Mixed light sources
For this portrait I excluded most daylight and used a cluster of candles as the main illumination supplemented by four desk lamps, as shown in the diagram.
☐ *Pentax, 50 mm, Ektachrome 200, 1/15 sec, f 4*

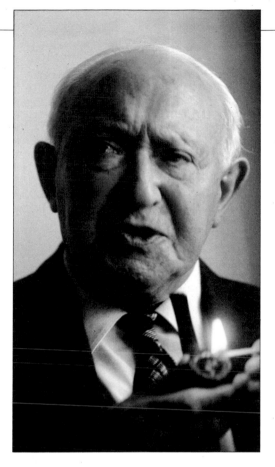

pattern. This, however, is no longer such a problem, since new films have been developed that have extreme sensitivity to light without grain being excessive.

It is also possible, even if you find yourself with too slow a film in the camera, to expose it as if it were faster. Every f stop you underexpose, or push, the film equals an effective doubling of the ISO number. You will find information on the leaflet accompanying your film explaining the degree of underexposure it will tolerate and special processing that is necessary. But any increase in development time resulting from this may increase contrast.

Color rendition
When you expose film under unusual light sources, such as candles, oil lamps, fluorescent tubes, and so on, you should not expect color results to be faithful to the original. All color film is formulated to produce particular color results under very specific types of illumination.

▶ Morning light
I took this shot of Manny Shinwell, a British Labour Party MP from 1922 to 1970, in early morning light. The match added nothing to light levels but it provided a very welcome highlight.
☐ *Pentax, 85 mm, Ektachrome 200, 1/30 sec, f 2.8*

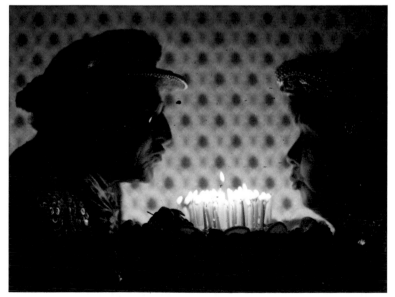

◀ Reflective surfaces
The buttons on the costumes of this Pearly King and Queen make wonderful reflective surfaces, acting as tiny beacons glowing out of the shadows.
☐ *Pentax, 50 mm, Ektachrome 200, 1/15 sec, f 2.8*

SEE ALSO
BASIC LIGHTING, 78-9
SELECTIVE LIGHTING 84-5
DRAMATIC LIGHT 144-5
HIGH-CONTRAST LIGHTING 152-3

SILHOUETTES

Silhouettes concentrate attention on form and shape for their own sake and help to destroy the illusion of reality created by photographs. Shooting silhouettes is not difficult and involves taking advantage of a situation photographers are often warned to avoid — that of high-contrast lighting. In fact, the greater the difference between the highlights and the shadows, the stronger the silhouette.

It also means breaking another 'rule': always keep the sun behind you when taking pictures. Here you need to do the exact opposite, because shooting into the light will ensure that anything positioned between the camera and the light source is rendered in outline only. Remember to take your light reading from the light source, though, and do not increase exposure to compensate for the subject. Even with fully automatic cameras, all you need do is position yourself correctly in relation to the light source and not press the backlight-compensation button before taking the picture.

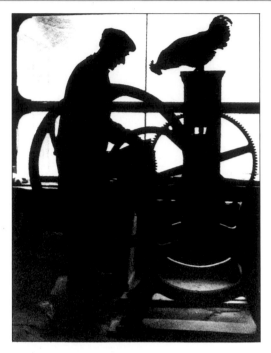

▶ Skylight
A perfectly exposed sky has thrown this girl's profile into high relief. There was, in fact, a four-stop difference between light readings taken from the sky and a close-up reading taken from the face — ample to create a silhouette.
☐ Pentax, 85 mm, Ilford HP5, 1/250 sec, f 8

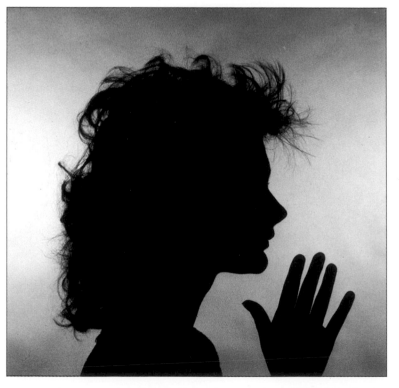

▶ High-contrast printing

More detail exists in the negative of this picture than appears here on the page. In order to strengthen the silhouette effect, I used a high-grade printing paper to remove many of the half-tones and create more of a graphic impression.
□ *Hasselblad, 120 mm, Kodak Tri-X, 1/125 sec, f 5.6*

◀ Window light

Bright daylight streaming through the workshop window has strengthened this scene, changing it into a study dominated by shape and outline only.
□ *Pentax, 50 mm, Kodak Tri-X, 1/125 sec, f 11*

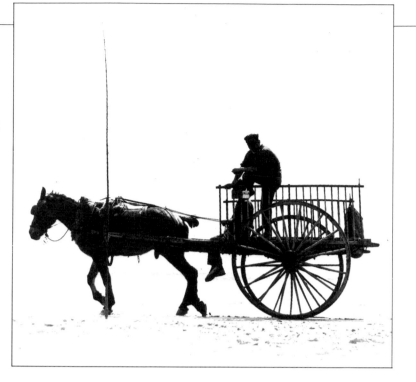

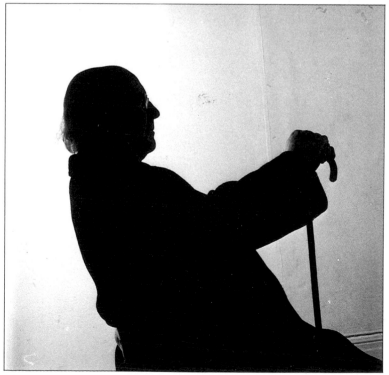

◀ Studio setting

Silhouettes in the studio do not present any problems. Set your lights so that the background only is illuminated and then take a highlight reading.
□ *Hasselblad, 80 mm, Kodak Tri-X, 1/60 sec, f 8*

SEE ALSO
SELECTIVE
LIGHTING 84-5
DRAMATIC LIGHT
144-5
LOW-LIGHT
PORTRAITS 146-7
HIGH AND LOW
KEY 156-61
THE STRENGTH OF
PATTERN 180-1

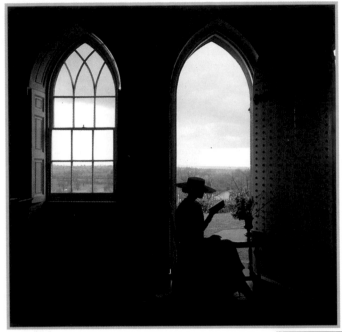

◄ **Daytime version**
All the pictures on these two
pages were taken within 10
minutes of each other. For this
one, I took an ordinary daylight
exposure reading and the
result, without artificial light
being used, was a silhouette.
□ *1/60 sec, f8 (no flash)*

▼ **The lighting set-up**
The photograph below and the
ones opposite demonstrate
the types of effect you can
achieve by progressively
underexposing the image
(according to the daylight
exposure reading) and then
compensating with fill-in flash.
For these examples I used two
studio flash units pointing
directly at the model from the
camera position, as shown in
the diagram below. For all pic-
tures I used a Hasselblad and
80 mm lens with Ektachrome 64.

Portraits taken at night or, better, dusk
often acquire an atmosphere that dis-
tinguishes them from the sort of shot pro-
duced in reasonably consistent daylight.
There is no need, however, to wait for
evening to produce this type of effect.

Determining exposure
If you are used to taking bracketed expos-
ure series for important shots, you would
have noticed that underexposure results in
a lack of subject detail, especially in
shadow areas — not the result you want at
all. In order to achieve a realistic impres-
sion of night, you need to boost the light
levels indoors where you have posed your
subject. By doing this, you can then use a
shutter speed and aperture combination
that results in underexposure of all out-
door parts of the scene not artificially lit.

Another way of creating the illusion of
night is by using tungsten-balanced film
and lighting the indoor scene with tung-
sten photolamps. Any areas of the scene
lit by daylight would then be rendered
a very deep blue, simulating that inky-
blue color seen before the blackness of
night sets in.

□ *1/60
sec, f8
(with
diffused
flash)*

☐ 1/60 sec, f 8 (with flash)

◄▼ The exposure sequence
These four photographs show how you can turn a daylight scene into a much more dramatic night-time sequence, simply by underexposing parts of the image lit by daylight and using variable-output flash to correct exposure indoors.

☐ 1/250 sec, f 16 (with flash)

☐ 1/125 sec, f 8 (with flash)

► Night-time version
The exposure difference between this shot and the one at the top of the page is equivalent to four f-stops, and now the outside scene is dark enough to pass for night.
☐ 1/500 sec, f 16 (with flash)

SEE ALSO
EXPOSURE LATITUDE 38-9
STUDIO LIGHTS AND
FLASH 76-7
SELECTIVE LIGHTING 84-5
DRAMATIC LIGHT 144-5
SILHOUETTES 148-9

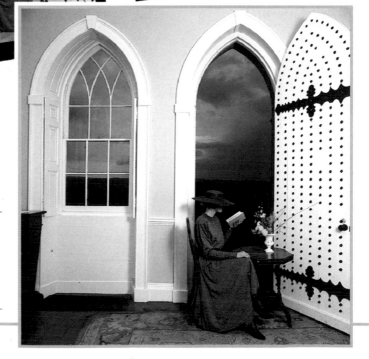

HIGH-CONTRAST LIGHTING

Knowing exactly the exposure latitude of your film (the range of tones it is capable of recording between dense black and pure white) is a matter of experience and trial and error. So, too, is the ability to recognize situations that might push your film beyond its recording capabilities. Certainly it is a good idea to experiment with different films, but once you find those that perform well in specific types of conditions, stick with them.

Shooting in high-contrast lighting, whether natural or created in the studio, is an easy way to introduce drama and interest to your pictures. If contrast is too high, and you don't want to create a full silhouette, you may have to use a weaker, supplementary light on the shadow side of your subject. If this is not possible, then a simple white cardboard reflector or length of kitchen foil will reflect back sufficient light to provide a little modeling.

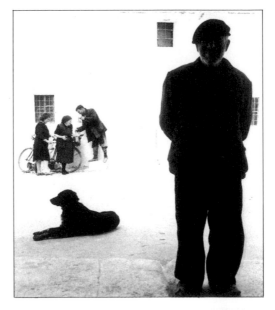

▶ Selective light reading
In situations such as this, where you cannot hold exposure for both the highlights and the shadows, you need to make a decision about which elements are most important for the shot. Here, I took a spot reading from the man's face and set the camera controls accordingly.
□ *Pentax, 50 mm, Kodak Tri-X, 1/60 sec, f 4*

SEE ALSO

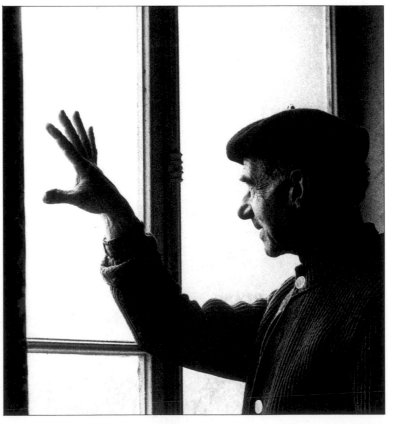

◄ Balancing tones
Although the shadowy foreground figure takes up only a small part of the frame, he balances perfectly the much larger area of sun-bleached white. The dark tones act almost like stepping stones, taking the eye progressively deeper into the picture.
☐ Pentax, 50 mm, Kodak Tri-X, 1/250 sec, f 8

▼ Royal profile
For this picture of Her Majesty Queen Elizabeth II a single floodlight was used to light the face, while a low-power spot threw just a little illumination on to the neck. To keep the background completely black, you need a good separation between it and your subject so that no reflected light can reach it.
☐ Hasselblad, 80 mm, Kodak Tri-X, 1/125 sec, f 4

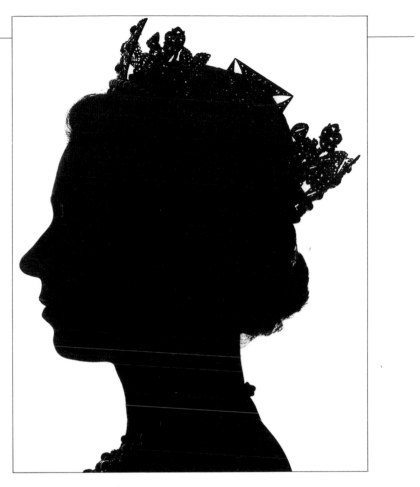

▲ Stamp of approval
This picture shows what can be achieved with a few simple studio lights. For the full silhouette, I used a plain white background paper and lit it with three floodlights to make sure the tone would be even throughout.
☐ Hasselblad, 80 mm, Kodak Tri-X, 1/125 sec, f 5.6

FLASH LIGHTING

◀ **Before and after**
For the shot far left, I took an exposure reading from the sky and set the camera controls that produced a silhouette. For the second shot, I kept the camera controls the same and used camera-mounted flash to fill in subject detail.
☐ *Pentax, 28 mm, Ektachrome 200, 1/125 sec, f 5.6*

SEE ALSO
FLASH 31
STUDIO LIGHTS AND
FLASH 76-7
SILHOUETTES 148-9

▶ **Dominant flash**
It was night when I set up this shot and the real difficulty was choosing the precise moment to press the shutter, even though I had marked a spot for sharp focus beforehand. Capturing the relevant action was still a matter of luck.
☐ *Pentax, 50 mm Ektachrome 64, x-sync, f 4*

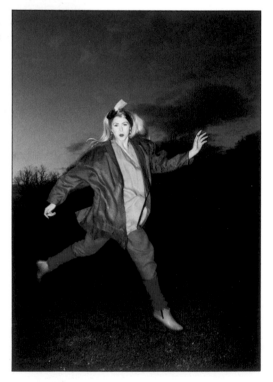

Modern electronic flash is a more versatile lighting medium than many people give it credit for. Even quite physically small units are capable of providing sufficient light to expose correctly the interior of most normal-sized rooms, taking into account the color, and therefore the reflective qualities, of the walls and ceiling. The built-in sensor will also allow you to bounce the light, off the ceiling for example, or a special flash umbrella, to produce a softer, more diffused, lighting effect, while still ensuring that there is enough light output to do the job. But instead of letting flash become the dominant source of light, you can also use it in a supplementary, or fill-in, role.

Although when using a compact or 35 mm SLR you have to set the camera's shutter speed to a specific synchronization speed (usually 1/125 sec or longer), bear in mind that it is the duration of the flash of light that determines exposure. Even with basic units, this can be as short as 1/1000 sec and, with more sophisticated ones, 1/30,000 sec.

▶ **Action stopping**
This is another shot from the series above. For this picture I asked the model to jump up and down so that her hair would really fly away. The action-stopping flash has frozen all movement.
☐ *Pentax, 85 mm, Ektachrome 200, 1/125 sec, f 5.6*

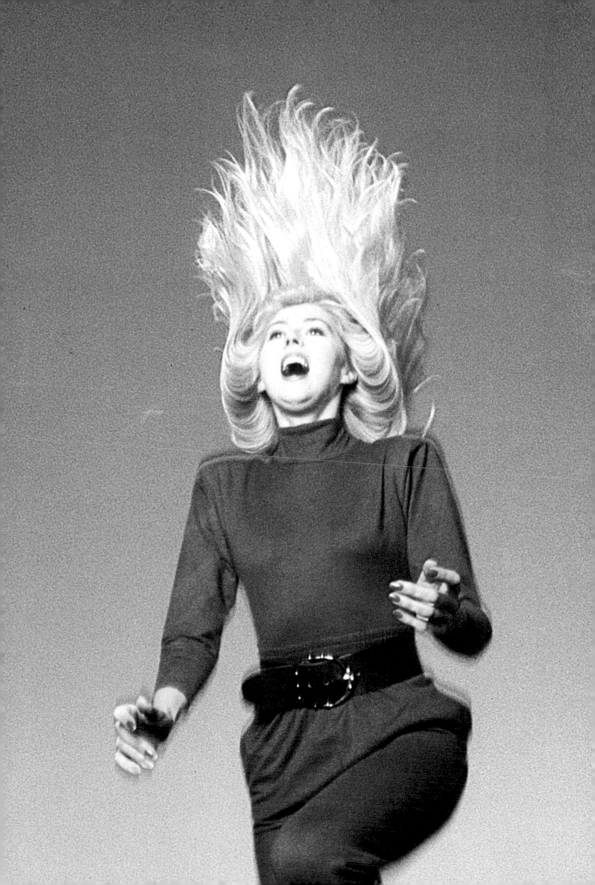

HIGH AND LOW KEY

Undeniably, tone and color affect the way we regard photographs and influence our feelings toward the people or scenes depicted. In portrait photography, an often-used technique is to restrict the tonal or color ranges contained in pictures in order to accentuate a particular atmosphere and thus manipulate the mood of the shot.

Low-key lighting
This type of lighting scheme consists of dark tones or colors. The lighting technique is often used to imply strength and masculinity, but you should take this as a guideline only, because as you can see from the picture below, it can also be used to good effect with female subjects to produce a sense of mystery.

Creating a low-key effect in the studio is simple. You can use any point source of light: candle, desk lamp, naked bulb, or the narrow beam of a spotlight, masked down even further if necessary, but not the more uncontrollable spread of light from a

▲ Available light
Often, when working indoors without artificial light, pictures tending toward low key are forced on you, as in this example.
□ *Pentax, 50 mm, Kodak Tri-X, 1/30 sec, f 4*

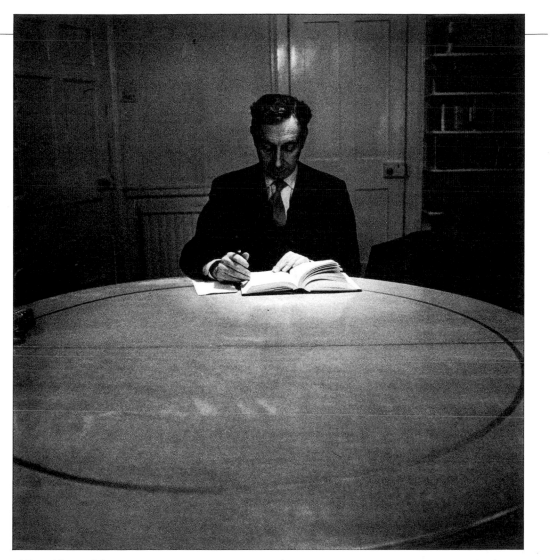

◄ Breaking with tradition

This shot goes to prove that low-key lighting can be used to good effect with either male or female subjects. I made sure that just enough of the model's face could be seen in order to intrigue and tantalize the viewer. Lighting was not difficult and was provided by an ordinary domestic table lamp held a few feet away from her face. If reflections from the setting cause you problems, then surround the model with dark cloth.
□ *Pentax, 85 mm, Ilford HP5, 1/15 sec, f 2.8*

▲ Unusual highlight

With this portrait, taken in the study of the philosopher A. J. Ayer, I did not have the option of using flash. Instead I had to rely on the ordinary tungsten-balanced room lights. Another consideration was the composition. I particularly wanted to use the large expanse of table as a foreground, which meant a small aperture to ensure an adequate depth of field. Working in my favor though, was the lighting, which reflected off the pages of the open book and threw sufficient light on to the face to give an unusual highlight.
□ *Pentax, 50 mm, Kodak Tri-X, 1/30 sec, f 8*

▷

floodlight. If the density of shadows created by these types of arrangement are not sufficient to kill most extraneous detail, then you will have to use black background paper as well.

High-key lighting

This describes an effect where you eliminate nearly all shadows and create a photograph with light tone or coloration, as in the examples shown overleaf. Usually, high-key lighting is applied to female subjects, but you can easily see in the photographs overleaf how the removal of many of the darker, contrasting tones produces a light, airy atmosphere.

To create high-key lighting in the studio you must surround your model with soft light sources, further diffused with tracing paper, so that shadows do not form. Any that do can be filled in with reflectors. Use a light or white, background paper or setting. In the less-controllable light outdoors, you need a bright, overcast day when contrast is naturally flat.

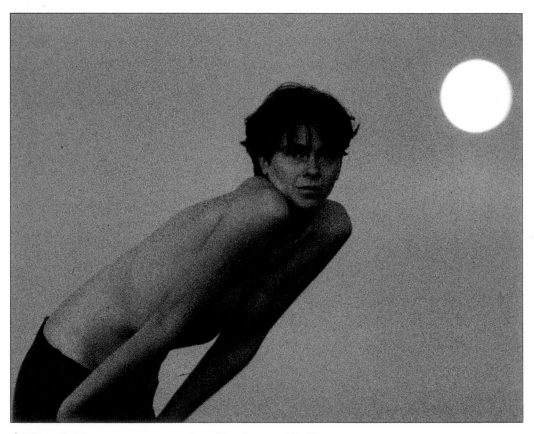

▲ **Moonlight exposure**
High- and low-key pictures are somehow less obvious in color than they are in black and white. I took this shot just after moon rise when there was still just a little light coming up over the horizon from the setting sun. This happy combina-
tion of lighting provided just sufficient illumination to fill in some subject detail. The long focal-length lens needed to bring the moon up in size meant that I had to use a tripod.
□ *Pentax, 250 mm, Ekta-chrome 200, 1/30 sec, f 16*

▼▶ Twilight exposures

Striking images result at twilight. In the shot below, the difference in light levels between a sky reading and one for the shadow side of the figure resulted in a complete silhouette. For the version right, the sun was much lower and, although there was less light, contrast was also reduced.

☐ *Right: Pentax, 85 mm, Ektachrome 200, 1/125 sec, f 5.6*
☐ *Below: Pentax, 85 mm, Ektachrome 200, 1/30 sec, f 5.6*

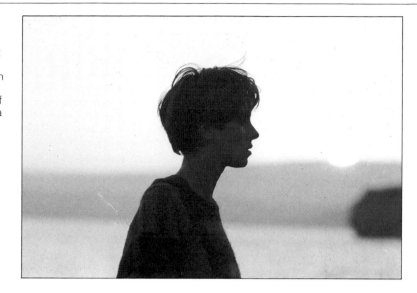

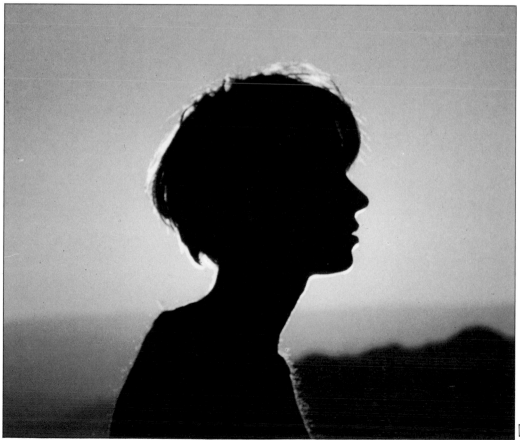

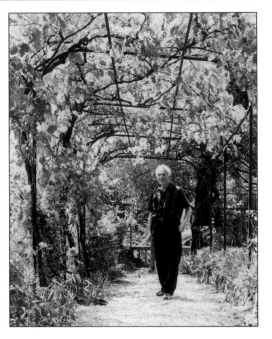

▶ Dappled light
Take advantage of natural conditions in order to create high-key effects. Here, in this picture of the painter Marc Chagall, bright sunlight filtering through the foliage and reflecting back from the pathway helped spread and diffuse a soft light into many of the near shadow areas.
□ *Pentax, 50 mm, Kodak Tri-X, 1/125 sec, f 8*

▼ Appropriate background
For this photograph of the painter William Scott, I used the strong sunlight to produce a light, airy high-key effect. Light reflecting back from the wall behind, and the light-toned shirt worn by the subject ensured that very little shadow was left unfilled.
□ *Pentax, 85 mm, Kodak Tri-X, 1/250 sec, f 16*

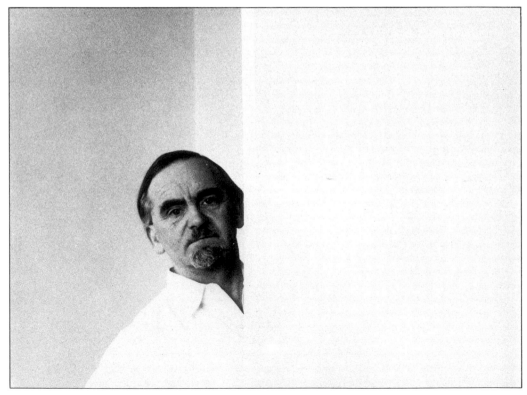

▲ Misty conditions

Obtaining the correct exposure is always tricky in misty light conditions, since the meter tends to 'see' more light than there really is, so bracketing shots is a good idea. Another feature of mist is that it spreads light and therefore reduces contrast – ideal for a high-key effect. These conditions were perfect for this milkman delivering from a hand cart, taken in the 1950s.

□ *Hasselblad, 150 mm, Kodak Tri-X, 1/60 sec, f 5.6*

SEE ALSO
EXPOSURE LATITUDE 38-9
THE STUDIO 74-5
BASIC LIGHTING 78-9
HIGH-CONTRAST
LIGHTING 152-3

DEVELOPING
A STYLE

☐ Pentax, 50 mm, Kodak
Tri-X, 1/125 sec, f 8

☐ Rolleiflex, Kodak Tri-X, 1/60
sec, f 11

☐ Nikon, 50 mm, Kodak Tri-X,
1/60 sec, f 8

□ Pentax, 35 mm, Kodak
Tri-X, 1/60 sec, f 5.6

□ Pentax, 35 mm, Kodak
Tri-X, 1/60 sec, f 8

□ Hasselblad, 80 mm, Ilford
HP5, 1/60 sec, f 11

IMPLIED RELATIONSHIPS

Proximity, or even a chance visual alignment, is often enough to imply a relationship between people. More often, though, expression and physical attitude are our guidelines, and to capture these requires alertness and quick reflexes.

Look at the pictures on these two pages and it is possible to see that in each case the shutter has been pressed at just a significant moment. Each one encapsulates a relationship, which might have existed only for a few brief moments, but is nevertheless wonderful material for the camera. It is worth noting, too, that at least one of each couple was conscious of the camera and this fact has added to the expressiveness of the images.

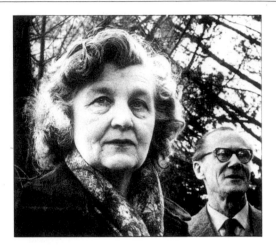

▲ Passers-by
Simply by including two people in the same shot you can imply that a relationship of some sort exists between them. In this picture of Elspeth and Gervase Huxley, neither one is reacting at all to the presence of the other. The only thing linking them are the edges of the frame, yet the connection is undeniable, even to an outsider.
□ *Pentax, 135 mm, Kodak Tri-X, 1/250 sec, f 8*

▲ Pulling a crowd
People have different reactions to the camera. These old actors were very pleased to pose when they saw me photographing somebody else. In fact, they would not let me go until I had snapped them.
□ *Nikon, 135 mm, Ilford HP5, 1/250 sec, f 5.6*

► Contrasting characters
The camera is marvellous for revealing facial expressions that would otherwise be too fleeting to register. Here, the contrast between the animated expression of Otto Preminger and the passive expression of his wife creates a fascinating image.
□ *Pentax, 35 mm, Kodak Tri-X, 1/60 sec, f 4*

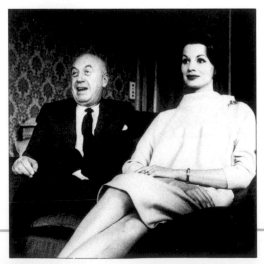

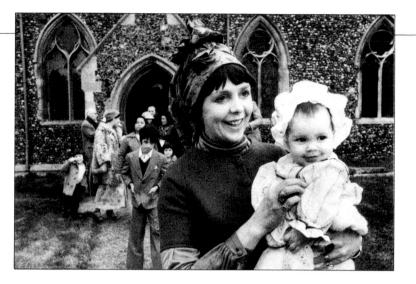

▶ Prominent position

Ensuring that the mother and child took up the prominent fore-ground position emphasized the Christening that had just taken place. It is assumed that the others leaving the church are connected in a very direct way.
☐ *Pentax, 50 mm, Ilford HP5, 1/125 sec, f 11*

▶ Music teacher

Photographs like this can become treasured family possessions. Here, the piano teacher cups a hand over her ear, listening in minute detail as her young pupil struggles to master the complexity of the keyboard. Window light, diffused through net curtains, gives a gentle illumination.
☐ *Nikon, 50 mm, Kodak Tri-X, 1/60 sec, f 8*

SEE ALSO
MOOD AND EXPRESSION 46-51
CANDID PORTRAITS 54-9
VIEWPOINTS 62-5

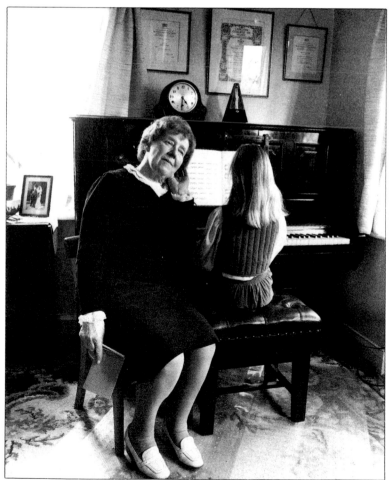

CLOSE RELATIONSHIPS

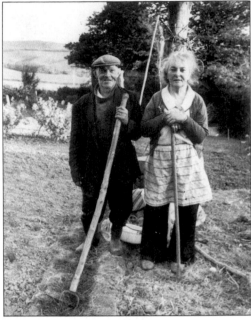

▲ Flash and tungsten
For this shot I bounced flash off the side wall to light the boy's face and used ordinary domestic tungsten light to the right of his mother.
□ *Pentax, 35 mm, Kodak Tri-X, x-sync, f 4*

▼▶ Flash and daylight
I relied on daylight from behind the farmer to illuminate him and that part of the room and used diffused flash to light the woman and the center of the room, as shown below.
□ *Pentax, 50 mm, Kodak Tri-X, x-sync, f 11*

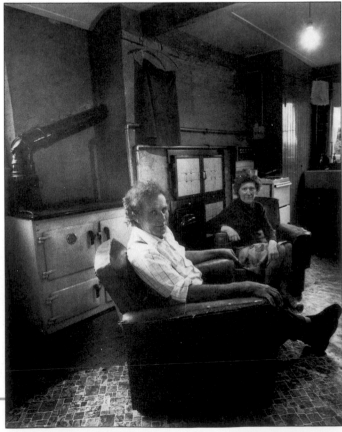

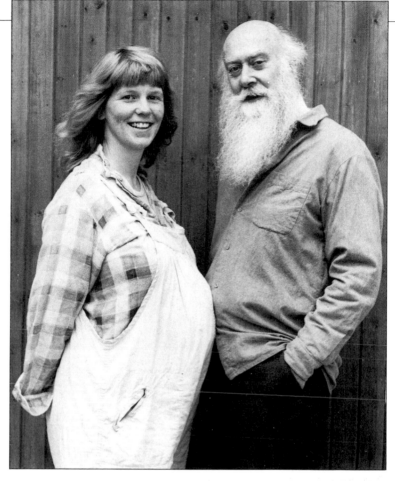

◄ Farm setting
Appearing almost shrunken by a life of manual labor, this farm worker and his wife had been on the land for more than 45 years. The bond between them is powerful — both have shared the same struggle and developed a unity often missing from relationships in a softer environment.
□ *Pentax, 85 mm, Kodak Tri-X, 1/125 sec, f 5.6*

► Swelling with pride
The disparity in the ages of this couple obviously makes no difference to the closeness of their relationship — their sparkling eyes and easy smiles say it all. They even seem to have adopted a similar shape.
□ *Pentax, 85 mm, Ilford HP5, 1/250 sec, f 8*

► Strong contrasts
The relationship between these two girls has been implied by using tone of a similar density to link them. Photofloods have cast dense facial shadows, which heighten the effect.
□ *Hasselblad, 80 mm, Kodak Tri-X, 1/60 sec, f 11*

SEE ALSO
STUDIO LIGHTS
AND FLASH 76-7
BASIC LIGHTING
78-9

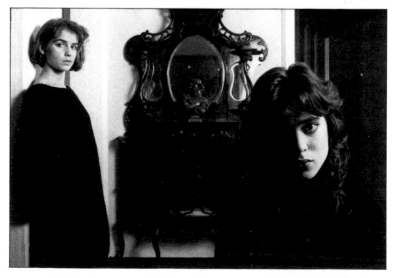

A SENSE OF SCALE

All too often, the reaction of people on seeing their latest photographs is that they do not portray the scene they remembered. Human eyesight is selective: it is capable of increasing the apparent size and importance of elements it concentrates on and decreasing those that it considers less so. The camera lens is also capable of changing the scale of objects it records, but in a far less discriminatory manner, perhaps giving importance to objects you hardly noticed at the time.

Manipulating scale

A person does not need to loom large in a photograph in order to acquire importance, as you can see in the photograph below, where a figure occupying a relatively small area of the frame is able to hold his own against the grandeur of a towering, marble fireplace. The apparent scale of any object is affected by many things, including framing, strength of tone, color contrast or harmony, camera position, and the lens.

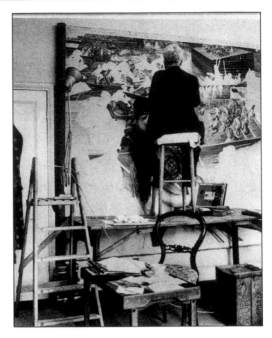

▲ Precarious perch
To indicate the size of the canvas, and thereby give a sense of scale, I moved back from the subject as far as possible and used a wide-angle lens. This way, I could show the setting and the arrangement of supports needed to give access to the picture.
□ *Pentax, 35 mm, Kodak Tri-X, 1/60 sec, f 8*

◄ Overwhelming proportions
Tonal contrast in this picture of Lord Howard, shot in the hallway of Castle Howard, helps prevent the figure becoming absorbed against the massive fireplace behind.
□ *Hasselblad, 60 mm, Ilford HP5, 1/5 sec, f 16*

▲ Camera angle
Wanting to emphasize
the towering presence
of the statues, I used
the cleaner as an indi-
cator of scale and
human life amongst all
the stone. If you can
introduce humor, so
much the better.
□ *Pentax, 28 mm, Il-
ford HP5, 1/30 sec,
f 11*

A useful exercise is to look back through
your stock of photographs and take note
of why certain parts of compositions seem
dominant. Perhaps it is because you have
included a small area of strongly contrast-
ing color or tone or because you have
positioned your subject in a strategically
important part of the frame. It could be
that you have brought a figure forward in
the frame by using a telephoto lens or
caused distracting or secondary elements
to recede by the use of a wide-angle.

SEE ALSO
VIEWPOINTS 62-5
USING INTERIORS
122-5
DOMINANT
SETTING 126-9
USING WIDE-
ANGLE LENSES
182-3
CREATING A FOCAL
POINT 206-7

PROPS

There is no good reason to feel that portraits need to be shots of figures in isolation. If you can help your subjects to relax, or reveal something about them as people, by allowing them to pose in certain settings or use other props, such as newspapers, musical instruments and so on, then so much the better. Photographs that pose questions for the viewer are far more likely to sustain interest for longer than completely straight portraits. Bear in mind, though, that the prop should act in a subsidiary role only, and not deflect attention too strongly from the subjects of the photographs themselves.

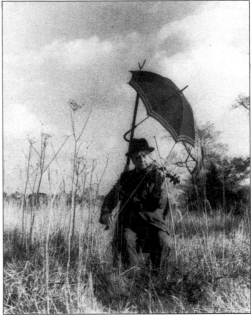

◄ Masthead
For this portrait of former *Tribune* editor Dingle Foot, I had him pose with the left-of-center paper he was associated with.
☐ *Hasselblad, 80 mm, Kodak Tri-X, 1/30 sec, f 8*

▲ Unusual venue
This retired musician still practiced every day, but in the garden so that his wife could clean their small cottage.
☐ *Pentax, 85 mm, Kodak Tri-X, 1/125 sec, f 11*

► Set on a pedestal
For this shot of Henry Moore, I placed him on a pedestal instead of one of his sculptures. Although I took this picture as a joke, the Henry Moore Foundation used it on a poster for an exhibition.
☐ *Hasselblad, 60 mm, Kodak Tri-X, 1/60 sec, f 4*

▲ Appropriate background
This gentleman kept many of his fellow passengers amused on a Thames riverboat with his anecdotes. I tried to capture his lively and extrovert personality as well as the imposing river background, with Tower Bridge strad-dling the river.
□ *Rolleiflex, Kodak Tri-X, 1/125 sec, f16*

SEE ALSO
TYPES OF APPROACH 42-3
MOOD AND EXPRESSION 46-51
REVEALING
CHARACTER 52-3
USING SHAPE 66-7
USING EXTERIORS 118-21
USING INTERIORS 122-5

USING GRAIN

What is commonly described as grain is, in fact, the visible impression after the development process has taken place of the light-sensitive silver halide crystals that comprise the film emulsion. Film speed (its sensitivity to light) is dependent on the type of crystals present – the larger the crystals and the more densely packed they are in the emulsion, the more sensitive, or faster, is the film.

Because grain can be seen only after the image has been developed, the apparent graininess of the film is directly dependent on the degree of enlargement, either as a print or when projected as a transparency. Advances by film manufacturers in the last few years have resulted in modern emulsions consisting of specially grown crystals that, although extremely sensitive to light, are of a very regular and interlocking shape, which is not particularly visible when enlarged.

An important point to bear in mind is that the appearance of grain lessens image definition, so finer-grain films generally produce sharper subject details. Sometimes, though, you may want to use the graininess of certain films in order to create a more impressionistic, even abstract image, as with the two photographs here. Even if you have a low-ISO, fine-grain film in your camera, you can still emphasize grain by using special grain-enhancing film developers.

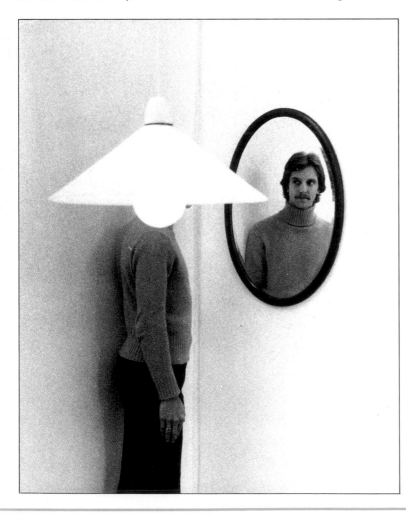

◄ Texture through grain
Grain effects are strongest in opened-out shadow areas of the image. Under-expose by one stop and then increase development time to compensate.
☐ *Pentax, 50 mm, Kodak Tri-X, 1/30 sec, f 11*

► Grain and blur
An image that evokes feelings of joy and exhilaration has been created through movement, which blurs subject details, and grain, which further softens outlines.
☐ *Pentax, 85 mm, Kodak Tri-X, 1/30 sec, f 4*

SEE ALSO
MOVEMENT 176-7
REFLECTIONS 196-7
POST-CAMERA
TECHNIQUES
212-13

Apart from vacations and other special family occasions, children are probably one of the most photographed subjects. All parents would regret not having a pictorial record of their children as they grow up and, because development is rapid, especially in the first few years, many pictures are likely to be taken.

Older children are fast on their feet, subject to rapid changes of mood and attitude, and, in most cases, quite prepared to forget about the camera and simply get on with whatever it is they are doing. As a

▲ Fleeting expression
Your reflexes need to be quick with children. The grim-faced determination evident on the face of this junior 'outlaw' lasted only a few seconds before he was off and running after his friends again. Owners of compacts or automatic SLRs have a real advantage in this type of situation.
☐ *Pentax, 85 mm, Kodak Tri-X, 1/125 sec, f4*

◀▲ Moving round the subject
The environment of this reed-fringed pond is like an adventure playground for children. The shot on the left is important because it shows the viewer something of the setting but, from a portrait point of view, not enough of the children themselves. The shot above is better from this aspect, and the figures make an excellent composition.
☐ *Above: Pentax, 85 mm, Kodak Tri-X, 1/60 sec, f8*
☐ *Left: Pentax, 50 mm, Kodak Tri-X, 1/125 sec, f8*

▲ Powerful setting
Strong vertical, diagonal and horizontal lines and the stark contrast between the burnt wood and snow, frame perfectly the rounded forms of the horse and rider.
☐ *Rolleiflex, Kodak Tri-X, 1/125 sec, f11*

result, they make excellent material for photography. But, as with taking portraits of any type of subject, your work will have additional impact if it contains more than a simple likeness. Composition, background, tonal contrasts, color combinations, environment, and so on, are all factors you need to take into account. Do not, however, let technique get in the way. Often it is better to have the record picture than none at all.

SEE ALSO
CANDID PORTRAITS
54-9
VIEWPOINTS 62-5
USING EXTERIORS
118-21
MOVEMENT 176-7

MOVEMENT

With most modern cameras, stopping, or freezing, the motion of cars, running figures or pieces of machinery is no problem — on 35 mm SLRs, for example, it is not unusual to find a shutter speed of 1/2000 sec. Often, though, you can add dramatically to the impact of a photograph by choosing a shutter speed that does record some movement.

Recording movement works best on light-toned subjects or when there are strong highlights in the picture: these tend to spread and 'eat into' darker, shadowy areas of the scene. Another way to record motion is to move in parallel with, for example, a figure on a roundabout, as in the example opposite, and use a shutter speed that blurs the stationary background while recording a relatively clear picture of the subject.

◀▲ Angle of view
These two pictures demonstrate that the angle of the camera in relation to the direction of travel of the moving figure or object is important to the way it is recorded. Both shots were taken at a shutter speed of 1/125 sec, but in the version above I stood so that the hand-cranked spindles were moving directly toward and away from me as they spun. The result is that they appear motionless. In the version left, spindles being turned at about the same speed were moving across the field of view of the camera and they have recorded as a continuous blur.
□ *Both: Pentax, 50 mm, Kodak Tri-X, 1/125 sec, f8*

SEE ALSO
PEOPLE AT WORK 104-5
DRAMATIC LIGHT 144-5
LOW-LIGHT PORTRAITS
146-7
THE STRENGTH OF
PATTERN 180-1

▶ Cartwheels

To have frozen the movement of this figure would have been easy, but unattractive and also unnatural. The hint of movement adds vitality.
□ *Nikon, 50 mm, Ilford HP5, 1/125 sec, f 8*

▼ Roundabout

With this shot, I chose a shutter speed that allowed me to record enough of the figure while blurring all the surrounding lights.
□ *Pentax, 50 mm, Kodak Tri-X, 1/30 sec, f 4*

CARS

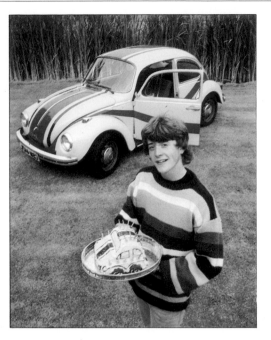

▶ **Special occasion**
A much-loved VW 'Beetle' and the boy's color-coordinated jumper were the inspirations for the celebratory birthday cake, and the picture.
□ *Pentax, 35 mm, Ektachrome 64, 1/125 sec, f 11*

▼ **Unusual cropping**
The cropping of this photograph emphasizes the sleekness of the car. The implied power of the machine has been stressed by the model thrusting herself back in the seat, simulating the effects of speed.
□ *Pentax 50 mm, Ektachrome 200, 1/60 sec, f 5.6*

▶ **Camera angle**
I deliberately chose a high camera angle and a wide-angle lens for this shot to allow me to highlight the middle ground, where the owner had parked her new car.
□ *Pentax, 28 mm, Ektachrome 200, 1/250 sec, f 16*

SEE ALSO
FRAMING HEADS
60-1
VIEWPOINTS 62-5
PRIDE OF
POSSESSION 100-1
USING EXTERIORS
118-21
PROPS 170-1
USING WIDE-
ANGLE LENSES
182-3

THE STRENGTH OF PATTERN

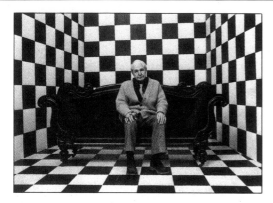

◄ **Geometric pattern**
Here, stark, powerful, repeating pattern has a disturbing and confusing effect on perspective. You will need to make sure that your subject's character is not totally submerged and lost in a set such as this.
☐ *Hasselblad, 80 mm, Kodak Tri-X, 1/60 sec, f 16*

▼ **Random pattern**
The strength of this shot comes from the randomness of the pattern created by the faces. The eye jumps from face to face looking for a sense of order and, finding none, moves on to the next. Every pair of eyes seems to compete for attention.
☐ *Pentax, 135 mm, Kodak Tri-X, 1/250 sec, f 11*

The challenge is always for the photographer to endeavor to find a new approach to portraiture. To produce a varied and interesting portfolio is an exciting prospect and, potentially, a very rewarding one.

Taking photographs that show people relating to their environment or to other people is one way to communicate more. This approach broadens the scope of your work tremendously, informs the viewer about your subjects' backgrounds, and allows you to introduce other vital elements into your work, such as perspective, framing, atmosphere, and, very importantly, pattern.

▲ **Symmetry and pattern**
This shot has been framed to highlight the symmetry of the setting — regular blocks of hedges flanking a perfect sward of grass, which draws the eye to the middle of the house, creating great depth and perspective.
☐ *Hasselblad, 60 mm, Kodak Tri-X, 1/125 sec, f 11*

SEE ALSO
OTHER LENSES 37
FRAMING HEADS 60-1
USING SHAPE 66-7

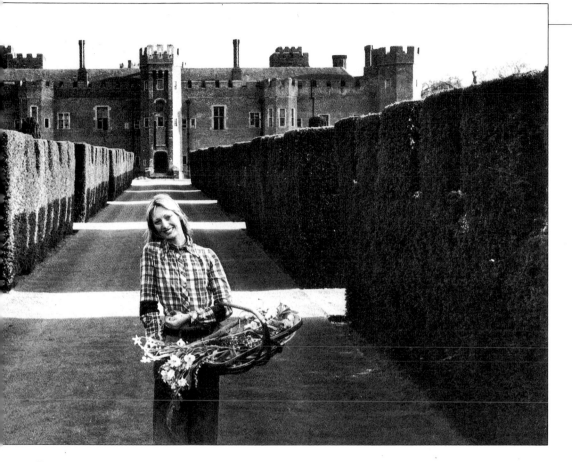

Perspective can have a great effect on the way pattern is perceived and, where possible, adjust framing to include naturally occurring examples: regular patches of sunlight seen through the repeating shapes of a hedge-lined pathway, or the repetitive element in a collection of faces. Pattern can be created, too: the perspective-flattening, geometric pattern of alternating black and white squares surrounding on all sides, incongruously, the late Henry Moore, a man whose life's work revolved around the creation in stone of flowing, sensuous shapes.

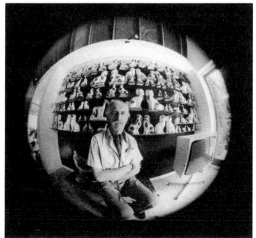

▶ **Repeating pattern**

The sense of pattern in this picture has been strengthened by the use of a fisheye lens, which produces a completely circular image and so seems to confine the various elements within the frame.

☐ *Pentax, 16 mm fisheye, Kodak Tri-X, 1/250 sec, f 2.8*

USING WIDE-ANGLE LENSES

Used indoors or outdoors, the wide-angle lens can be invaluable. It is easy to see the more obvious optical characteristics wide-angles display, such as converging verticals when the lens is pointed up at a subject. However, there is also something less tangible — a subtle shifting of perspective resulting in objects within the frame having apparently different relationships to each other.

One of the benefits of working with an SLR is that you can preview on the focusing screen exactly how the image will finally appear. Use this facility by directing your subjects to pose in different areas covered by the lens.

▲ Isolating the subject
This small room was not much longer than the bed the girl is sitting on, yet the picture manages to convey the dowdy starkness of the setting.
☐ *Hasselblad, 60 mm, Ektachrome 64, 1/60 sec, f 8*

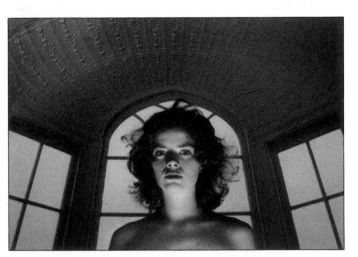

◄ Converging verticals
The relative sizes of the girl and windows were vital here. A low camera angle with the lens pointing upward, making the windows appear to converge, brought the elements together perfectly.
☐ *Pentax, 28 mm, Ektachrome 200, 1/30 sec, f 4*

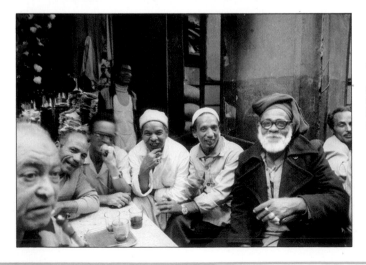

◄ Crowd scenes
Light levels were low here, yet I needed a small aperture and moving farther back from the group was not possible. With no option left, I used a shutter speed that resulted in some subject movement.
☐ *Pentax, 28 mm, Ektachrome 64, 1/15 sec, f 8*

► Depth of field
Notice that although the man's grasping hand is only inches from the lens, it is acceptably sharp. Sharpness improves rapidly as you follow the line of his arm into the frame.
☐ *Hasselblad, 50 mm, Ektachrome 64, 1/60 sec, f 16*

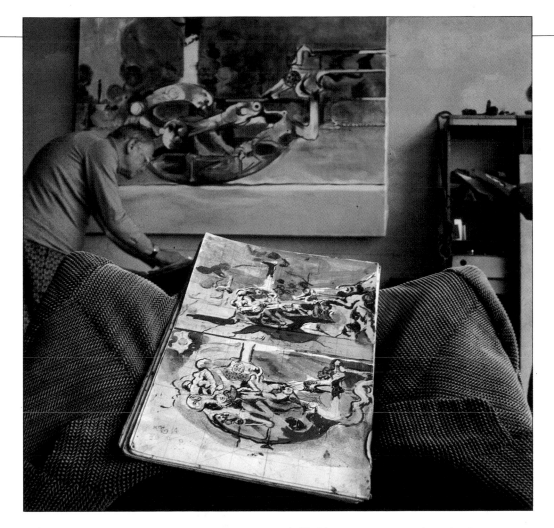

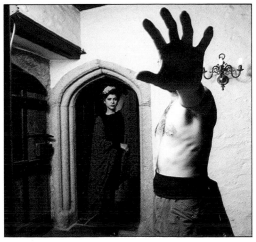

▲ Making relationships

Part of portraiture is showing something of your subject's life — interests or work, for example. Here, use of a wide-angle lens has drawn a powerful relationship between the artist Graham Sutherland and his paintings. It also conveys his method of working, progressing from colored sketches through to canvas.
□ *Hasselblad, 60 mm, Ektachrome 64, 1/60 sec, f 5.6*

SEE ALSO
THE 35 mm SLR
CAMERA 22-4
THE WIDE-ANGLE
LENS 35
EXPOSURE
LATITUDE 38-9

DETAIL IN PORTRAITS

There are good reasons to include isolated parts of your subjects' bodies as an element of portrait photography; after all, not all pictures need to be instantly recognizable as a particular person in a specific setting.

When you start to explore parts of the body other than the face or full figure, you will find that the hands are usually the most revealing of character and personality. They can inform you at a glance whether the sitter has used his or her hands in some sort of manual occupation, for example, or whether they have led an entirely different sort of life. Even commissioned portraiture can be more imaginative than the usual head-and-shoulders.

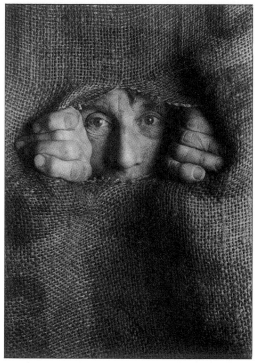

▼ Informal attitude
I did not direct the model for this shot, but in order to record the delicate skin texture I used three reflected floodlights.
□ *Hasselblad, 150 mm, Ilford HP5, 1/60 sec, f 5.6*

▶ Hands as frames
Isolated parts of the body can be startling, as in this shot of hands pulling back the edges of a sack to allow a face to peer out.
□ *Hasselblad, 120 mm, Kodak Tri-X, 1/125 sec, f 2.8*

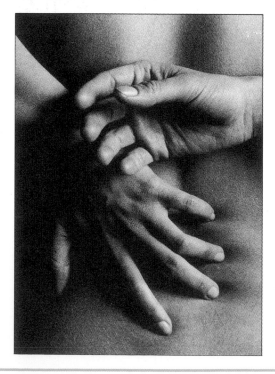

Looking at detail

Once you have accepted the idea that portraits can be pictures of the body other than the face and that you will concentrate your attention on your subjects' hands, look at people when they are in conversation, at work, or involved in some other activity. The thing that immediately strikes you is that hands are very seldom still. They are constantly on the move, fingers stabbing the air to emphasize a point, palms spread upward to invite a response, or grasping, gripping or finely adjusting some tool or piece of machinery. Even in repose, hands form beautiful shapes and at such times are particularly expressive of mood.

Focus closer on the hands and even more of the personality can be deduced. There are hands twisted and lined with the passing years that make the viewer of the photograph long to see their owner's face; hands soft and rounded, still not fully formed; hands perfect in their presentation; and hands used as vehicles for displaying ornamentation and revealing status.

▶ **Insight**
For this photograph of Henry Moore, I wanted his hands to say something about him and his work. I thought that his entwined fingers were reminiscent of the types of sculptures he produced.
□ *Hasselblad, 150 mm, Ilford HP5, 1/60 sec, f 4*

▼ **Window light**
Daylight from the left provided superb modeling for these wrinkled, calloused hands.
□ *Pentax, 85 mm, Kodak Tri-X, 1/125 sec, f 5.6*

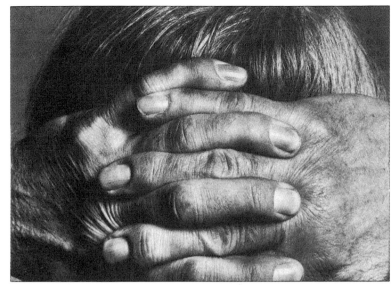

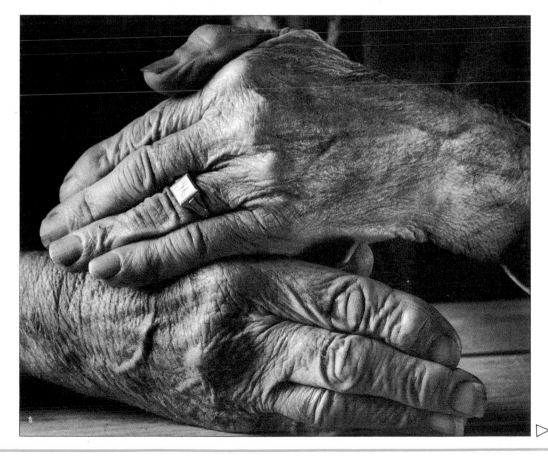

▲ Showcase

When using hands as a show-case for a client's products, such as a range of jewelry and other accessories, then you must ensure that presentation is superb. The condition of the model's skin and nails must be faultless — the camera lens is far more critical than normal vision. For these two pictures I used diffused flood-lights either side of the hands to minimize reflections.

□ *Hasselblad, 80 mm, Kodak Tri-X, 1/60 sec, f 8*

▼ The passing years

The hand of an old man gently cradles a photograph of him-self taken nearly 90 years before. Pictures such as this are priceless.

□ *Pentax, 135 mm, Kodak Tri-X, 1/60 sec, f 4*

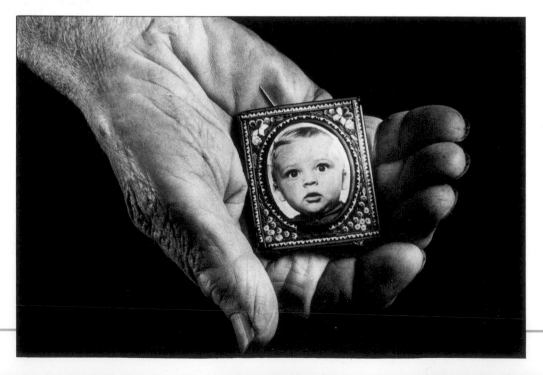

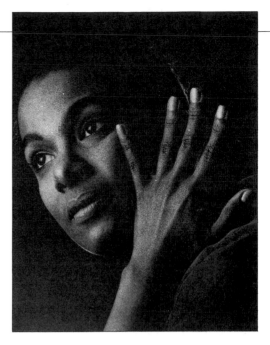

▼ Focusing attention
For the British sculptor Henry Moore, the significance of showing the hands in a portrait is more obvious, since it is the hands that are the focus of creative output. It is also a characteristic since he used his hands this way to view his work.
□ *Hasselblad, 60 mm, Ilford HP5, 1/125 sec, f 8*

▶ Balanced composition
Do not concentrate on one aspect of a picture to the detriment of the rest. Here, the tilt of the model's head required her hand in shot to give the composition balance. The tension is such, the sides of the frame seem barely able to contain the two elements.
□ *Pentax, 80 mm, Ilford HP5, 1/30 sec, f 4*

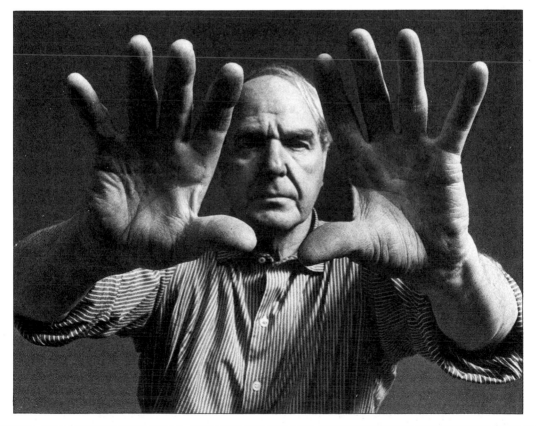

LEGS AND FEET

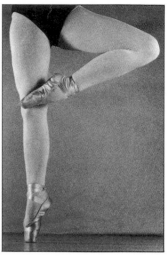

▲ Formal beauty
For this series of pictures, I wanted a completely neutral setting so that nothing would detract from the grace and beauty of the ballerina's legs. Plain gray background paper, one floodlight, and a series of white card-board reflectors were sufficient to create a formal composition where there was just enough shadow to provide essential modeling.
□ *All pictures above: Pentax, 85 mm, Kodak Tri-X, 1/125 sec, f 5.6*

▼ Manipulating attention
Posing the model on flagstones emphasizes her nakedness. A carefully placed spotlight then produces an unexpected highlight.
□ *Pentax, 50 mm, Kodak Tri-X, 1/60 sec, f 8*

► Focusing on feet
Seen in isolation, feet take on an almost abstract, sculptural quality. Lighting for this shot was simple window light from the right.
□ *Pentax, 135 mm, Kodak Tri-X, 1/125, f 4*

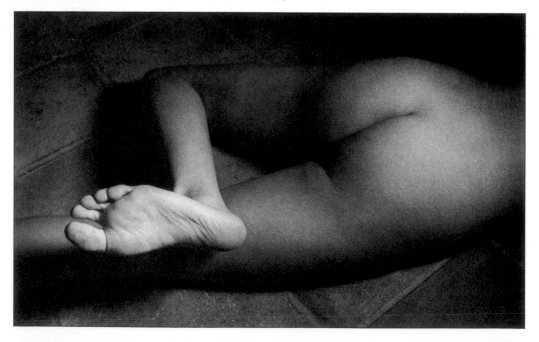

LIP GLOSS

▼▶ Faultless presentation

Close-ups of parts of the face, such as lips, do benefit from special lighting — usually a soft, directional light is best. You can get round the problem of not having a long-focus lens by selectively cropping the image, but use a fine-grain film for best results. But what will let your work down is if the model's make-up is not faultlessly applied. Defining the edge of the lips with a slightly darker shade helps, as does a coat of protective lip gloss afterwards.

▲□ *Pentax, 85 mm, Ektachrome 160T (lit by a diffused spotlight), 1/125 sec, f 4*

◀□ *Pentax, 100 mm (image cropped), Ektachrome 64 (lit by daylight), 1/250 sec, f 8*

◀□ *Nikon, 135 mm, Ektachrome 200 (lit by bounced studio flash), x-sync, f 8*

▲□ Nikon, 135 mm (image cropped), Ektachrome 160T (lit by red-filtered floodlight). 1/60 sec, f 5.6

▶ Full face

Even when you include the full face, you still invite the viewer of the photograph to explore it in minute detail, so make sure make-up, if used, is perfectly applied.
□ Pentax, 85 mm, Ektachrome 160T, 1/125 sec, f 11

SEE ALSO

FRAMING HEADS 60-1
DETAIL IN PORTRAITS 184-7
LEGS AND FEET 188-9
HATS 192-5

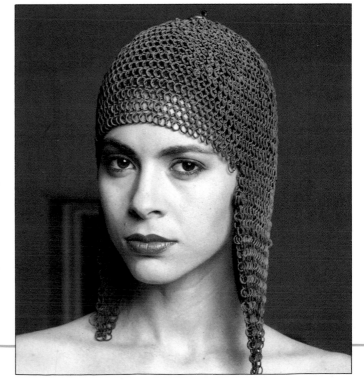

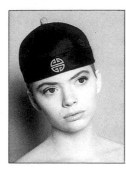
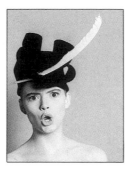

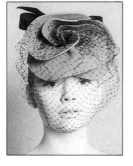

In portrait photography, a minor thing such as selecting a hat for your model to wear can be great fun. Using props like this represents just one of the techniques you can employ in order to develop your own ideas and to stretch your imagination and photographic ability.

Framing and lighting

If you frame your shots tightly you can impart greater impact to the picture, by making use of vibrant and eye-catching color. Also, by framing tightly you do not have to concern yourself with how the model is dressed.

It is not possible to give very specific advice on the type of lighting to use because so much depends on the style of hat, the shape of the model's face, and the type of make-up she is wearing, but by using angled lighting, not only from the sides but also from above or below, you should avoid the problem of the lighting becoming too flat and uninteresting.

In general you will find that pictorial elements, such as color, shape, texture, and form, become more pronounced with

◄▼ Using hats to good effect
If chosen with care, a hat can lift a photograph and become the center of attraction in itself. Using a hat as a prop for portraits can also be the means of providing an interesting group of pictures that have the added strength of comparing hat styles and the way they affect the face. As well, hats, like any other piece of clothing, are a fascinating indicator of changing fashion.

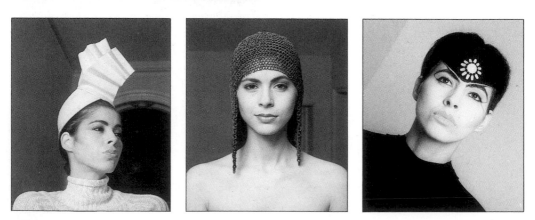

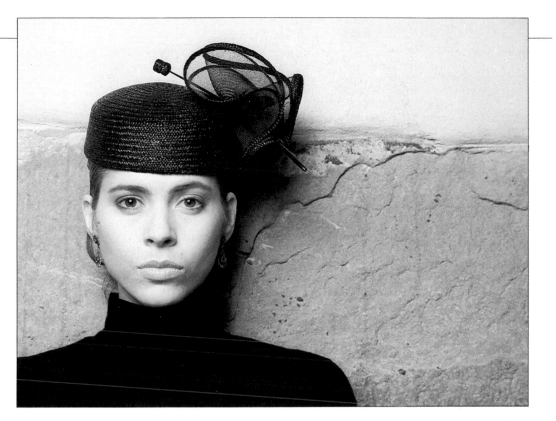

▲ Contrasting background

The smooth, sleek lines of the model's clothes and hat, as well as her cool, sophisticated appearance, are contrasted well by the rough stone wall behind.
☐ *Hasselblad, 150 mm, Kodak Tri-X, 1/125 sec, f 4*

SEE ALSO

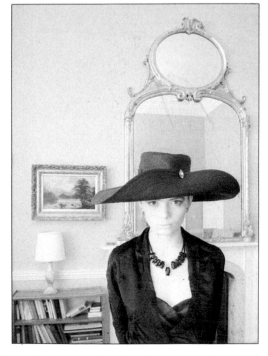

◄▲ Complementary background

The background for this picture is entirely in keeping with the model's appearance. Note how the eye travels from the hat to the top of the mirror, and then back to the face as shown above.
☐ *Pentax, 50 mm, Ilford HP5, 1/125 sec, f 5.6*

▷

a soft, directional illumination although, on occasion, a strong spotlight will help to abstract shape, accentuate expression, and simplify an unnecessarily intrusive background. If shadows then become a problem, use reflectors under the face to return some of the light.

An eye for detail

As soon as you pull the camera back a little, you also need to take into account the colors and style of the model's clothes. Colors can either coordinate or contrast, depending on the effect you are trying to achieve. But you must ensure that the style of hat and that of the clothes work together so that you do not end up with an elegant face and hat coupled with a less appropriately attired body. This type of advice holds good for most pictures, but there is no reason why you should not introduce a sense of incongruity on occasion.

The use of make-up is another factor that can make your work stand out and, if applied skilfully, it is an indication that you are somebody who cares about detail. Use make-up color to help link hat and face or face and clothes. Or, depending on the circumstances, the cut of the front of a helmet-style hat can find a sympathetic shape in the sculptured form of the model's eyebrows.

If you decorate the hat with, for example, highly reflective jewelry, you must be careful to avoid creating bright highlights which will flare into the camera lens and spoil the shot. The angle of the lights is the determining factor here, but if these 'hot spots' prove impossible to avoid, you can spray the jewelry with a proprietary brand of 'dulling' spray to reduce the amount of light reflected back.

▼▶ Showing the setting
In a detailed picture such as this the impact of the hat is lessened. Lighting was provided by flash from below, as shown in the diagram.
☐ *Hasselblad, 80 mm, Ektachrome 64, 1/60 sec, f 8*

▼▶ Removing the setting
With this type of framing the hat becomes the focus of the shot. Flash lighting from below was directed up at the face, while a secondary flash was reflected to light the rim of the hat.
☐ *Hasselblad, 150 mm, Ektachrome 64, 1/125 sec, f 4*

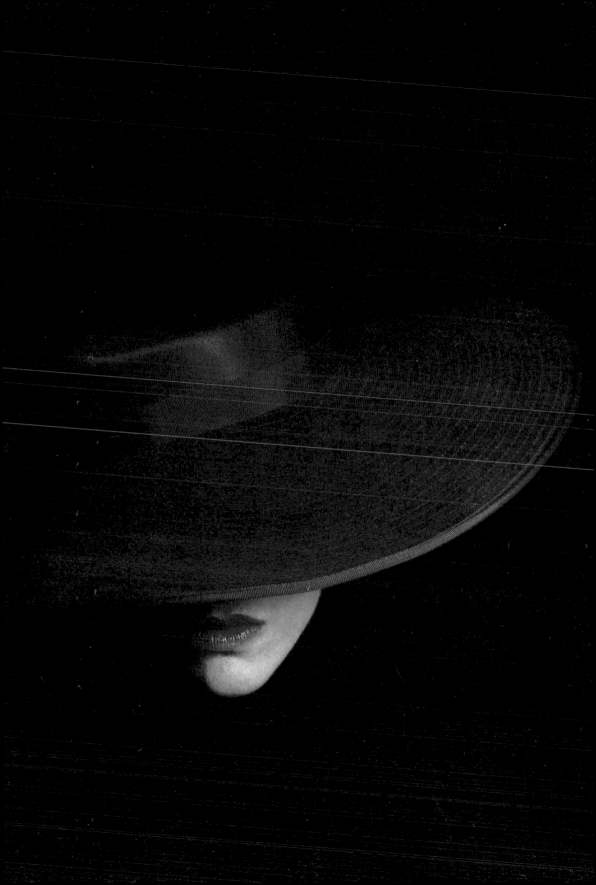

REFLECTIONS

Reflections, and especially those cast by mirrors, are often used by photographers in order to produce a different slant and a more imaginative type of portrait. For the effect to work, however, you must ensure that the glass surface is completely clean. Lighting such a picture is no different to taking the subject straight, but you do need to consider changing your focus and aperture settings.

When both the subject and his or her reflection are to be in shot, and you want them equally sharp, then you need to select an aperture that will give you an appropriate depth of field. Bear in mind that if the subject is 3 ft (1 m) in front of the mirror, then the reflection will be 6 ft (2 m) from the subject. If you are including the reflection only, then focus the camera not on the surface of the mirror but on the reflection itself. This is an ideal technique to use for taking self-portraits, especially if you do not have a self-timer.

▶ **Lead-in line**
This is a simple way of using a mirror to create a portrait, which gains additional impact by the use of the model's arm as a lead-in line to the face against a plain background.
□ *Pentax, 35 mm, Kodak Tri-X, 1/60 sec, f 11*

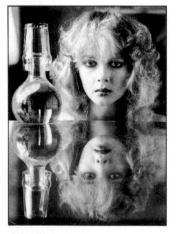

▲ **Repeating images**
A highly polished surface makes an ideal reflector for this double-image portrait.
□ *Pentax, 50 mm, Kodak Tri-X, 1/60 sec, f 8*

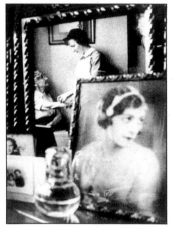

▲ **In the frame**
Including only the reflected images transforms the mirror into a picture frame.
□ *Pentax, 85 mm, Kodak Tri-X, 1/125 sec, f 11*

▲ **Central framing**
Here I used a mirror to provide a double image of the girl with her father in the background.
□ *Pentax, 28 mm, Kodak Tri-X, 1/60 sec, f 16*

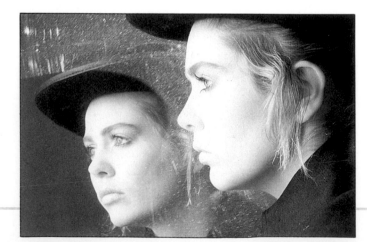

◀ **Selective focus**
Using reflections gives you plenty of opportunity for exciting double portraits.
□ *Pentax, 35 mm, Ilford HP5, 1/125 sec, f 2.8*

SEE ALSO
EXPOSURE LATITUDE 38-9
VIEWPOINTS 62-5
PROPS 170-1

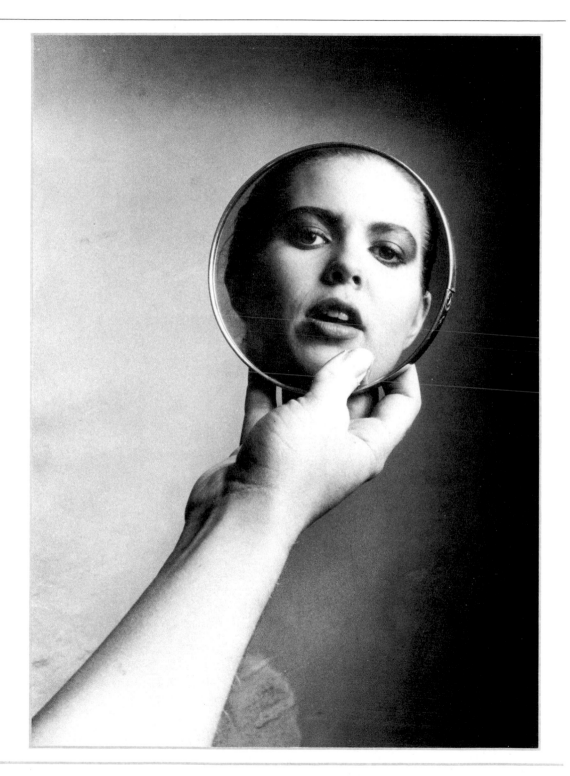

Whether you have a market for the pictures or not, using theatrical props such as masks, apart from being good fun, is an ideal opportunity to experiment with more creative styles of make-up, types of costume and setting, and unusual lighting schemes.

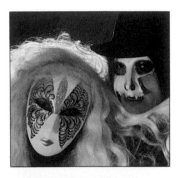

Many photographers, both amateur and professional, find that once the model slips on an identity-revealing mask it becomes easier to direct him or her into a variety of poses. Since the situation you are trying to record is unreal, you can afford to be a little more extravagant in your approach and you should be aiming to produce a dramatic impact on the viewer of the pictures.

You will discover that pictures work better if you allow your model the freedom to move round the set. You are after a different result now than in straight portraiture, and so you must adapt your technique accordingly. Rather than setting lights for a very general, overall effect, try instead for a more selective lighting scheme, relying more on spotlights than on floods.

Also, use the qualities of the mask itself to dictate the type of picture you take. Here, the long, backlit flowing 'hair' makes an ideal feature to highlight.

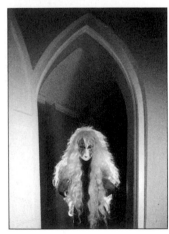

▲▶ Backlighting
For this shot, I wanted to emphasize the 'hair'. For the most dramatic impact backlighting is best, and I used a spot pointing directly at the back of her head. Modeling was provided by another spot reflected from a piece of cardboard near the camera, as shown above.
□ *Pentax, 35 mm, Scotch 640T, 1/60 sec, f 4*

SEE ALSO
THE STUDIO 74-5
STUDIO LIGHTS
AND FLASH 76-7
BASIC LIGHTING
78-9
PROPS 170-1

▲▶ Lighting the shots
With this type of subject material, lighting should be slightly over the top. For these pictures, I just used a few spotlights.
□ *Top and right: Pentax, 85 mm, Scotch 640T, 1/125 sec, f 4*
□ *Above: Pentax, 35 mm, Scotch 640T, 1/125 sec, f 8*

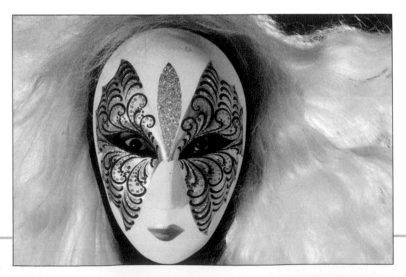

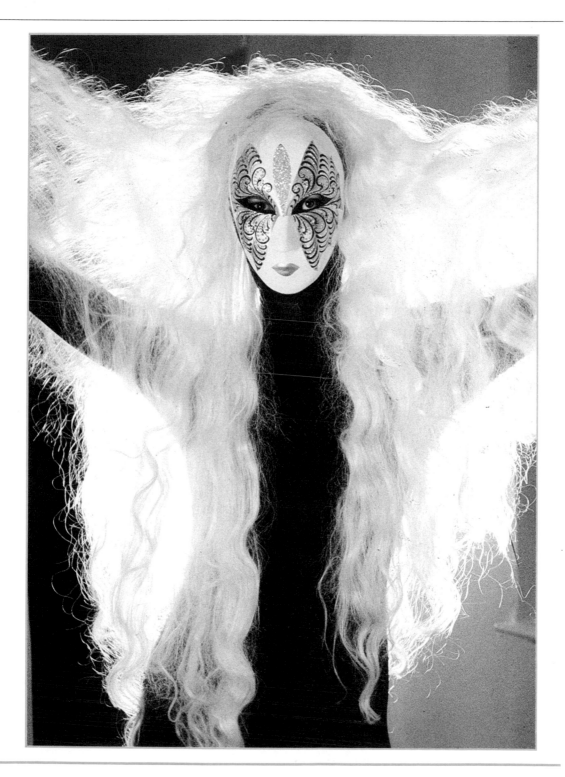

ALBUM PICTURES

The appeal of photography is that it is accessible: you need no special skills, no period of training and, especially with modern fully automatic 35 mm compacts and SLRs, you are virtually guaranteed of achieving a result. With a little bit of thought, however, your pictures, even if intended only for the family album, can have more impact and a far wider appeal.

Basic rules concerning framing the head correctly, avoiding unflattering facial shadows, separating your subject from the background, using simple studio lights as well as daylight and, perhaps most important of all, drawing your subject out of him or herself are not difficult to learn and will, after a short period, become second nature.

As you can see from the selection of shots here, all of which could be described as album pictures, composition and technique do not need obviously to intrude.

▲ Facial contortions
People often pull faces. For some it helps them to relax, for others it is natural showmanship.
☐ Pentax, 135 mm, Kodak Tri-X, 1/60 sec, f 4

▼ Stern expression
In the studio, some people adopt a very serious, almost stern expression.
☐ Pentax, 50 mm, Kodak Tri-X, 1/125 sec, f 8

▶ Children
Location shots tend to work best with young children, since the studio environment can be a little over-powering. Direct sunlight indoors does tend to be contrasty.
☐ Pentax, 85 mm, Kodak Tri-X, 1/60 sec, f 8

SEE ALSO
FRAMING HEADS 60-1
BASIC LIGHTING 78-9
PROPS 170-1
CHILDREN 174-5

▲ Dressing up
Using the minimum of props can give your model numerous ideas for different poses and expressions.
☐ Nikon, 85 mm, Ilford HP5, 1/125 sec, f 5.6

▲ Babies
With pictures of babies you need to get down to their level or raise them up to yours.
□ *Pentax, 50 mm, Kodak Tri-X, 1/60 sec, f 4*

◀▲ Simple home set-up
For a very modest outlay in terms of lighting equipment, as shown in the diagram, you can achieve professional results. To create a more even, rounded scheme, use reflectors either side of the subject.
□ *Hasselblad, 120 mm, Kodak Tri-X, 1/125 sec, f 8*

FANTASY GLAMOR

There are two distinct but complementary elements to this approach to portraiture, and success depends heavily on striking a good balance between the two.

The fantasy element implies that you need to introduce something not only out of the ordinary into the photograph but also something not quite 'real'. Props are the obvious way of achieving this end and the effect can be sufficient in itself. Another way is to present your model in an off-beat way. All-over body paint is an often-used technique, but look how successful just a small area of paint is in the example below.

For the glamor aspect of this topic, you should not necessarily jump to the conclusion that the pictures need to reveal expanses of naked flesh, as 'glamor' shots often do. Certainly the pictures need to have sex appeal, but much here depends on how your model projects his or her personality. With the right model, just showing the lips or the lips with the curve of a bare shoulder is sufficient.

◁ **Simple set-up**
Strongly contrasting colors and futuristic hats and sunglasses did not require complicated lighting — just two diffused floodlights positioned in front of the models.
□ *Pentax, 85 mm, Ektachrome 160T, 1/60 sec, f 5.6*

▶ **Projecting your personality**
Glamor can mean just a hint of sexuality if the model can project her personality, as in these two photographs. The color of your light source also affects the mood of the picture — in the shot above right, I used warm-colored tungsten lamps, while for the shot below right I changed to studio flash bounced off a silver-colored reflector.
□ *Above right: Pentax, 135 mm, Ektachrome 160T, 1/125 sec, f 4*
□ *Below right: Pentax, 85 mm, Ektachrome 64, x-sync, f 5.6*

◀ **Body paint**
Just a small amount of body paint can have great impact. Here the painted hand looks like some huge spider.
□ *Pentax, 85 mm, Ektachrome 160T, 1/60 sec, f 2.8*

SEE ALSO
STUDIO LIGHTS AND FLASH 76-7
BASIC LIGHTING 78-9
STUDIO FANTASY 86-7
PROPS 170-1

BUILDING A PORTFOLIO

If you are keen to develop as a photographer and to put together a portfolio of portraits that show a range of approaches and styles, you need to be flexible not only in respect of the techniques involved but also in how you perceive your work. Much to do with photography can be automated — exposure, focusing, and so on. What cannot, however, is your ability to present your subjects in an original or revealing way: this comes from having a basic understanding of people.

When on assignment on location in somebody's home, spend as much time as possible beforehand speaking to them. Find out their likes and dislikes, and soak up the atmosphere before starting work.

▼ Shrinking horizons

It is an unfortunate fact of growing old that with decreased mobility your horizons tend to shrink, especially, as with this elderly lady, if you are confined to bed. For her, the tangible world was to be found within the four walls of her sitting room, which now also served as a bedroom. On the walls, the mantlepiece, tables, and shelves stood the cluttered momentos of her youth — a fascinating collection of glass, souvenir china, family photographs, and lovingly tended plants. I wanted this photograph to reflect the feeling of looking in on a window on the past and to include the whole room, and decided to shoot from outside and use the lace-edged curtains as a type of vignette.
□ *Rolleiflex, Kodak Tri-X, 1/60 sec, f 16*

▲ Bright future
Contrasting with the picture opposite, this study of writer and historian Marina Warner expresses the lighter side of character. In terms of visual interest the room offered tremendous scope, so I framed the shot to include all the elements.
□ *Pentax, 28 mm, Ilford HP5, x-sync, f 11*

SEE ALSO
PHOTOGRAPHING
ELDERLY PEOPLE
106-7
USING INTERIORS
122-5

CREATING A FOCAL POINT

Most photographers, especially those who take a lot of studio pictures, sometimes feel the need to introduce an artificial focal point into their compositions. Even a simple prop, such as a hat or an arrangement of flowers, can help to lift a shot out of the ordinary.

Bearing in mind that the object of the session is to produce a portrait, you need to ensure that your focal point does not dominate. Rather, it should initially attract attention to the picture by providing the setting and then invite the viewer to look carefully at the main subject.

▼ Changing the emphasis
I wanted to introduce a less-formal focal point here. A simple ploy was to add a few twigs to her hat.
□ *Pentax, 85 mm, Ektachrome 64, x-sync, f 8*

▲ Floral arrangement
A great deal of time went into creating and lighting this floral arrangement, using two diffused floods.
□ *Pentax, 50 mm, Ektachrome 160T, 1/125 sec, f 5.6*

◄ Hair accent
Here I used dead leaves and moss as a contrast with the silky texture of the hair.
□ *Pentax, 85 mm, Ektachrome 64, 1/30 sec, f 4*

► Forest nymph
An almost complete shroud of ivy only helps to draw attention to the model in this shot.
□ *Hasselblad, 120 mm, Ektachrome 160T, 1/60 sec, f 11*

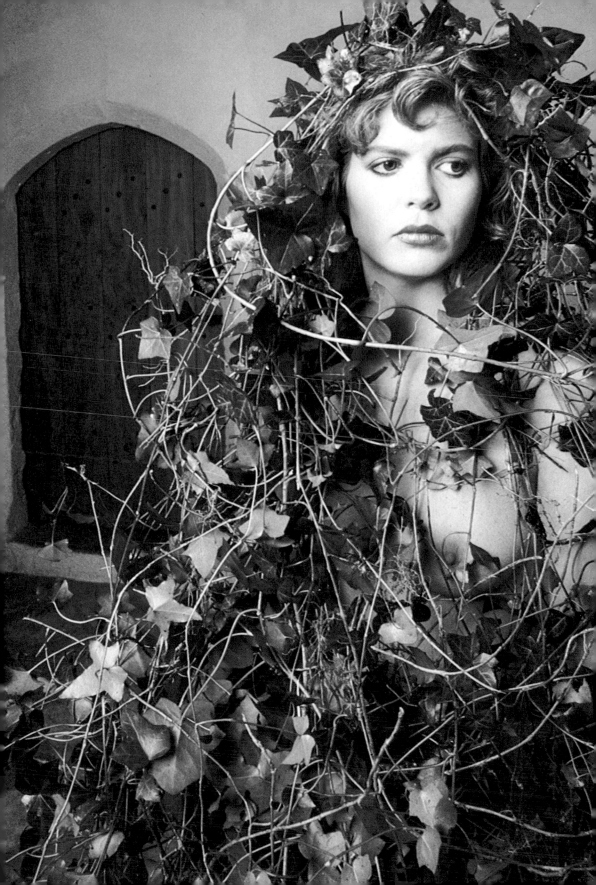

MONTAGE

Montage is a general term used to cover a number of different methods of physically combining portions of various prints. The technique can involve black and white prints, color prints or a mixture of the two.

The process of selection
As with all photographic techniques, it helps if you have at least a vague notion of how the finished product should look before starting. Look through your collection of existing prints and decide whether any are suitable. Perhaps you could use the sky from one print, a person from another, and some interior feature from a third. If, however, there are elements of the final composition missing, you will need to shoot material specifically.

The more elements you combine from different originals the more abstract the finished montage is likely to be. You could, for example, use most of the elements of a base print and just stick a person on top to make an odd juxtaposition; or you could, as in the example above, opt for a totally abstract image.

▲ Abstract imagery
This image makes no concession at all to reality: it is bold and striking with the components simply cut out, arranged and then stuck down with a suitable paper glue. Montaging is easier if you first mount the background print on rigid board.

► Montage and airbrushing
This montage is an example of a much more refined technique. The two figures obviously come from separate prints and have been arranged on the mounted base print of the landscape. Then, almost challenging reality, a shadow leading from the body builder has been added using an airbrush and dyes.

▼ Selecting images
The strength of this composition relies on the carefully selected images. Again, the base print is the landscape and a cutout J. B. Priestley looks thoroughly disgruntled with his new surroundings.

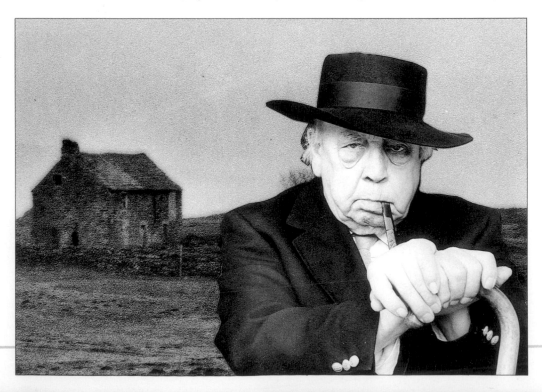

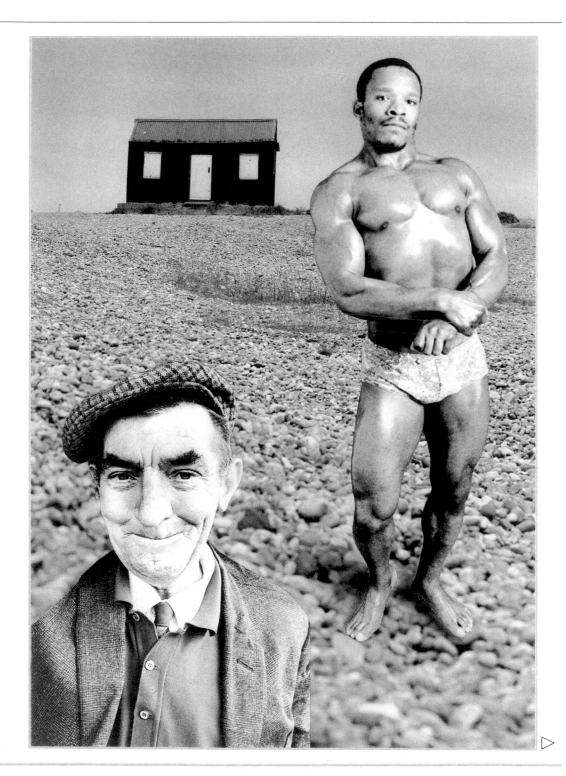

The first step with any style of montage is to cut out carefully the portions of images you want to use with a sharp craft knife. Where you place one image on top of another, the extra thickness of paper will reveal the join. If you do not want this to show, you will need to remove as much of the excess paper as possible. To do this, turn the surface print over and sandpaper away the edges of the paper until you almost reach the emulsion layer, and then blacken the exposed edges to hide the joins. With resin-coated printing papers, you may be able to peel back the emulsion layer itself and then cut away the base.

For a particularly realistic effect, you can combine montage with airbrushing in order to cover joins, blend tones and colours together, and even add shadows. Simple airbrush cans of compressed air and suitable dyes are readily available, but you will have to mix these until you achieve precisely the color or tone you need.

◀ Various sources
If you do not have direct access through your photographs to such people as Sir Winston Churchill, and you feel that your montage would benefit from a famous face or a particular location, you could utilize other visual sources, such as books, brochures, magazines, posters, and so on. The base print, or other elements of the montage, could be drawn from your own resources and the other pictorial features simply added in the usual way. In some ways, this variation on the technique makes for a neater finish (if that is what you want), since you will not usually have the problem of too much excess paper to deal with as with two ordinary overlapping photographic prints.

Remember that permission must be obtained for the use of all copyrighted material.

◀ The eyes have it

With a close-up of a human face, probably the first instinct we all have is to look at the eyes, since these are the most expressive indicators we have of personality and mood. In this montage, the multiple eyes have an immediate impact and quite a disturbing effect. The technique, however, is very simple. All that was needed was five identical prints of the same face. The first print was cut off just above the eyes and then the eyes of three other prints positioned so that they just overlapped to the same degree. The fifth print was cut below the eyes, just as the other three, but the top of the head was left on to complete the face. When utilizing identical 'slices' of prints you need to take account of the background showing behind, since this will be repeated, too. This was not a problem here because of the featureless gray coloration.

▶ Panoramic view

This type of technique is often employed when taking broad panoramas — you move the camera across the scene, keeping the horizon in a consistent position, and take a series of photographs. Afterwards, they are aligned and mounted to give a broad sweep that could not be accomplished with a single shot. Here, a wide-angle lens used from a low camera angle was used to take a series of photographs moving down the girl, so altering the viewpoint slightly each time. Different sections of the three photographs were then selected and mounted so that they were slightly disjointed. The effect has been to create a figure of monumental proportions.

POST-CAMERA TECHNIQUES

For many photographers, the image produced by the camera is regarded as being merely the starting point in the creative process. Black and white photographers in particular are often inclined to have their own film-processing and print-making facilities at home: all that is needed is a small, light-tight space and a basic amount of equipment.

A home black and white darkroom is likely to be a more attractive proposition not only because equipment needs are minimal but also because black and white chemicals and printing papers are more tolerant of slight changes in processing times and temperatures. With color, as well as very precise time and temperature control, you also have the additional problem of judging, testing, and setting a series of filters in order to produce successful prints. Color analyzers are readily available but these add to the cost, making the use of a laboratory more likely.

Special effects

With a black and white darkroom set up, the range of special effects you can achieve is wide, including the selection presented here. The ghost-like negative print below and the two different types of Sabattier effect (also, incorrectly, known as solarization) at the bottom of the page require no special equipment at all. The print opposite, although not in any way difficult to produce, does require a special screen, which you can either buy or make yourself from any suitably patterned, translucent material.

◄ Negative print
For this result, place a slide in the enlarger and project it on to ordinary printing paper. It is also possible to contact print a photograph to make a negative print by placing the picture face down on a sheet of printing paper and projecting light through the back of it. Lay a piece of clean glass over the top to bring the print and paper into close contact.

► Sabattier effect
For the type of effect right, allow the print to develop for about half its normal time (approximately 1½ min) and then flash the white room lights on for about 1 sec and continue development. For the picture far right, place a piece of black cardboard over areas of the print you do not want affected by white light.

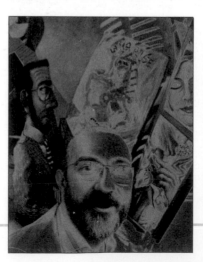

▲ Screen prints
Printing ordinary negatives through a textured screen is a very easy and eye-catching technique. For this print, a piece of clean frosted and etched glass was laid over the printing paper and the negative projected down from the enlarger as normal. The type of screen effect you get in the end depends entirely on the material you use. Also available are commercially produced screens giving a wide range of patterns. A variation on this is to include the screen material with the negative.

PAPER GRADES

Photographers working in black and white have a level of control over image contrast that is not available to users of color — that of paper grade. If you have a darkroom at home, you can choose printing paper from approximately six different contrast grades, ranging usually from 0 to 5, in either single-weight or double-weight fiber-based types or in medium-weight resin-coated stock. Also available is a variety of paper finishes, such as stipple texture, matt, or glossy. If you have your negatives printed at a laboratory, you should still be able to specify the type of paper you want used.

Which paper?

Briefly, in terms of image contrast only, fiber-based papers tend to produce a more solid black and a cleaner white than resin-coated, though resin-coated papers are quicker to process (especially at the washing stage, since processing chemicals cannot penetrate the paper itself) and easier to dry.

In terms of paper grade, 0 produces the maximum number of half tones between pure white and solid black and, therefore, the least contrasty image. If you have a contrasty image, however, then grades 0 or 1 should produce the most normal-looking print. Grades 2 and 3 are meant for use with normal-density negatives, and grades 4 and 5 are designed to produce normal-looking prints from low-contrast negatives.

To avoid having to keep a stock of different-grade papers, you can, instead, use a multigrade paper. This paper is made so that its contrast-recording ability can be altered depending on the type of filter positioned under the enlarger lens.

▶ Reducing film contrast

This picture showing the composer Igor Stravinsky during a rehearsal session was taken in dim lighting conditions without flash. To compensate for this I under-exposed the film one stop and increased development time accordingly. The resulting negative was then printed on grade 1 paper in order to correct, as far as possible, the overly harsh contrast typical of film that has been pushed in this way.

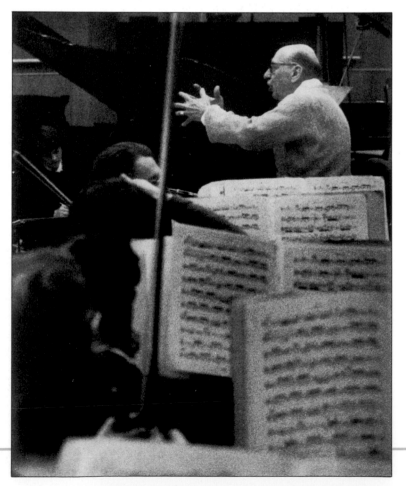

▶ Using medium-contrast paper
The negative for this picture, showing the author Agatha Christie, was of normal density, with contrast neither too harsh nor too soft. With a negative such as this, medium-contrast printing paper, usually designated as grade 2 or 3 by the manufacturers, will produce the best type of print, with a good, solid black, clean whites, and a wide range of grays in between.

◀ Using soft-grade paper
In this version of the print the same negative was used. The only difference is that it was printed on grade 0 paper. Even allowing for the fact that some subtlety is lost during the book-production process, it is possible to see that a normal-contrast negative starts to take on a 'muddy' appearance on soft paper, with the whites, especially, looking a little gray.

▶ Using hard-grade paper
Again, the same normal-contrast negative was used, but this time it was printed on grade 5 printing paper. The differences are now startling. Gone, almost completely, are the gradations of gray, and the image largely consists of blocks of black and areas of white. If this paper had been used with a very soft-contrast negative, though, the result would have been more like the version at the top of the page.

GLOSSARY

Air brushing A technique in which dye or pigment is sprayed with compressed air over an area of a print. Air brushing can be used to remove unwanted parts of a scene, to change its color or texture, or to hide joins where prints overlap, as in *montage*.

Ambient light The light that is normally available. Outdoors, this would be light from the sun, while indoors the term describes ordinary domestic lighting, as opposed to photographic lighting in a studio.

Angle of view The outer limits of the image area seen by a lens. Wide-angle lenses have a wider angle of view than telephoto lenses. Also sometimes known as the covering power of a lens.

Aperture The opening in a lens through which light is admitted. On all but the simplest cameras, the size of the opening can be varied, either automatically by the camera or manually by the photographer via the *aperture ring*.

Aperture priority A type of camera exposure system where the photographer determines the *aperture* and the camera sets the *shutter speed*.

Aperture ring The control ring located on the barrel of most lenses that can be turned by the photographer to control the size of the *aperture*. The aperture ring is calibrated in a series of *f-numbers*.

Artificial light film Color film designed to be exposed under tungsten light with a *color temperature* of usually 3200K. Under this type of lighting, colors will appear normal; if exposed in daylight, however, an orange *color cast* will result unless an appropriately colored correction filter is used over the camera lens.

ASA A number classification devised by the American Standards Association to represent the sensitivity of film to light. Now almost universally replaced by the *ISO* classification, which uses identical numbers.

Available light See *Ambient light*.

B

Backlighting Light coming from behind the subject and toward the camera. Unless a backlight-compensation button is provided, automatic cameras will tend to *underexpose* a main subject lit this way.

Barn doors A lighting accessory, comprising usually of four metal flaps, that fits round the lighting head of a *floodlight* or *spotlight* and is used to control the spread of the light beam.

Bounced light Light, usually from a flashgun or photographic light, that is directed at a surface, such as a wall, ceiling or special reflective umbrella, and is reflected on to the subject. This arrangement gives a soft, diffused effect and helps to avoid unattractive shadows.

Bracketing A series of different exposures of the same scene and viewpoint taken in order to obtain the best result. Usually, the difference in exposure between frames in the series is one-half of a *stop* above and below the estimated exposure level.

B-setting A *shutter* setting that holds the shutter open for as long as the release button is depressed. Its purpose is to provide exposure times longer than those allowed for on the camera controls.

C

Catadioptric lens A telephoto lens that uses a combination of lens elements and mirrors to increase the length of travel of light within the lens and so produce a long focal length in a short barrel. Also known as a mirror lens.

Close-up A photograph in which the subject's head occupies most of the frame.

Color cast An overall bias toward one particular color in a color print or slide. A blue color cast is noticeable when *artificial light film* is exposed in daylight.

Color saturation The purity or apparent strength of a color. With color film, color saturation can be strenghtened by slight *underexposure*, with an associated loss of some shadow detail.

Color temperature A method of describing the color content of different light sources, usually expressed in degrees Kelvin (K). Red light, at approximately 1800K, has a lower color temperature than blue light, approximately 6000K. Many studio light sources have a color temperature of 3200K, while sunlight has a value of between 4500 and 5000K.

Compact camera A small, highly automated 35 mm camera, usually featuring automatic exposure, autofocus, and automatic film transport.

Contre-jour An alternative name for *backlighting*.

Converter lens An accessory that fits between the camera body and lens and doubles (x2) or trebles (x3) the focal length of the lens. With this accessory there is always some loss of lens speed and of *resolving power*.

Covering power See *Angle of view*.

D

Darkroom A light-tight, well-ventilated room used for developing film and making prints.

Dedicated flash A flashgun designed for use with a specific camera or range of cameras. It connects to the camera's circuitry and can, for example, alter the camera *shutter* to ensure a correct *exposure*.

Depth of field The zone of acceptably sharp focus surrounding the point of true focus. The size of this zone extends approximately one-third in front of and two-thirds behind the point of focus and varies according to the *aperture* set, the focal length of the lens, and the distance of the subject from the lens. Basically, the smaller the aperture, the shorter the focal length, and the more distant the subject, the greater the depth of field.

Diffuser Any translucent material held over a light source or, less usually, the camera lens, that can scatter light and produce a softer lighting effect or image.

E

Emulsion The light-sensitive coating on film or printing paper where the image forms.

Exposure The product of the intensity of light reaching the film (controlled by the *aperture*) and the length of time the light is allowed to act (controlled by the *shutter*).

Exposure latitude The degree of *over-exposure* or *under-exposure* an *emulsion* will tolerate and still produce an acceptable image.

F

Fast film Film that is highly sensitive to light. Such films have an *ISO* rating of 400 or more.

Fast lens A lens with a wide maximum *aperture*, denoted by a low *f-number*.

Fill-in light A secondary artificial light source, usually used to lessen contrast and lighten or remove shadows.

Film plane The position in a camera where the film lies. This is also the plane where light from the lens is brought into focus.

Filter factor The number engraved on a filter mount by which *exposure* must be increased to compensate for light removed by the filter.

Fisheye lens An extreme wide-angle lens, with an *angle of view* exceeding 180°. This type of lens produces highly distorted images, with distinct curving of vertical and horizontal lines. *Depth of field* is, however, almost infinite with this type of lens, and so focusing is very often unnecessary.

Flash synchronization A system of ensuring that the flash fires only when the *shutter* is fully open. This synchronization speed is often marked in red on the *shutter speed* dial.

Floodlight A studio tungsten light source with a dish-shaped reflector producing a wide beam of light.

f-numbers A series of numbers found on the aperture control ring of a lens indicating the size of the *aperture*. Moving the control ring to the next lowest number doubles the size of the aperture and reduces *depth of field*. Also known as f-stops.

Focal plane The position in a camera where light from the lens is brought into focus. The focal plane and the *film plane* coincide.

Focal plane shutter A mechanism consisting of two horizontally or vertically traveling 'blinds' placed just in front of the *focal plane*. The gap between the two blinds is determined by the *shutter speed*.

G

Grade A system of numbers describing the contrast-recording ability of black and white printing papers. Grade 0 records the greatest number of tones; grade 5 the least.

Graduated filter A colored filter that gradually reduces in density towards the center, leaving the other half clear.

Graininess The visual appearance of the black metallic silver grains that make up, after development, the photographic image. Pronounced graininess has a detrimental effect on the detail-recording ability of the photographic *emulsion*. Graininess is more obvious in *fast film*.

Guide number A number denoting the power of an artificial light source such as flash. To determine ▷

the *f-number* to set, divide the subject distance by the guide number. The figure applies to *ISO* 100 film and to subject distances measured in feet or meters.

H

High key A photograph or slide in which lighter, paler tones predominate.

Highlight The lightest part of a positive image. On a negative, a highlight appears as the area of greatest density.

Hot-shoe An accessory found on the top of nearly all modern cameras that do not have built-in flash. An electrical contact on the bottom of the shoe fires the flash and forms part of the *flash synchronization* circuit.

Hue The name of a color.

I

Incident light The light falling on an object or scene. An incident-light exposure reading measures this light, as opposed to that reflected back by it.

Intersection of thirds Also known as the rule of thirds, a method of image composition in which the frame is divided into thirds, both horizontally and vertically, by imaginary lines. Any object positioned at the intersection of any of these lines is thought to have additional emphasis within the composition.

ISO A number classification devised by the International Standards Organization to represent the sensitivity of film to light. It has now almost universally replaced the *ASA* system, although it uses identical numbers.

K L

Kelvin (K) A unit of temperature measurement used to describe the color content of a light source. See also *Color temperature*.

Key light The principal light source used to light the subject in a studio set-up.

Kilowatt A measurement of electrical power (and, thus, of light output) signifying 1000 watts.

Large-format camera A camera, usually used in the studio, that takes individual pieces of cut film, as opposed to 35 mm cassettes or rollfilm.

Latitude See *Exposure latitude*.

LED (light-emitting diode) A visual display system for indicating camera functions, such as shutter speed and aperture, seen either in the camera *viewfinder* or on a panel on the top plate of the camera.

Lens speed See *Fast lens*.

Low key A photograph or slide in which dark, somber tones predominate.

M

Magazine A light-tight container used for bulk lengths of film. Also used to describe the type of removable film holder found on most medium format cameras.

Mirror lens See *Catadioptric lens*.

Mode An exposure operating programme (usually one of several) available on automated cameras.

Modelling light A light used to create shadow and light and a more natural, three-dimensional effect. Also a low-output, continuous light source built into the lighting head of studio flash units. It does not affect exposure but allows the photographer to preview the pattern of light and shade that will be created when the flash fires.

Montage A composite picture made by physically combining parts of prints to create a new composition.

N O

Neutral density filter A grey filter used over the camera lens to reduce the amount of light reaching the film without affecting the color balance of the photograph or slide.

Opening up Increasing the size of the *aperture* by selecting a lower *f-number* in order to allow more light to reach the film.

Overexposure The result of exposing a light-sensitive *emulsion*, either film or paper, to too bright a light source or allowing that light source to act on the emulsion for too long.

P

Panning Swinging the camera to track a moving subject while the *shutter* is open. This produces a relatively sharp image of the subject against a blurred background.

Parallax error The difference in viewpoint between the scene recorded by light entering the lens and that seen through a direct-vision *viewfinder*. This problem does not arise with an *SLR*.

Pentaprism A five-sided prism found on the top plate of nearly all *SLR* cameras. Its internal reflective surfaces produce a correctly orientated image in the viewfinder. Without a pentaprism, the image seen would be reversed left to right.

Portrait lens A short telephoto lens with a focal length about twice that of a standard lens, and considered ideal for *close-ups* and head-and-shoulder shots.

Pushing Under-exposing film to gain speed in low-light conditions and then compensating by increasing development time. There is an associated increase in image contrast with this technique. Also known as uprating.

R

Recycling time The time taken for an electronic flash to recharge, ready to fire again.

Reflected light reading A measurement of the amount of light being reflected by the subject. Used by all *TTL systems*.

Resolving power The ability of a lens to produce fine subject detail.

Reversal film Any film producing a direct positive image that is

viewed by transmitted light. Also known as transparency or slide film.

S

Sabattier effect A part positive, part negative image formed by briefly exposing printing paper to white light during the development process. Development then continues normally.

Sensitivity The degree by which a photographic *emulsion* is affected by exposure to a light source.

Shutter Any mechanical arrangement that determines the length of time light is allowed to act on the film in a camera. See also *Focal plane shutter*.

Shutter priority A type of camera exposure system where the photographer determines the *shutter speed* and the camera sets the *aperture*.

Shutter speed The length of time the *shutter* remains open, allowing light to act on the film.

Slave unit A device that reacts to light from the main light unit connected to the camera and triggers an additional electronic flash. Allows multi-flash set-ups to be used without any connecting cables.

SLR (single lens reflex) A camera system that uses a 45° mirror situated behind the lens to direct light entering the lens to a *viewfinder*. Just before exposure, the mirror swings out of the way, the *shutter* opens, and the film is exposed. This arrangement means that the image in the viewfinder always exactly corresponds to that recorded by the film. At the time of actual exposure, though, the *viewfinder* goes blank.

Spotlight A studio tungsten light source that uses a reflector and lens to produce a narrow and focusable beam of light.

Stop Another name for *aperture*.

Stopping down Decreasing the size of the *aperture* by selecting a higher *f-number* in order to restrict the amount of light reaching the film.

T

Tonal range The shades of gray between pure white and solid black, or between the lightest and darkest areas in a particular image.

Transparency See *Reversal film*.

TTL (through the lens) An exposure system that uses sensors inside the camera

body to measure light entering through the lens. This system is used in nearly all *SLR* cameras.

Tungsten light film Color film that is designed to be exposed to studio lights of about 3200K. If exposed under daylight conditions, this type of film will produce a distinct blue *color cast* unless a correction filter is used over the camera lens. See also *Color temperature*.

U V

Underexposure The result of exposing a light-sensitive *emulsion*, either film or paper, to an insufficiently strong light source, or allowing that light source to act on the emulsion for too short a period.

Uprating See *Pushing*.

Viewfinder An optical sighting device on a camera, used as an aid to composition and for focusing. The viewfinders of many modern cameras also contain all exposure information.

INDEX

ACKNOWLEDGMENTS

Mobius International Limited would like to thank the following individuals and organizations for their assistance in the production of this book: Department of Fashion Design, Royal College of Art, London SW7, Gavins Models, London W1, Philip Somerville (milliner), London W1, Leichner Cosmetics, London SW19

Illustrators: Gary Marsh, Brian Sayers, James G. Robins

Photographic services: Negs Photographic Limited, Chromacopy, Keith Johnson Photographic Limited

Additional typesetting: Elements, Ampersand Communications Limited

Manufacturers: Pentax UK Limited, Polaroid (UK) Limited, 3M (UK) PLC

Editor and associate writer Jonathan Hilton

Art editor Nick Harris

Editorial assistance James McCarter

Design assistance Debbie Rhodes

Photographic assistance Libi Pedder

Editorial director Richard Dawes